Denny Rogers

THE ILLUSTRATED

OWL

BARN, BARRED &
GREAT HORNED

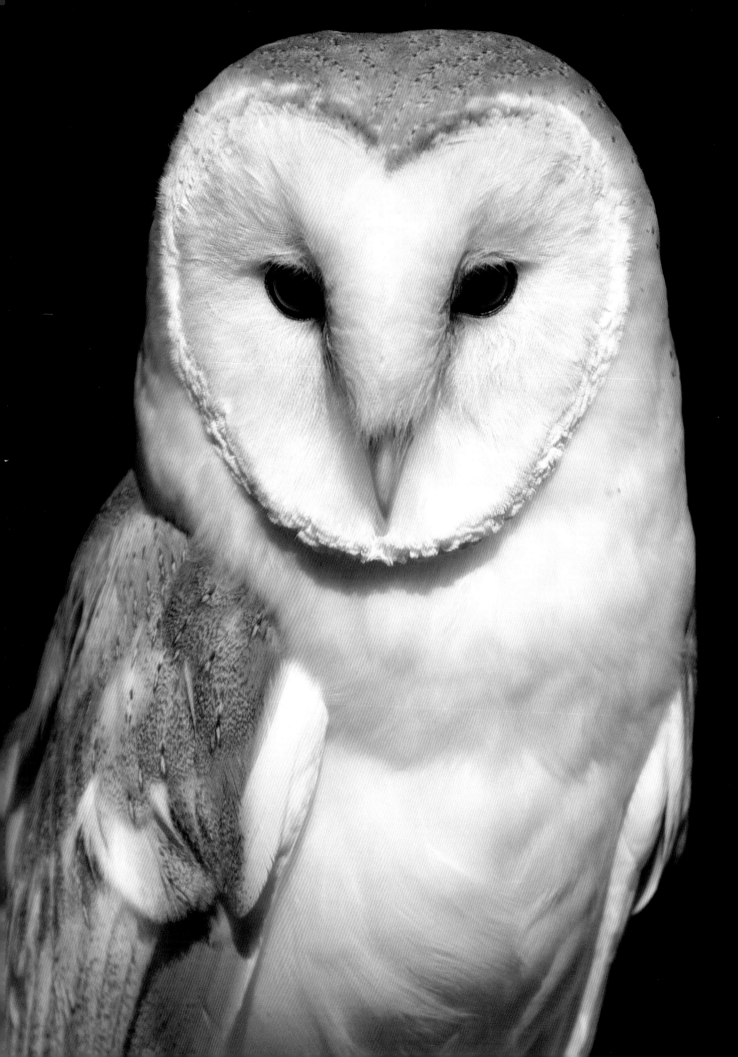

Denny Rogers

THE ILLUSTRATED

OWL

BARN, BARRED &
GREAT HORNED

Fox
Chapel Publishing

1970 Broad Street • East Petersburg, PA 17520
www.FoxChapelPublishing.com

Alan Giagnocavo
President

J. McCrary
Publisher

Peg Couch
Acquisition Editor

Kerri Landis
Editor

Troy Thorne
Design and Layout

Lori Corbett
Color Charts and Illustrations

Chanyn DeShong
Layout

Acknowledgments

Special thanks to all those who contributed to the gallery section of the book.
Thanks to Dr. James Thean, PhD, for creating the Physics of Flight section.

© 2008 by Fox Chapel Publishing Company, Inc.

The Illustrated Owl: Barn, Barred & Great Horned is an original work, first published in 2008 by Fox Chapel Publishing Company, Inc. The patterns and drawings contained herein are copyrighted by the author. Readers may make copies of each pattern for personal use only. The patterns themselves, however, are not to be duplicated for resale or distribution under any circumstances. Any such copying is a violation of copyright law.

ISBN 978-1-56523-313-3

Publisher's Cataloging-in-Publication Data

Rogers, Denny.

 The illustrated owl : barn, barred & great horned / Denny Rogers. –
1st ed. – East Petersburg, PA : Fox Chapel Publishing, c2008.

 p. ; cm.
 ISBN: 978-1-56523-313-3

 Includes color charts created by bird carver Lori Corbett.
1. Owls in art. 2. Owls–Physiology. 3. Wildlife wood-carving–
Patterns. 4.Wood-carving–Patterns. 5.Woodwork–Patterns.
I. Corbett, Lori. II. Title.

NC782 .R643 2008
743.6/897--dc22 0803

To learn more about the other great books from
Fox Chapel Publishing, or to find a retailer near you,
call toll-free 1-800-457-9112 or visit us at *www.FoxChapelPublishing.com*.

Note to Authors: We are always looking for talented
authors to write new books in our area of woodworking, design,
and related crafts. Please send a brief letter describing your idea to
Peg Couch, Acquisition Editor, 1970 Broad Street, East Petersburg, PA 17520.

Printed in China
10 9 8 7 6 5 4 3 2 1

PUBLISHER'S NOTE

It all started with his research on the American Bald Eagle.

In 1985, while doing doctoral work at Illinois State University, author/illustrator/sculptor Denny Rogers created *Winged Magnificence*, a life-size bronze American Bald Eagle in dramatic flight, for President Ronald Reagan's second inauguration.

Suddenly, Denny found himself fielding requests from artists across the country who wanted patterns from which they could create their own eagles. With the help of scientists and the U.S. Fish and Wildlife Service, Denny researched and developed 28 ultimate reference products for artists wanting to create birds of prey. These highly detailed patterns of eagles, hawks, owls, and falcons have been used by thousands of artists around the world to create award-winning wildlife projects.

Now, for the first time ever, Fox Chapel Publishing is pleased to bring together in *The Illustrated Owl: Barn, Barred & Great Horned* the meticulously crafted and anatomically accurate barn, barred, and great horned owl patterns and diagrams created by this highly acclaimed artist. On the pages of this definitive reference for woodcarvers, sculptors, artists, and craftsmen of all types, you will find Denny's majestic bird renderings, his intensely illustrated animal physiology, forensic analysis, and detailed measurements.

Whether you aspire to a world championship or simply want to create lifelike owl art, you'll find *The Illustrated Owl: Barn, Barred & Great Horned* with its patterns, diagrams, and many reference photos of actual birds as well as finished projects, to be indispensable.

For those who use Denny's drawings in their artwork, the author would like to hear from you. Please send photographs of your finished creation, along with an explanation, permission to use it in future publications, and your name, address, and telephone number to Denny Rogers, 13723 Burr Oak Road, Bloomington, IL 61704. You can reach Denny by phone at (309) 622-0182.

FROM THE AUTHOR

Sculpting clay for limited-edition bronze crucifix.

Limited-edition bronze portrait busts of Lincoln and Reagan in various stages.

Above right:
Winged Magnificence, Denny's full-scale sculpture of an American Bald Eagle.

"Every life is lived as a comedy and a tragedy, a surreal drama acted out in the nether region between who we are and who we want to be." Mine's been no exception.

My earlier childhood memories involve leaving home in all weather and seasons, wandering fields, creeks, and woods, taking in everything there was to see and experience, and always coming home late with lame excuses. I'd smuggle home toads, frogs, snakes, and any orphaned critter, much to the annoyance of my mother. I'd dissect for study, and watch plants, trees, clouds, skies, moon, and stars. I had to know how everything worked on the inside as well as the outside. Happy times were often spent alone, discovering what was over the next hill. I had no sense of time or boundaries, which often got me in trouble.

In my Huck Finn/Tom Sawyer way of thinking, time was the continuous flow of "now," so how could I be late? If you don't acknowledge time, how can a kid be lost? No matter where I went, there I was. If kids can locate their own personal north star, they'll never be lost. I've never been lost. A mite confused and beaten down at times, but never lost. But often wet, cold, and hungry. Poker-faced, with strange wit and dry humor, I can still find fun in an empty elevator.

A flunking 5½-year high school career behind me, entering Illinois State University as a freshman, a counselor said I was a puzzle. "Do you want to be a graphic designer, illustrator, product designer, forensic artist? Sculptor, animal/human artist, movie FX artist, museum artist? Architect, engineer? Physiologist? Professor? Author? What?" I told him, "Yes. All those things." It made perfect sense to me. He said, "Oh. A Renaissance man. You'll never get through college. No discipline." I told him I'd finish ISU with at least an M.S. and teach the curriculums he said I couldn't complete. And did. Mostly. But settled for pseudo-architect, engineer, and physiologist. I still haven't finished that Ph.D. thing. Time. Always time.

As a university student supporting a student wife (now an accountant) and two sons, I freelanced commercial art and worked as a laborer, ironworker, and—because I boxed—was always a nightclub bouncer. As a university teacher, I freelanced as a graphic designer/illustrator. In my own time, I'd do these bird drawings, and market, study, and create woodcarvings, bronze sculpture, and forms of construction and wander America and Canada in search of wilderness and creative art adventure and still do.

Over a lifetime, I've met and know well every type and social class of people, and buddied into every common interest crowd, always searching for that metaphorical thing in the woods that will eat you. On occasion, I've woken up in the arms of my nightmare, face-to-face with the real thing. I've had no boring travels I remember, and at the end of every trip, I carry fond memories homeward, in the cold gray light of gone, of the people and places I discovered. I've never been denied a welcome back from either newfound friends or the woman who warmed me, who's always known this man was born to roam.

This fourth book in the series is behind me now. Creating books is a lot like raising kids. You give it your all. Then, one day, they walk out the door into the bright white light of future history, leaving you as a bit player in your own play.

Creative misfit, hopeless romantic throwback, there's a thought I live by: "If a man is to keep safe from falling, he can never aspire to climb toward some incredible height and stand there alone, consider the smallness of valleys, and how far they lie beneath him." At 62 in 2007, I'm beginning contract talks with a mega construction tool manufacturer for a new tool product I designed, and I have numerous other products on file. I have a woodland grotto church, on hold, to develop later. I just agreed to do a Team Rogers total environment and bronze sculpture monument for Dream Catchers Foundation in Williamsburg, Virginia. And I'm meeting with prominent Peorians, universities, and senators about returning to academia as a professor to oversee a research and design project for a massive Illinois Presidents Monument as lead designer and sculptor. And I'm finishing my total reconstruction of my black and chrome '75 Harley Davidson Sportster, Ol' Crazy Horse. I'm not wet. I'm not cold. And I'm not hungry. Consider these good times.

ACKNOWLEDGEMENTS

This is the right place and time to thank many people who have helped my creative pursuits:

President Ronald Reagan and Vice President George H.W. Bush for their request to use my life-size American bald eagle sculpture for their second inaugural.

Celebrities of note, such as Willie Nelson, who hired me to create full-color art products of their personas and the opportunity to personally experience living history; Willie's parties aren't for the meek.

My movie special effects artist cronies for the good times, especially John Naulin and Jim Spinner: *Team America World Police* was more fun than the eighth grade picnic.

Prosecutors, coroners, and senior police who called on me for my anatomical understanding and illustrative skills. The many homicide cases gave me a lifetime of insight.

Professor Jim Fry, from my M.S. in Product Design/Manufacturing, for teaching me how diverse abilities can create needed new products.

Senior Agent John Mendoza of the U.S. Fish and Wildlife Service for "bending the rules" and providing me with excellent captive specimens.

Director Dr. Bruce McMillan and Dr. Tim Cashett of Illinois State Museums for providing direction while entrusting me with rare mounts and study skins.

Dr. Fred Mills and Bob Stefl, Chairman and Assistant Chair of Illinois State University Art Department, for 20 years of guidance, patience, and friendship.

Many fanatically loyal design and illustration students from my overflowing university classrooms; you still arrive at my door with stories of your success.

Incredibly tolerant faculty and staff of Springfield High School, who worked hard to keep me in school and out of trouble.

Sr. Pauletta and the sisters at Little Flower Grade School for your kind words and the lessons you taught.

The many professional senior artists from my teens who showed me the "little things" that separate professionals from amateurs.

Some always in my thoughts: Jim Spinner, Bill Hunt, Scott Jones, Marshall Mitchell, Rocky Schoenrock, Bill England, Maynard Upton, Keith Knoblock, and Lori Corbett among others. Every artist is the grand total of many.

Laborers 362 and Ironworkers 112 for providing me with the means to provide for my family while a university student; you launched this common man to very uncommon places and experiences.

The many woodcarvers and other artisans who submitted their prize-winning creations to form an incredible gallery in each of these books.

Those artists who endorsed this book series in writing; your kindness was unexpected and wonderful.

Fox Chapel Publishing for their excellent staff; their visionary mindset continues to provide insight and inspiration to many around the globe.

My wife, Carol, junior high sweetheart and life partner, who stuck with me in spite of me when all that stood beside me was my shadow on the floor. "You were always on my mind."

Al and Dorothy Rogers, parents to ten children; they believed in me, made me believe in myself, and dared me to be different. They didn't live to see my best work, but I feel their smiles.

When I left home, dad and I had a talk that has never stopped guiding my life. I'd like to pass his advice on to you: "All any man can really own is his name; everything else is passing. Work to perfection, always, and sign your name proudly—whether creating a masterpiece or digging a ditch. If you succeed, help others to succeed. Never start a fight, but finish every one put upon you. Be proud of your country; many worked hard to build it. Many died for it. Remember your Creator; He's the real artist. Make your mother proud." A million-to-one shot poor kid, I lived out most of my wildest fantasies. I lived an American Dream.

Full-color drawing of Willie Nelson for use in products.

Above:
Drawing of the Illinois Presidents' Monument.

© Copyright 2008

FOREWORD

I first met Denny Rogers in the early 1980s when I was ordering his red-tailed hawk reference diagrams over the telephone. I'd been carving professionally since 1979 and was in search of information on bone structure and anatomical detail. When Denny answered the phone, I said, expecting a celebrity of sorts, "Professor Rogers, I would like to order one of your birds of prey products." He laughed, "Call me Denny." We've had a 24-year friendship through the mail, by telephone, and through art shows since. He's the type of guy that, when you talk to him once, you feel like you've always known him—a genuine character. To Denny Rogers, a stranger is just another friend he hasn't met yet.

Every year since the first time I spoke to Denny about red-tailed hawk reference illustrations, I had a standing order with him, wanting each of his bird of prey, hawk, eagle, and owl products sent to me. In my spare time, I studied, and continue to study, birds in their natural habitat or at the Raptor Center and study skins at the Science Museum of Minnesota all for one purpose—to recreate birds'

looks and personalities. Over the years, I've carved hawks, eagles, falcons, owls, songbirds, and various waterfowl. I honestly believe that, without the reference provided to me by Denny, the quality of my work and my skill level wouldn't be where it is today.

Since 1984, I've received numerous Best of Show ribbons at national art shows. In 1999, I was awarded Best of Show in every category at the National Ducks Unlimited Show in Kansas City. I have won prizes at the Wildlife and Western Art Collectors' Society Show, the Wildlife Heritage Art Show, Ducks Unlimited Shows, Operation Wildlife, and Wisconsin Wildlife Forever Programs. I was also commissioned to create a life-size loon and chick for the Minnesota Loon Project.

Many of my creations are in private collections in the United States and Europe. I am also honored to have had one of my carvings inducted into the permanent White House collection by former President Ronald Reagan. The Department of Interior commissioned me to do a full-size American Bald Eagle for its facilities in Springfield, Missouri. Many other pieces of my work can be found at major corporations. All of this is thanks in part to Denny, to whom I gave my first male wooden kestrel and first bronze chickadee in deep appreciation.

My experience is just the story of one carver, but many carvers, sculptors, artists, craftsmen, and educators throughout America report the same results using Denny's diagrams. And, we're all overjoyed that these illustrations are now available in book format. I thank Denny for providing the reference material so unselfishly. He can never know the amount of people he has helped by sharing his many talents.

John Strutt, woodcarver
Saint Paul, Minnesota
June 2005

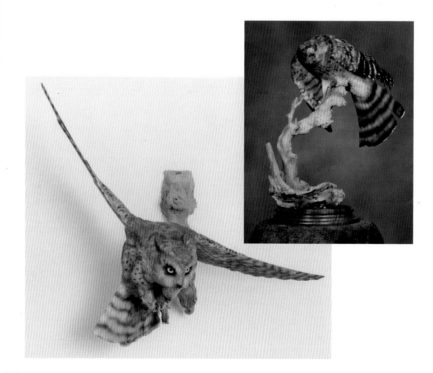

TABLE OF CONTENTS

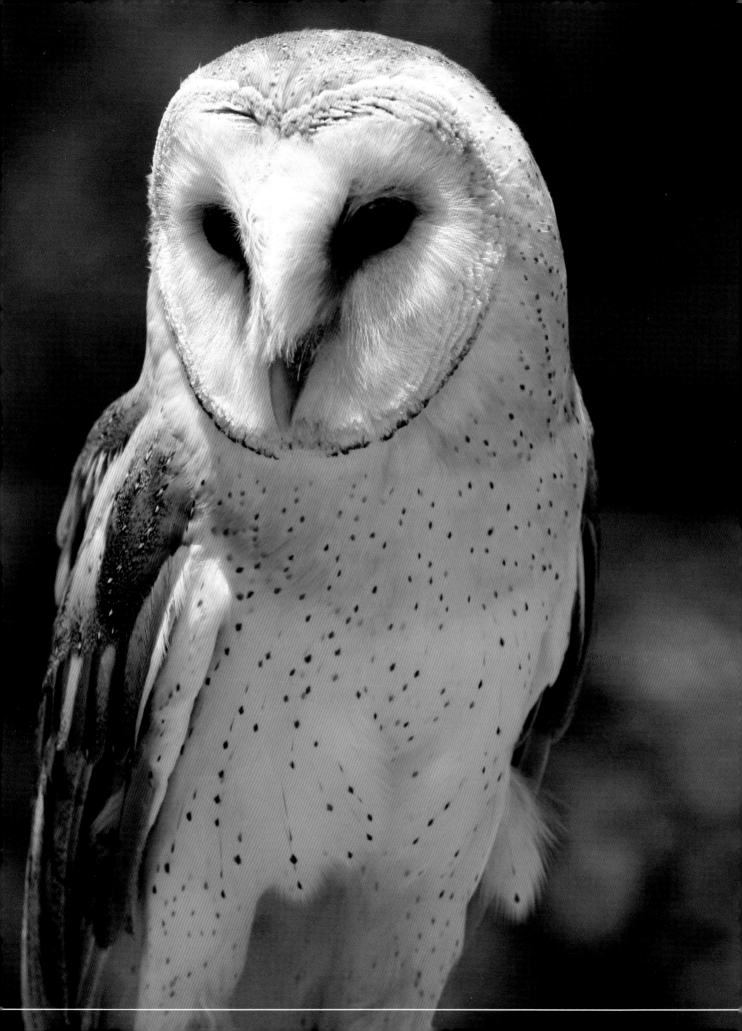

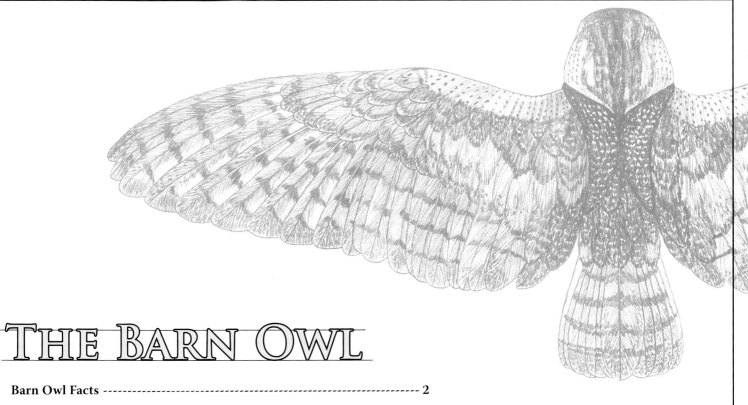

THE BARN OWL

© COPYRIGHT 2008

Barn Owl Facts

The barn owl (*Tyto alba*) is one of the most widespread owl species; it is present on six of seven continents, and can be found in such diverse locations as Tasmania, India, Ireland, and Hawaii. In the United States, the barn owl is considered endangered or rare in several states. This completely nocturnal owl is 14 to 20 inches (35 to 50 centimeters) in length and has a wingspan of 40 to 47 inches (101 to 120 centimeters). Other names for the barn owl include: the American barn owl, hissing owl, church owl, golden owl, monkey-faced owl, rat owl, steeple owl, stone owl, white owl, ghost owl, and white-breasted owl.

The sexes are very much alike, though the female is larger than the male. The barn owl is one of the few bird species where the female is showier than the male; the spottier a female's breast, the higher her attractiveness to males. The female will weigh 18 to 24 ounces (510 to 680 grams) while the male will average about 17 ounces (470 grams).

The barn owl is very pale below with a rusty buff black-speckled backside, and a heart-shaped ring encircles the owl's white face. It is a relatively slim owl, with long wings that fold beyond the tail. It has long, feathered legs, long claws, a large round head devoid of ear tufts, and small dark eyes. When viewed from below, the barn owl appears extremely white. The golden brown of the upper parts varies, but the color is generally slightly darker in the female.

Typical calls are long, drawn-out screams and a loud, raspy hiss (*sss-ksch*). It also utters chuckling notes reminiscent of a human snore. When perched, the barn owl has a curious habit of lowering its head and swaying from side to side, much like the bobbing and weaving mannerisms of a professional boxer.

Barn owls are killed by traffic, pesticide poisoning, illegal shootings, intense cold, starvation, and attacks by great horned owls and the occasional prairie falcon. The majority of wild barn owls live less than a year; if they live longer than a year, they typically survive to at least five years.

Diet and Habitat

The barn owl's diet consists mostly of small nocturnal rodents, including mice, moles, voles, shrews, rats, and muskrats, though the owl will also feast on gophers, squirrels, cottontails, jackrabbits, bats, skunks, and birds.

The barn owl roosts by day in evergreen trees, sycamores, cottonwoods, belfries, towers of old buildings, and even in cities. It will hunt in any open space. Barn owls are not territorial and will often live in colonies if the food supply is plentiful. Farmers commonly encourage barn owls to roost on their farms, where they do a significant amount of damage to the local rodent population.

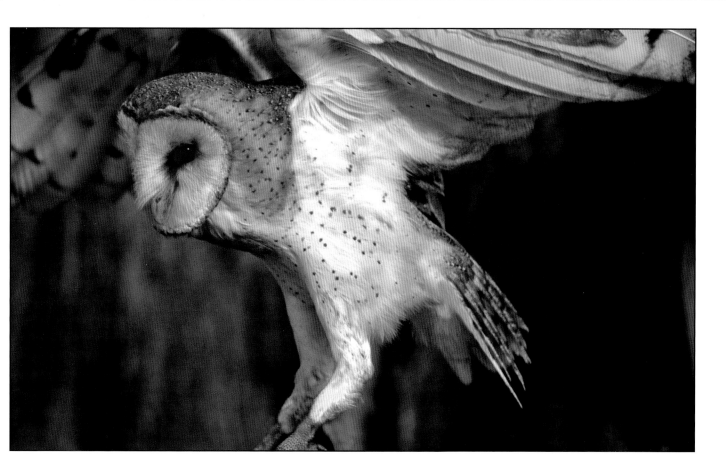

Nesting

Barn owls are not particular when it comes to nesting spots; they are cavity dwellers and will nest in any cave, barn, tree cavity, bird box, belfry, mine, or hole without building an actual nest. They can lay between three and eleven eggs, but typically lay five to seven. The eggs are white or buff with no distinguishing marks and are laid between February and October. Most nesting occurs between March and July in the Northeast and March to December in the Southeast. In California, the nesting season is mid-January to early June. The eggs are laid one at a time every few days and are incubated by the female for 32 to 34 days. During this time, the mother rarely leaves the eggs and is fed by the male. The owlets hatch in the order their eggs were laid, and will fly between 52 and 56 days after hatching. The male helps to feed and guard the young, which hiss when being fed. It has been estimated that an average brood of barn owls will ingest around 3,000 rodents during nesting season; adults will eat one a night, while a chick will dine on five or six.

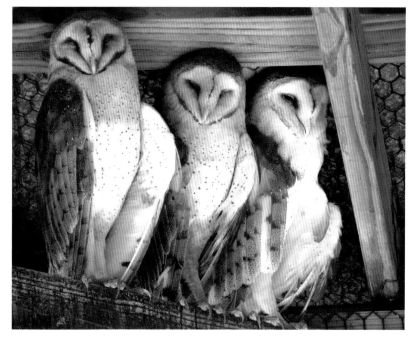

Denny Rogers

© Copyright 2008

3

DRAWINGS

These drawings are based upon a 14-inch-long barn owl with a 40-inch wingspan.

NN
4.5"

4" OO

PP .5"

12" QQ

14" UU

6" RR

SS
3"

TT
.5"

See the chart on pages 26 through 27 for a listing of the measurements. Also included are nine additional scales showing each measurement reduced proportionately so that accurate patterns can be laid out in any size.

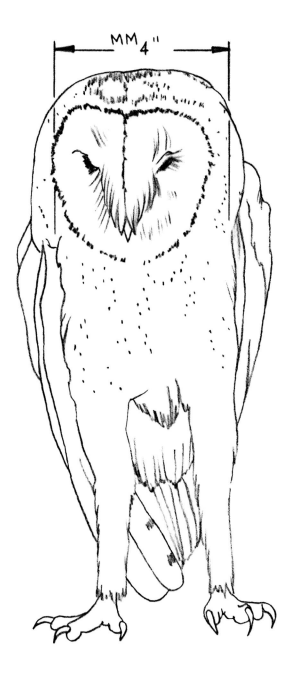

See the chart on pages 26 through 27 for a listing of the measurements. Also included are nine additional scales showing each measurement reduced proportionately so that accurate patterns can be laid out in any size.

© COPYRIGHT 2008

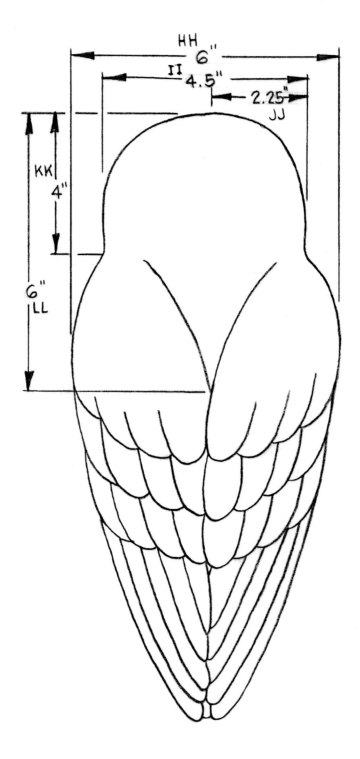

HH
6"

II
4.5"

2.25"
JJ

KK
4"

6"
LL

See the chart on pages 26 through 27 for a listing of the measurements. Also included are nine additional scales showing each measurement reduced proportionately so that accurate patterns can be laid out in any size.

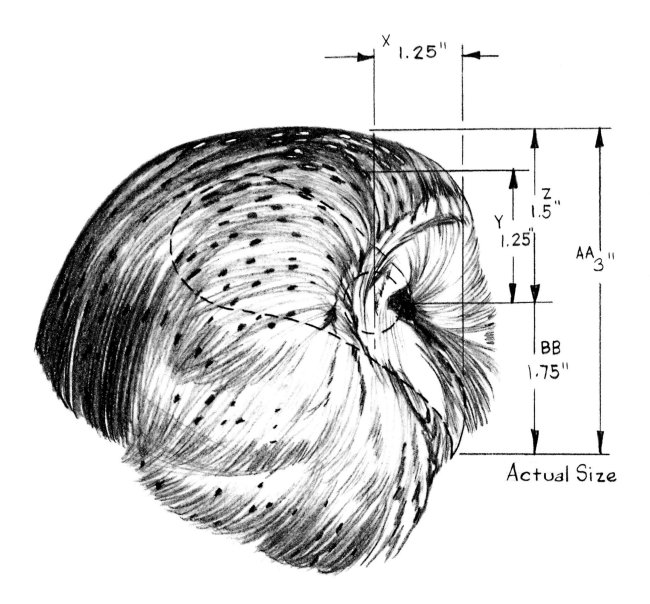

X 1.25"

Z 1.5"

Y 1.25"

AA 3"

BB 1.75"

Actual Size

See the chart on pages 26 through 27 for a listing of the measurements. Also included are nine additional scales showing each measurement reduced proportionately so that accurate patterns can be laid out in any size.

© Copyright 2008

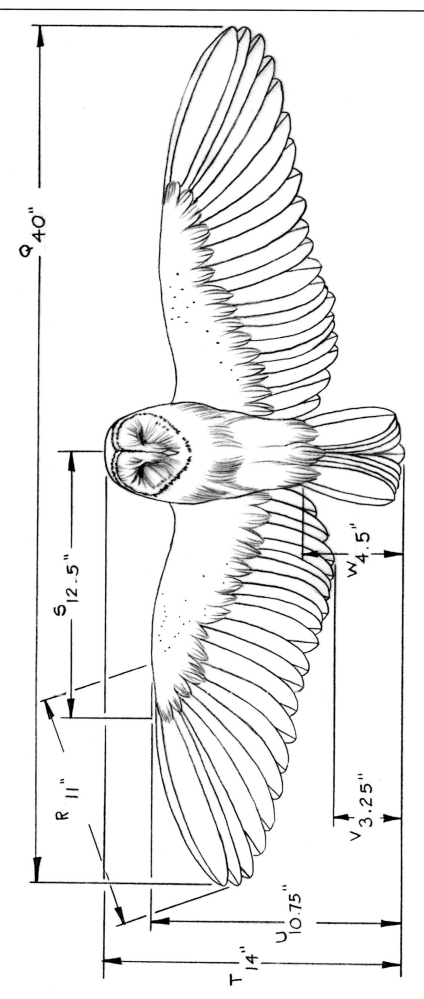

Q 40"

S 12.5"

W 4.5"

R 11"

V 3.25"

U 10.75"

T 14"

See the chart on pages 26 through 27 for a listing of the measurements. Also included are nine additional scales showing each measurement reduced proportionately so that accurate patterns can be laid out in any size.

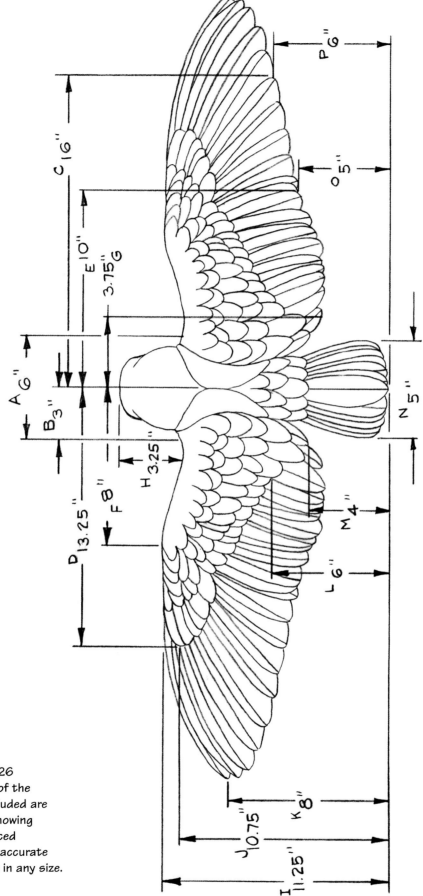

See the chart on pages 26 through 27 for a listing of the measurements. Also included are nine additional scales showing each measurement reduced proportionately so that accurate patterns can be laid out in any size.

P 6"
O 5"
C 16"
E 10"
3.75" G
A 6"
B 3"
N 5"
H 3.25"
D 13.25"
F 8"
M 4"
L 6"
J 10.75"
K 8"
I 11.25"

UNDERSIDE

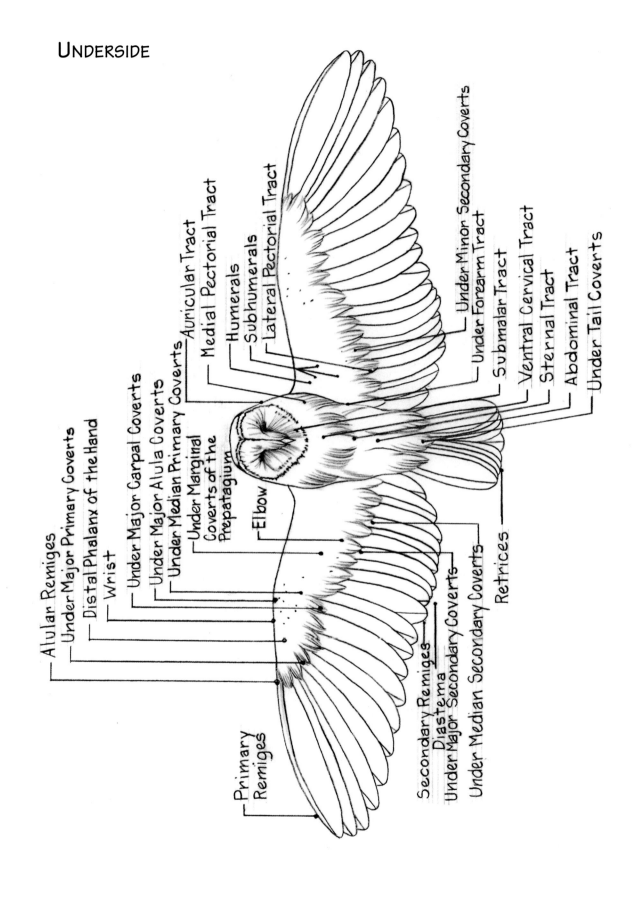

Auricular Tract
Medial Pectorial Tract
Humerals
Subhumerals
Lateral Pectorial Tract
Under Minor Secondary Coverts
Under Forearm Tract
Submalar Tract
Ventral Cervical Tract
Sternal Tract
Abdominal Tract
Under Tail Coverts

Alular Remiges
Under Major Primary Coverts
Distal Phalanx of the Hand
Wrist
Under Major Carpal Coverts
Under Major Alula Coverts
Under Median Primary Coverts
Under Marginal Coverts of the Prepatagium
Elbow

Primary Remiges

Secondary Remiges
Diastema
Under Major Secondary Coverts
Under Median Secondary Coverts

Retrices

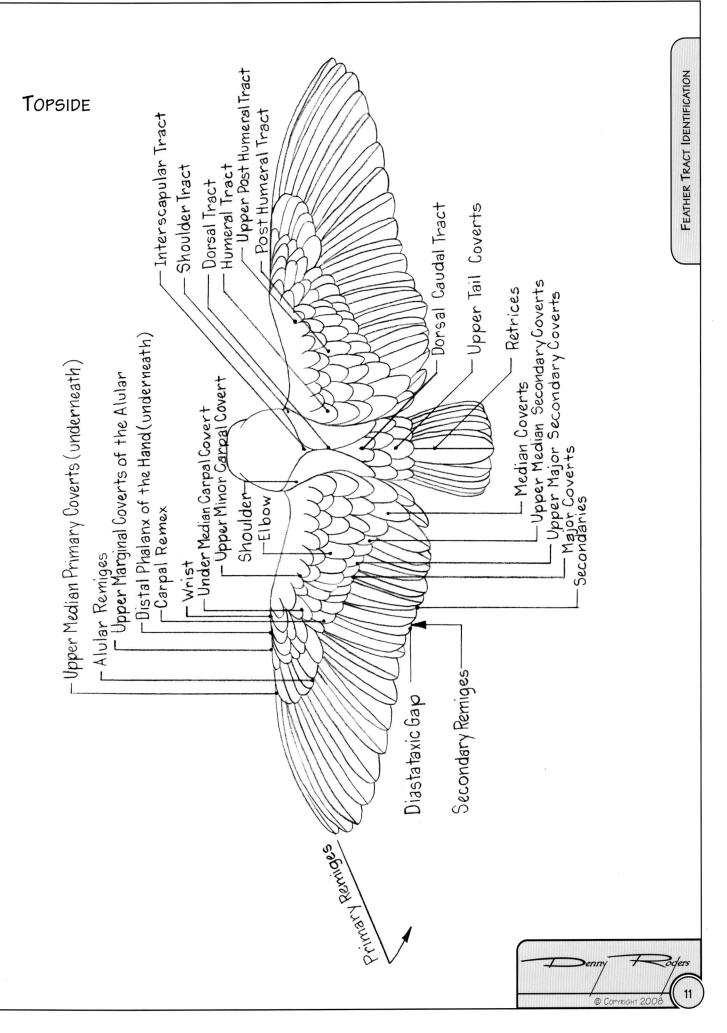

TOPSIDE

Interscapular Tract
Shoulder Tract
Dorsal Tract
Humeral Tract
Upper Post Humeral Tract
Post Humeral Tract

Dorsal Caudal Tract
Upper Tail Coverts
Retrices
Upper Median Secondary Coverts
Upper Major Secondary Coverts
Secondaries
Major Coverts
Upper Median Secondary Coverts
Median Coverts

Upper Median Primary Coverts (underneath)
Alular Remiges
Upper Marginal Coverts of the Alular
Distal Phalanx of the Hand (underneath)
Carpal Remex
Wrist
Under Median Carpal Covert
Upper Minor Carpal Covert
Shoulder
Elbow

Diastataxic Gap
Secondary Remiges

Primary Remiges

Denny Rogers

© COPYRIGHT 2008

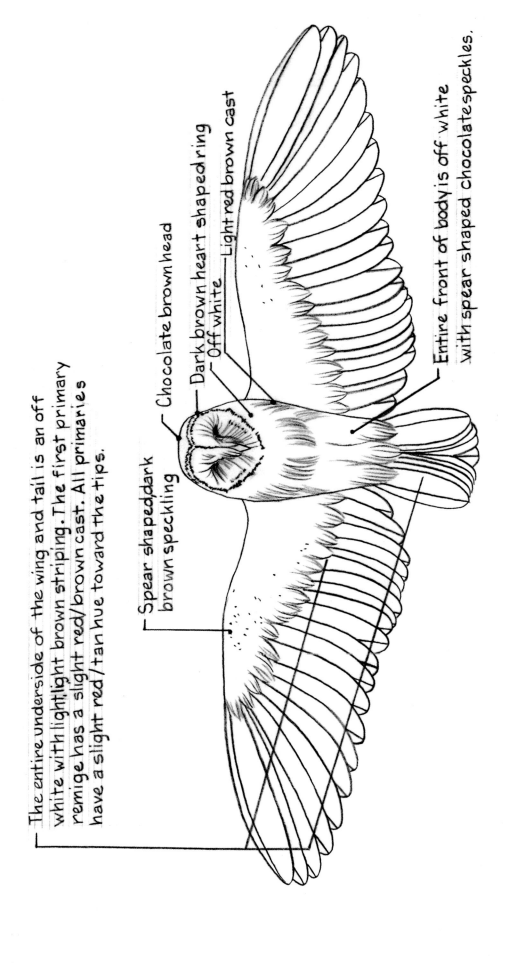

The entire underside of the wing and tail is an off white with light light brown striping. The first primary remige has a slight red/brown cast. All primaries have a slight red/tan hue toward the tips.

Spear shaped dark brown speckling

Chocolate brown head

Dark brown heart shaped ring

Off white

Light red brown cast

Entire front of body is off white with spear shaped chocolate speckles.

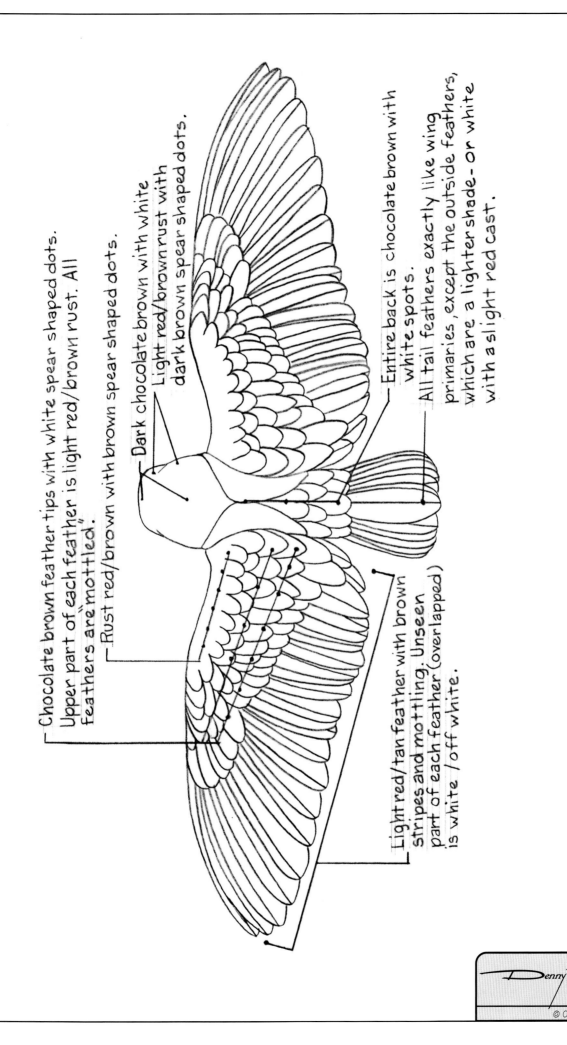

Chocolate brown feather tips with white spear shaped dots.

Upper part of each feather is light red/brown rust. All feathers are "mottled".

Rust red/brown with brown spear shaped dots.

Dark chocolate brown with white

Light red/brown rust with dark brown spear shaped dots.

Entire back is chocolate brown with white spots.

All tail feathers exactly like wing primaries, except the outside feathers, which are a lighter shade - or white with a slight red cast.

Light red/tan feather with brown stripes and mottling. Unseen part of each feather (overlapped) is white/off white.

© Copyright 2008

Denny Rogers

TO MATCH THE DIMENSION ON PAGES 8 AND 9, ENLARGE TO 256%. HOWEVER, AS DESCRIBED ON PAGE 2, WINGSPANS CAN VARY FROM 40 TO 47 INCHES. A SIMPLE STEP TO ENLARGE THIS PATTERN FOR EXACT MEASUREMENTS WOULD BE TO TAKE THE BOOK TO A LOCAL COPY SHOP, CREATE A PHOTOCOPY OF PAGES 14 AND 15, CUT APART, TAPE THE BODY TOGETHER, ASSIGN THE ENLARGED PERCENTAGE, AND RUN A LIFE-SIZE COPY TO THE DESIRED WINGSPAN FOR YOUR PROJECT. ALL DIMENSIONS WILL ENLARGE PROPORTIONATELY ON AN ENGINEERING PRINT MACHINE.

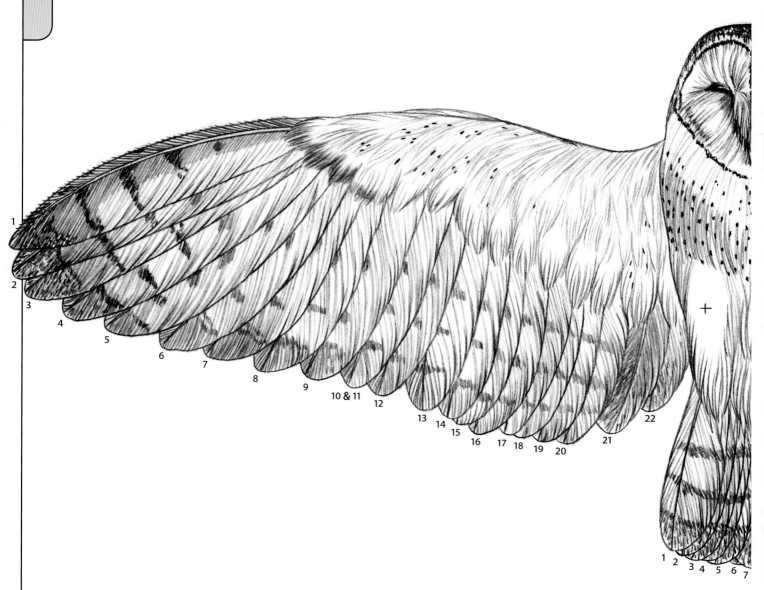

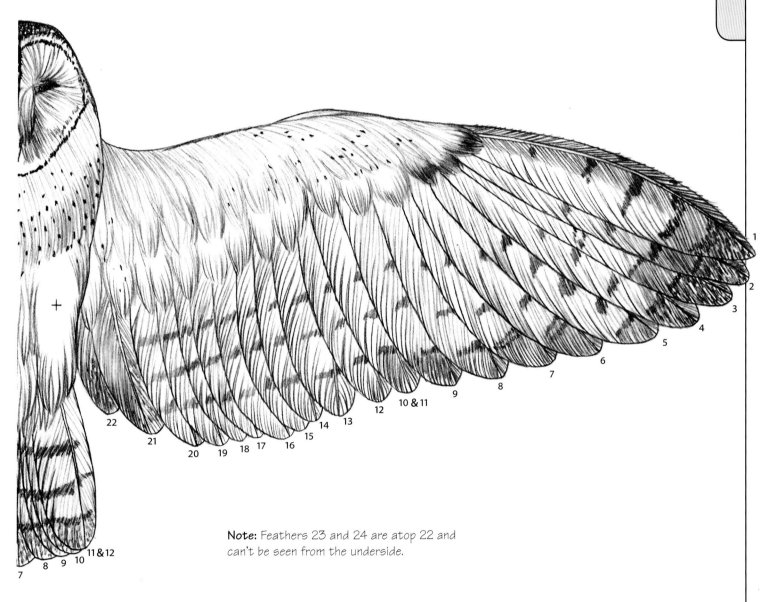

Note: Feathers 23 and 24 are atop 22 and can't be seen from the underside.

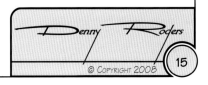

© COPYRIGHT 2008

TO MATCH THE DIMENSION ON PAGES 8 AND 9, ENLARGE TO 256%. HOWEVER, AS DESCRIBED ON PAGE 2, WINGSPANS CAN VARY FROM 40 TO 47 INCHES. A SIMPLE STEP TO ENLARGE THIS PATTERN FOR EXACT MEASUREMENTS WOULD BE TO TAKE THE BOOK TO A LOCAL COPY SHOP, CREATE A PHOTOCOPY OF PAGES 16 AND 17, CUT APART, TAPE THE BODY TOGETHER, ASSIGN THE ENLARGED PERCENTAGE, AND RUN A LIFE-SIZE COPY TO THE DESIRED WINGSPAN FOR YOUR PROJECT. ALL DIMENSIONS WILL ENLARGE PROPORTIONATELY ON AN ENGINEERING PRINT MACHINE.

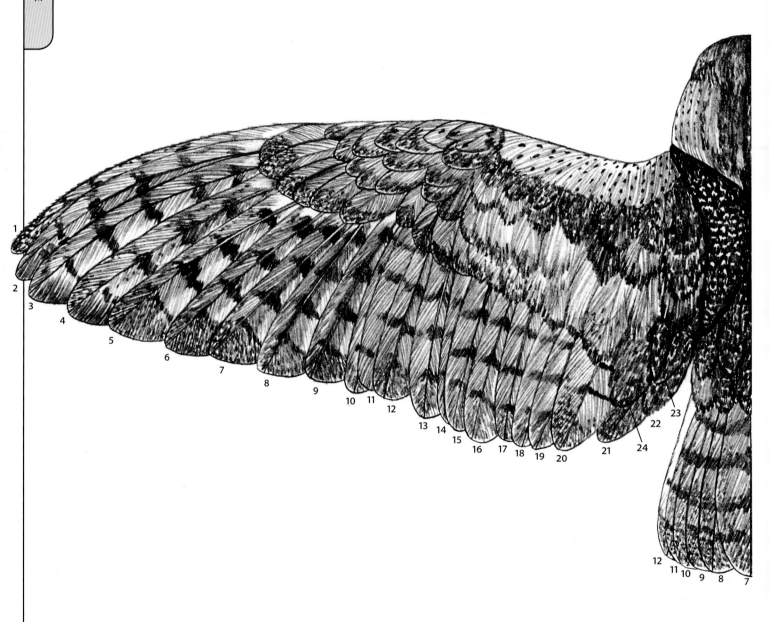

© COPYRIGHT 2008

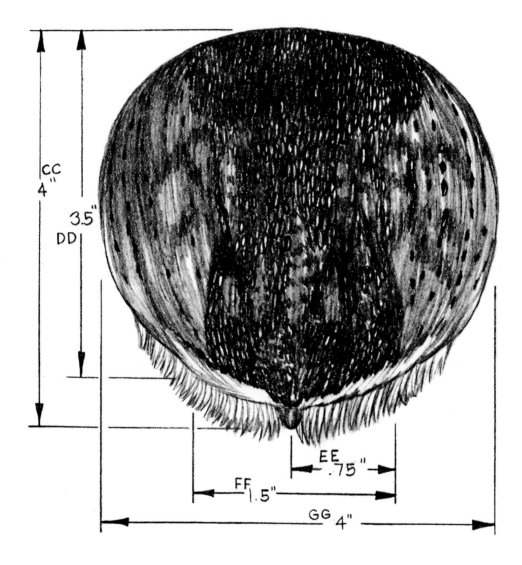

See the chart on pages 26 through 27 for a listing of the measurements. Also included are nine additional scales showing each measurement reduced proportionately so that accurate patterns can be laid out in any size.

Skull

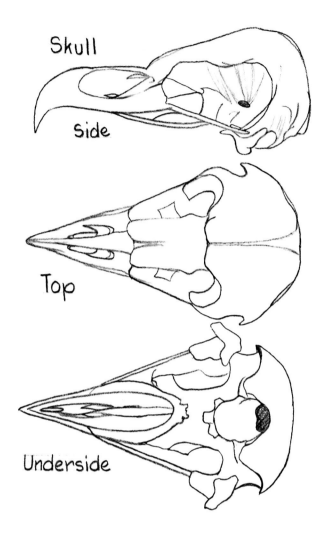

Side

Top

Underside

Mandible Bone

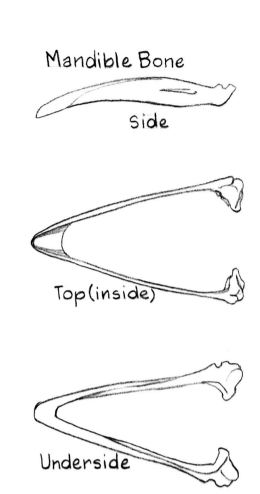

Side

Top (inside)

Underside

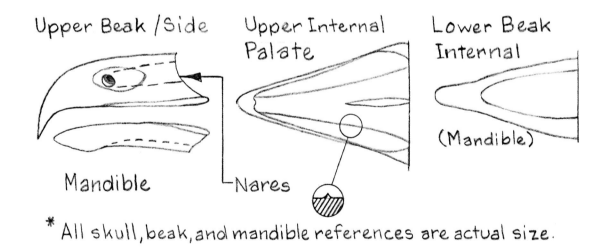

Upper Beak / Side

Upper Internal Palate

Lower Beak Internal

Mandible

Nares

(Mandible)

*All skull, beak, and mandible references are actual size.

Denny Rodgers
© Copyright 2008

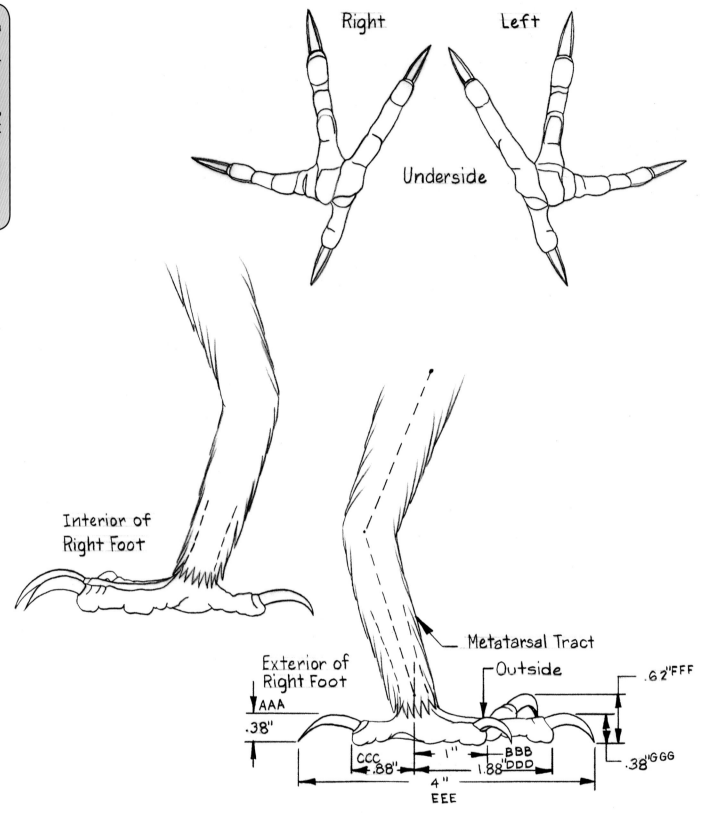

Right

Left

Underside

Interior of
Right Foot

Metatarsal Tract
Outside

.62"FFF

Exterior of
Right Foot

AAA

.38"

CCC
.88"

1"

BBB
DDD
1.88"

.38"GGG

4"
EEE

See the chart on pages 26 through 27 for a
listing of the measurements. Also included
are nine additional scales showing each
measurement reduced proportionately so that
accurate patterns can be laid out in any size.

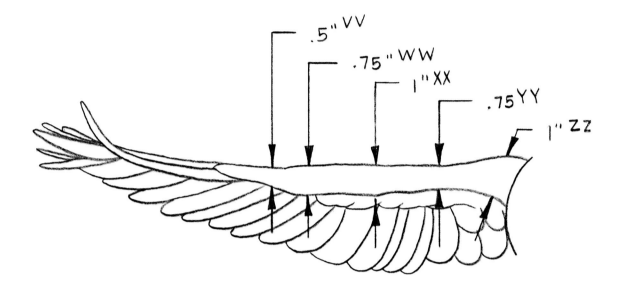

.5" VV
.75" WW
1" XX
.75 YY
1" ZZ

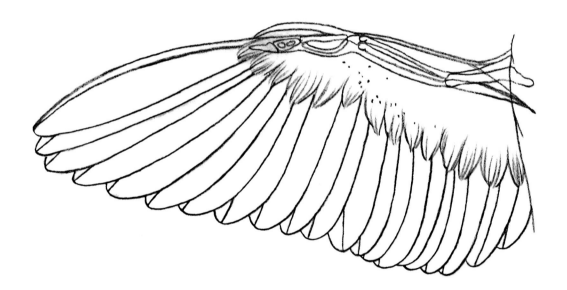

See the chart on pages 26 through 27 for a listing of the measurements. Also included are nine additional scales showing each measurement reduced proportionately so that accurate patterns can be laid out in any size.

© Copyright 2008

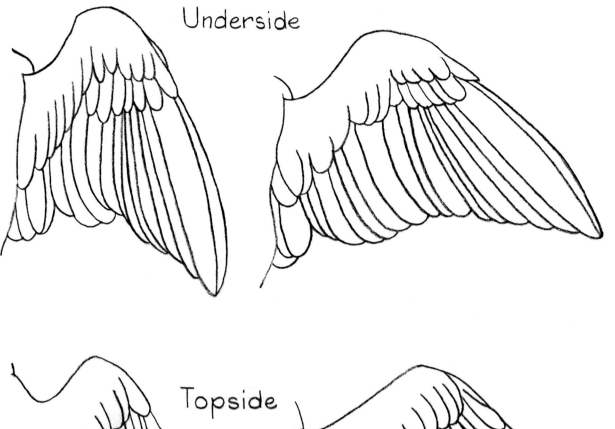

Underside

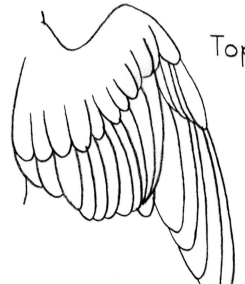

Topside

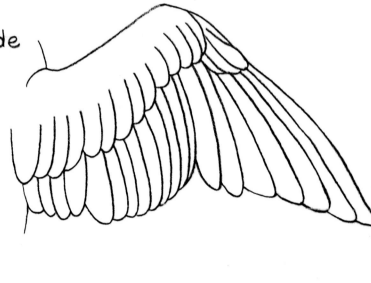

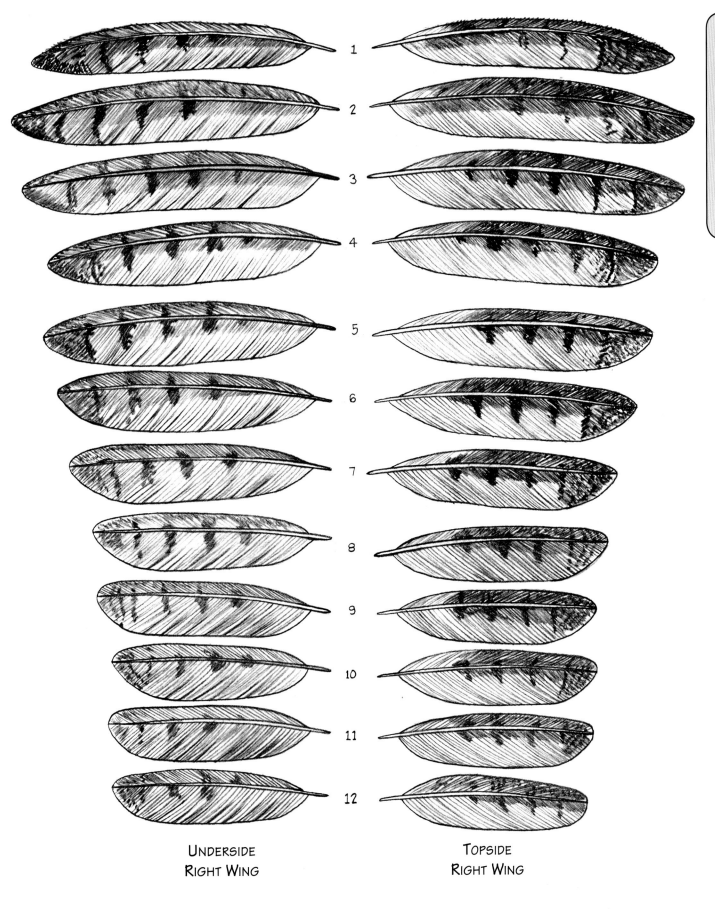

1

2

3

4

5

6

7

8

9

10

11

12

UNDERSIDE
RIGHT WING

TOPSIDE
RIGHT WING

© COPYRIGHT 2008

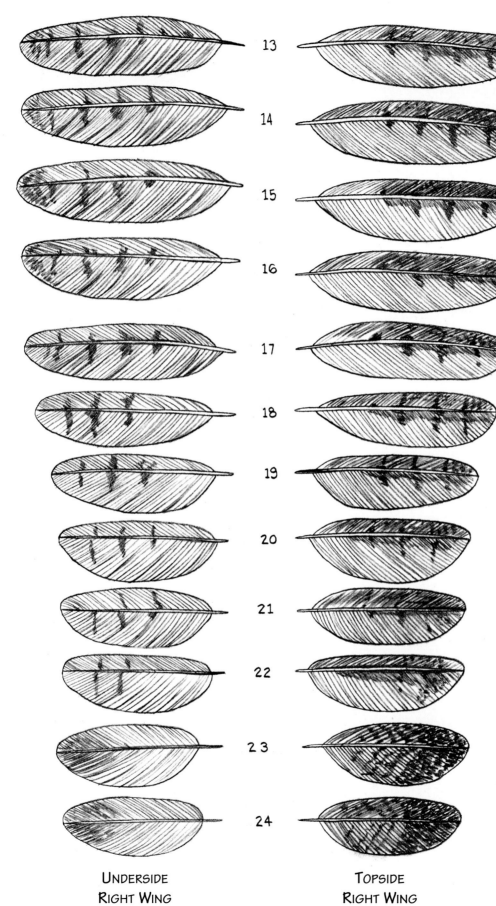

13
14
15
16
17
18
19
20
21
22
23
24

UNDERSIDE
RIGHT WING

TOPSIDE
RIGHT WING

The reference for the glide chart was a live specimen. The individual feather chart reference was taken from a study skin. The feathers were smoothed to minimize the width. However, the feather width can expand with air pressure and movement. Adjust as necessary.

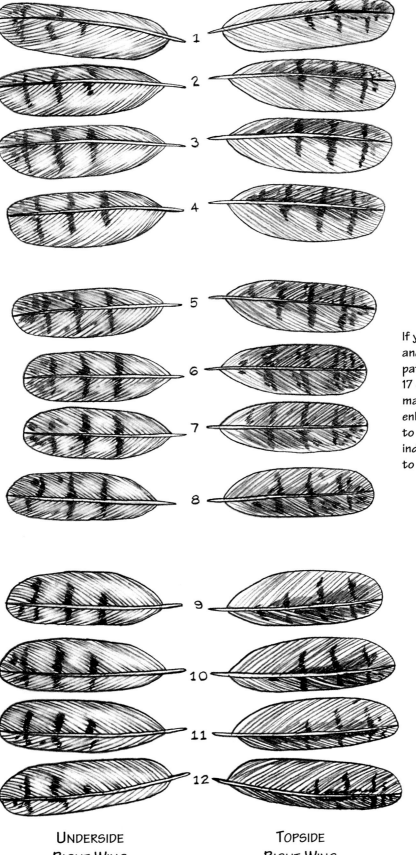

If you enlarge the topside and underside glide patterns on pages 14 to 17 on an engineering print machine, you can also enlarge the feather charts to match accordingly for individual feather inserts to your project.

UNDERSIDE RIGHT WING

TOPSIDE RIGHT WING

© COPYRIGHT 2008

Barn Owl Measurement Chart

Each measurement on this chart is coded from A to GGG. These letters correspond with the measurements on pages 4-9, 18, 20 and 21. Also listed are nine additional scales that show each measurement reduced proportionately so that patterns can be laid out in any size. The scales contain decimal equivalents.

	Full Scale	9/10 Scale	4/5 Scale	7/10 Scale	3/5 Scale	1/2 Scale	2/5 Scale	3/10 Scale	1/5 Scale	1/10 Scale
A	6.00	5.40	4.80	4.20	3.60	3.00	2.40	1.80	1.20	0.60
B	3.00	2.70	2.40	2.10	1.80	1.50	1.20	0.90	0.60	0.30
C	16.00	14.40	12.80	11.20	9.60	8.00	6.40	4.80	3.20	1.60
D	13.25	11.93	10.60	9.28	7.95	6.63	5.30	3.98	2.65	1.33
E	10.00	9.00	8.00	7.00	6.00	5.00	4.00	3.00	2.00	1.00
F	8.00	7.20	6.40	5.60	4.80	4.00	3.20	2.40	1.60	0.80
G	3.75	3.38	3.00	2.63	2.25	1.88	1.50	1.13	0.75	0.38
H	3.25	2.93	2.60	2.28	1.95	1.63	1.30	0.98	0.65	0.33
I	11.25	10.13	9.00	7.88	6.75	5.63	4.50	3.38	2.25	1.13
J	10.75	9.68	8.60	7.53	6.45	5.38	4.30	3.23	2.15	1.08
K	8.00	7.20	6.40	5.60	4.80	4.00	3.20	2.40	1.60	0.80
L	6.00	5.40	4.80	4.20	3.60	3.00	2.40	1.80	1.20	0.60
M	4.00	3.60	3.20	2.80	2.40	2.00	1.60	1.20	0.80	0.40
N	5.00	4.50	4.00	3.50	3.00	2.50	2.00	1.50	1.00	0.50
O	5.00	4.50	4.00	3.50	3.00	2.50	2.00	1.50	1.00	0.50
P	6.00	5.40	4.80	4.20	3.60	3.00	2.40	1.80	1.20	0.60
Q	40.00	36.00	32.00	28.00	24.00	20.00	16.00	12.00	8.00	4.00
R	11.00	9.90	8.80	7.70	6.60	5.50	4.40	3.30	2.20	1.10
S	12.50	11.25	10.00	8.75	7.50	6.25	5.00	3.75	2.50	1.25
T	14.00	12.60	11.20	9.80	8.40	7.00	5.60	4.20	2.80	1.40
U	10.75	9.68	8.60	7.53	6.45	5.38	4.30	3.23	2.15	1.08
V	3.25	2.93	2.60	2.28	1.95	1.63	1.30	0.98	0.65	0.33
W	4.50	4.05	3.60	3.15	2.70	2.25	1.80	1.35	0.90	0.45
X	1.25	1.13	1.00	0.88	0.75	0.63	0.50	0.38	0.25	0.13
Y	1.25	1.13	1.00	0.88	0.75	0.63	0.50	0.38	0.25	0.13
Z	1.50	1.35	1.20	1.05	0.90	0.75	0.60	0.45	0.30	0.15
AA	3.00	2.70	2.40	2.10	1.80	1.50	1.20	0.90	0.60	0.30
BB	1.75	1.58	1.40	1.23	1.05	0.88	0.70	0.53	0.35	0.18
CC	4.00	3.60	3.20	2.80	2.40	2.00	1.60	1.20	0.80	0.40
DD	3.50	3.15	2.80	2.45	2.10	1.75	1.40	1.05	0.70	0.35
EE	0.75	0.68	0.60	0.53	0.45	0.38	0.30	0.23	0.15	0.08

	Full Scale	9/10 Scale	4/5 Scale	7/10 Scale	3/5 Scale	1/2 Scale	2/5 Scale	3/10 Scale	1/5 Scale	1/10 Scale
FF	1.50	1.35	1.20	1.05	0.90	0.75	0.60	0.45	0.30	0.15
GG	4.00	3.60	3.20	2.80	2.40	2.00	1.60	1.20	0.80	0.40
HH	6.00	5.40	4.80	4.20	3.60	3.00	2.40	1.80	1.20	0.60
II	4.50	4.05	3.60	3.15	2.70	2.25	1.80	1.35	0.90	0.45
JJ	2.25	2.03	1.80	1.58	1.35	1.13	0.90	0.68	0.45	0.23
KK	4.00	3.60	3.20	2.80	2.40	2.00	1.60	1.20	0.80	0.40
LL	6.00	5.40	4.80	4.20	3.60	3.00	2.40	1.80	1.20	0.60
MM	4.00	3.60	3.20	2.80	2.40	2.00	1.60	1.20	0.80	0.40
NN	4.50	4.05	3.60	3.15	2.70	2.25	1.80	1.35	0.90	0.45
OO	4.00	3.60	3.20	2.80	2.40	2.00	1.60	1.20	0.80	0.40
PP	5.00	4.50	4.00	3.50	3.00	2.50	2.00	1.50	1.00	0.50
QQ	12.00	10.80	9.60	8.40	7.20	6.00	4.80	3.60	2.40	1.20
RR	6.00	5.40	4.80	4.20	3.60	3.00	2.40	1.80	1.20	0.60
SS	3.00	2.70	2.40	2.10	1.80	1.50	1.20	0.90	0.60	0.30
TT	0.50	0.45	0.40	0.35	0.30	0.25	0.20	0.15	0.10	0.05
UU	14.00	12.60	11.20	9.80	8.40	7.00	5.60	4.20	2.80	1.40
VV	0.50	0.45	0.40	0.35	0.30	0.25	0.20	0.15	0.10	0.05
WW	0.75	0.68	0.60	0.53	0.45	0.38	0.30	0.23	0.15	0.08
XX	1.00	0.90	0.80	0.70	0.60	0.50	0.40	0.30	0.20	0.10
YY	0.75	0.68	0.60	0.53	0.45	0.38	0.30	0.23	0.15	0.08
ZZ	1.00	0.90	0.80	0.70	0.60	0.50	0.40	0.30	0.20	0.10
AAA	0.38	0.34	0.30	0.27	0.23	0.19	0.15	0.11	0.08	0.04
BBB	1.00	0.90	0.80	0.70	0.60	0.50	0.40	0.30	0.20	0.10
CCC	0.88	0.79	0.70	0.62	0.53	0.44	0.35	0.26	0.18	0.09
DDD	1.88	1.69	1.50	1.32	1.13	0.94	0.75	0.56	0.38	0.19
EEE	4.00	3.60	3.20	2.80	2.40	2.00	1.60	1.20	0.80	0.40
FFF	0.62	0.56	0.50	0.43	0.37	0.31	0.25	0.19	0.12	0.06
GGG	0.38	0.34	0.30	0.27	0.23	0.19	0.15	0.11	0.08	0.04

© Copyright 2008

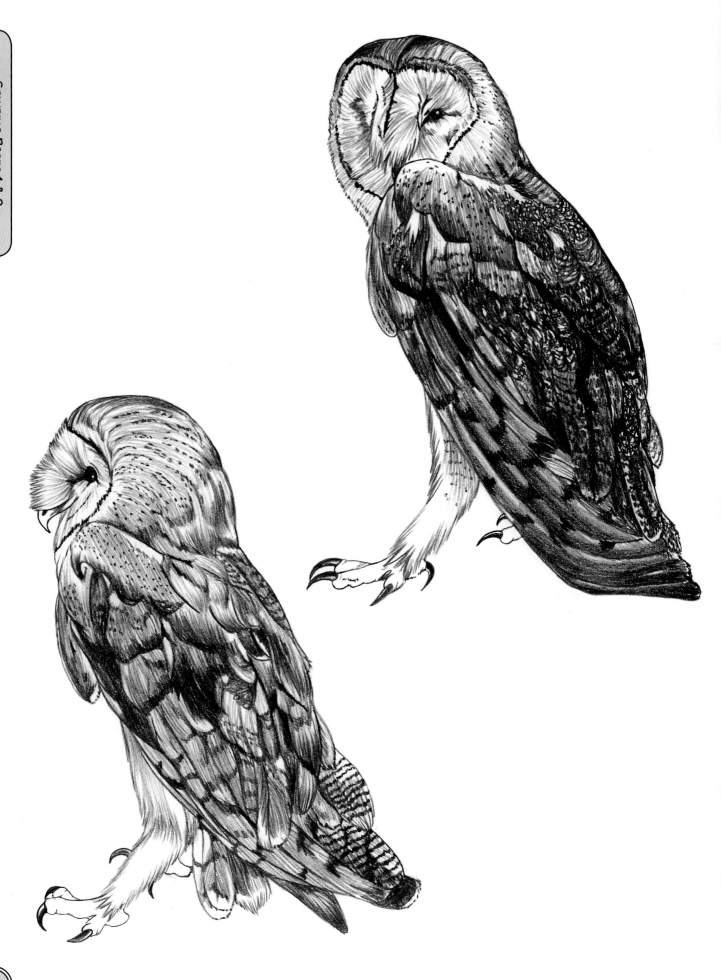

Denny Rogers

© Copyright 2008

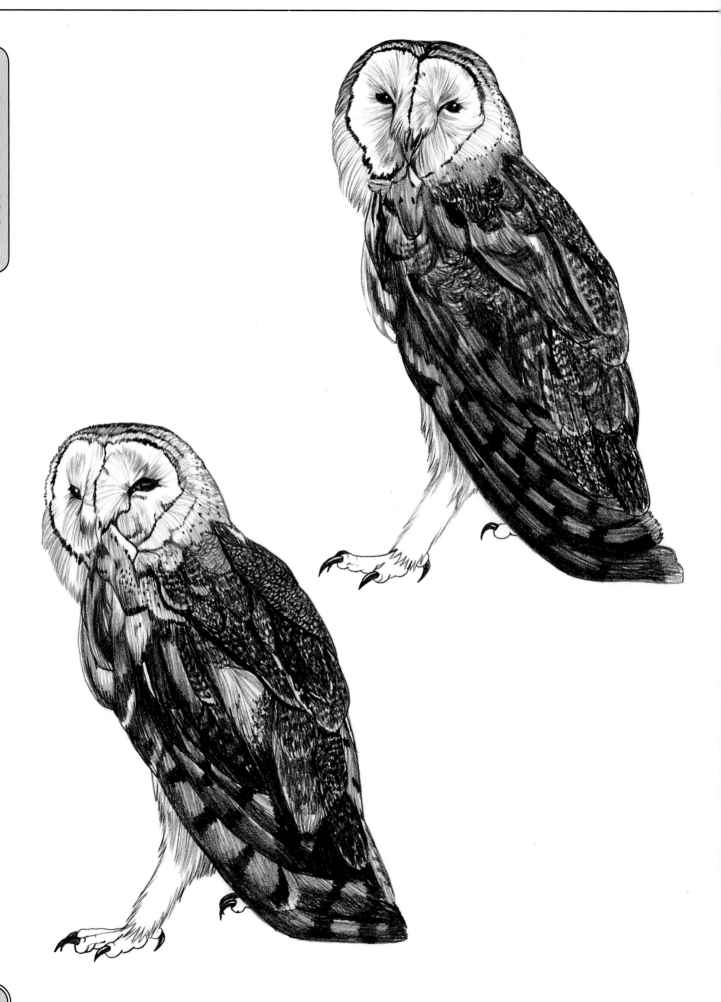

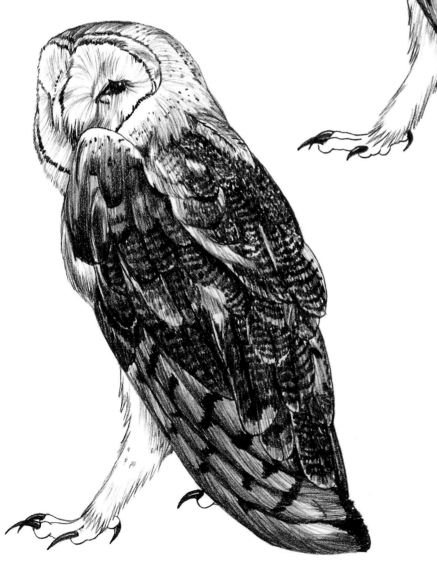

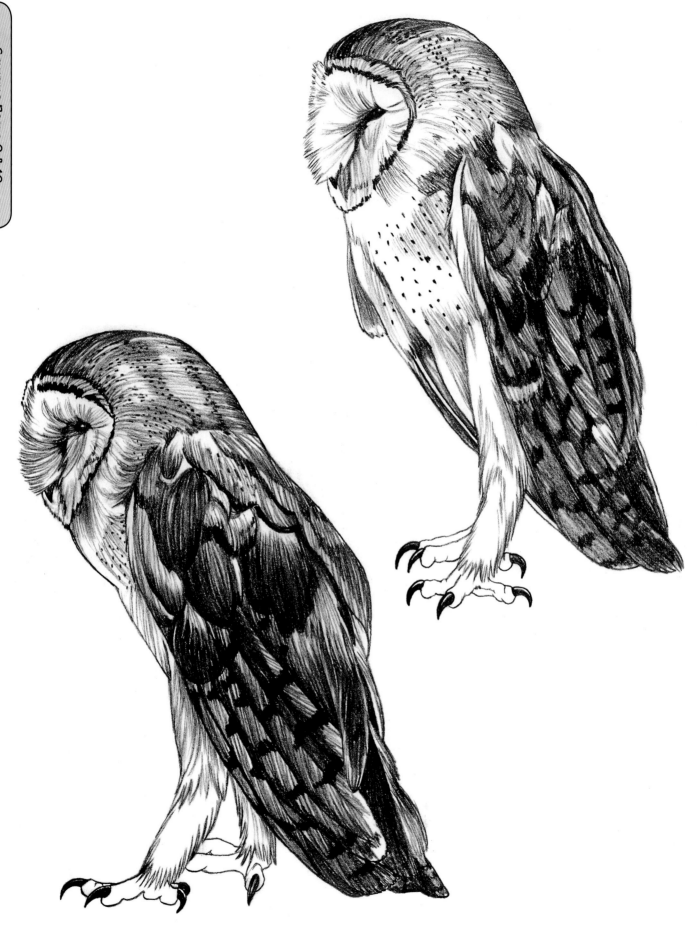

Denny Roders

© Copyright 2008

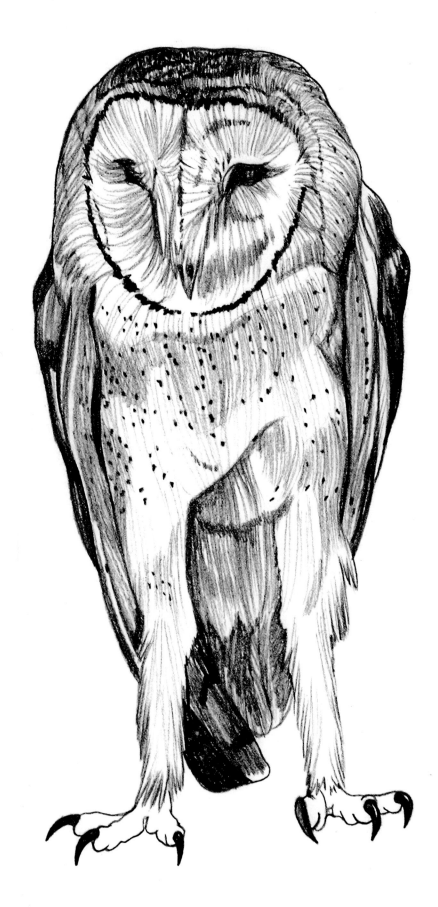

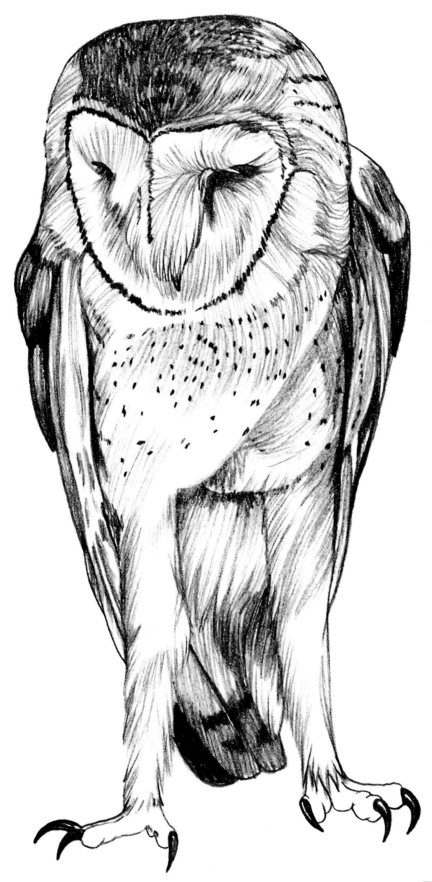

Denny Rogers

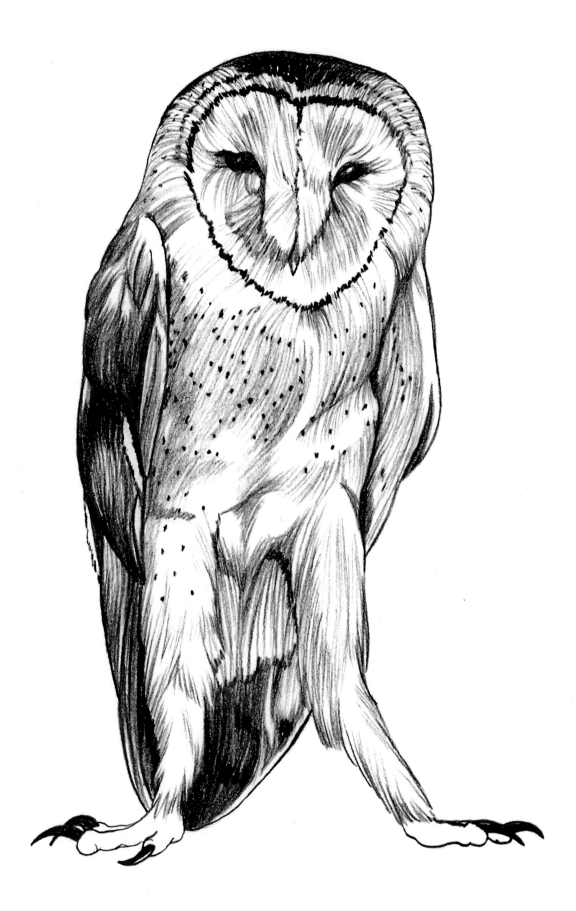

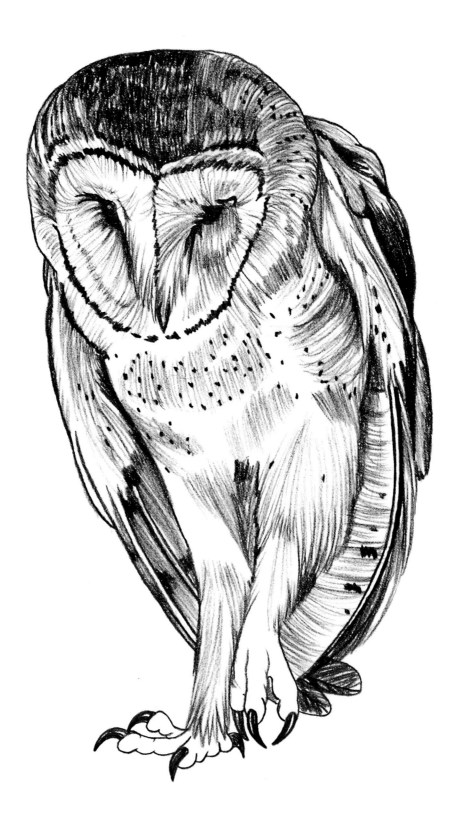

Denny Rogers

© Copyright 2008

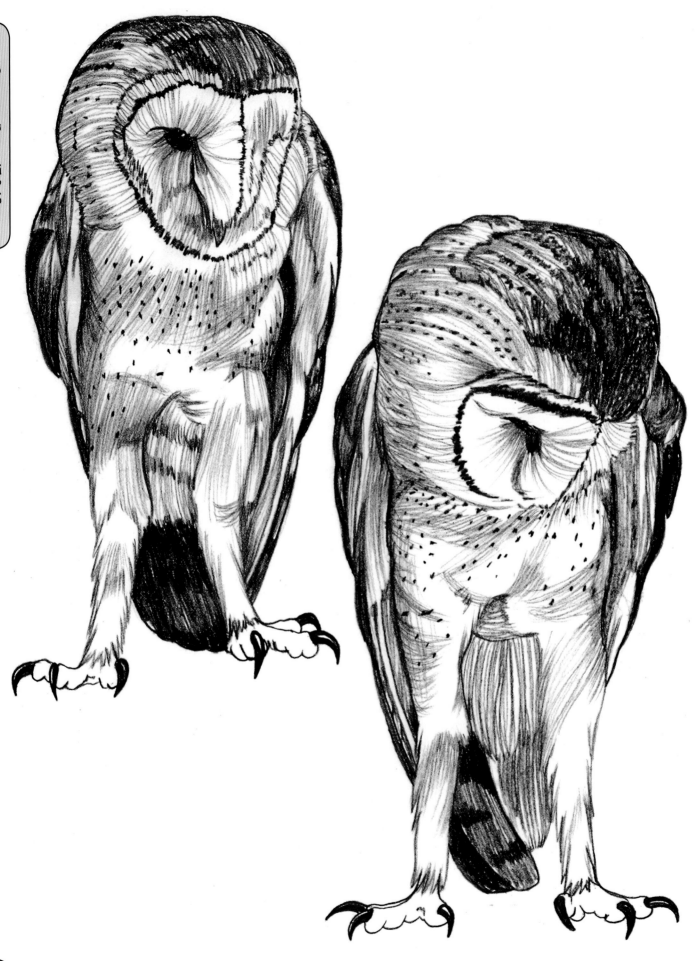

Denny Rogers

© Copyright 2008

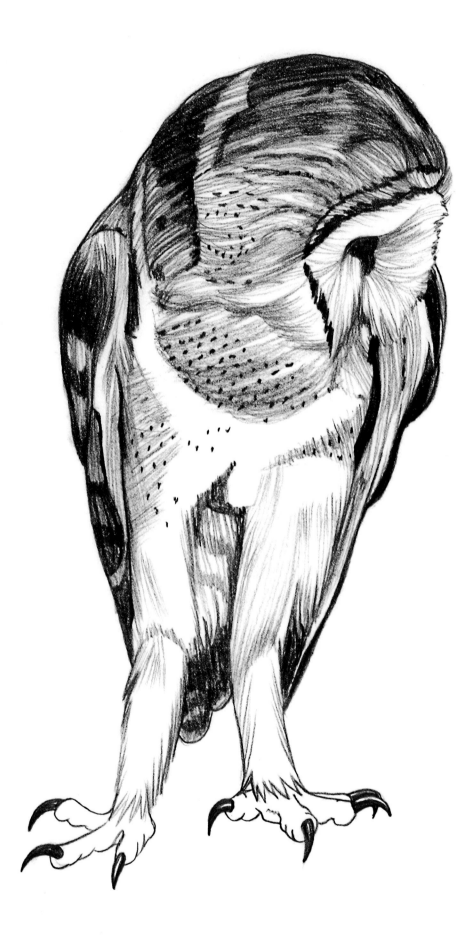

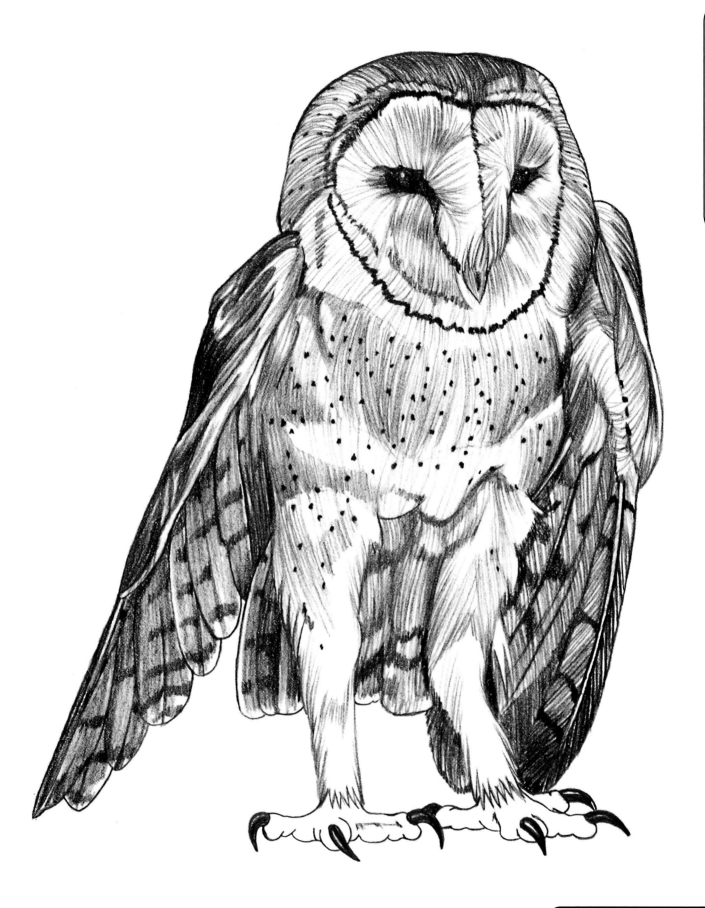

© Copyright 2008

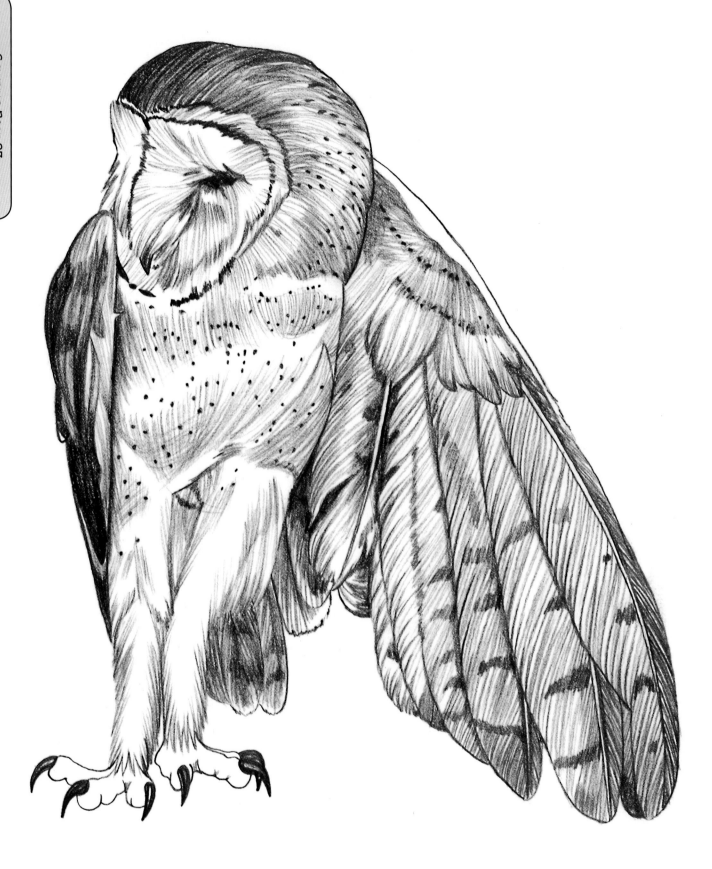

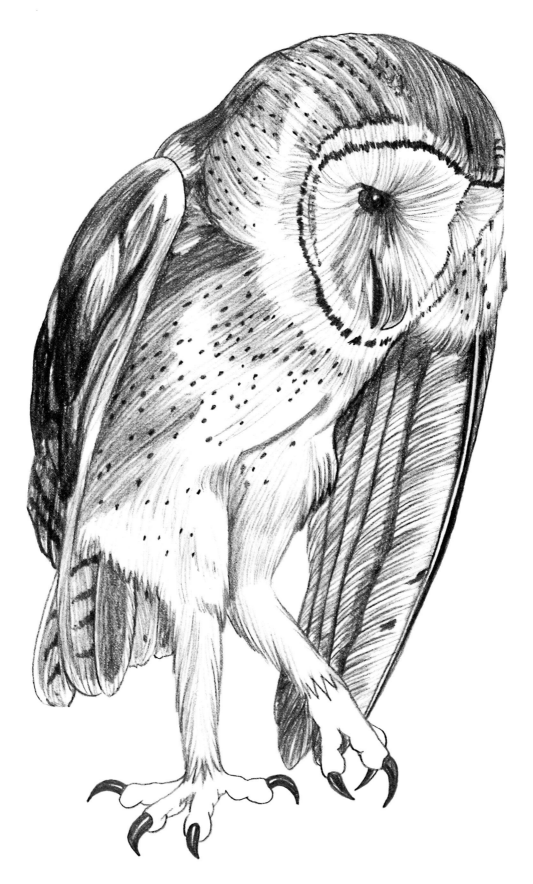

Denny Rogers

© COPYRIGHT 2008

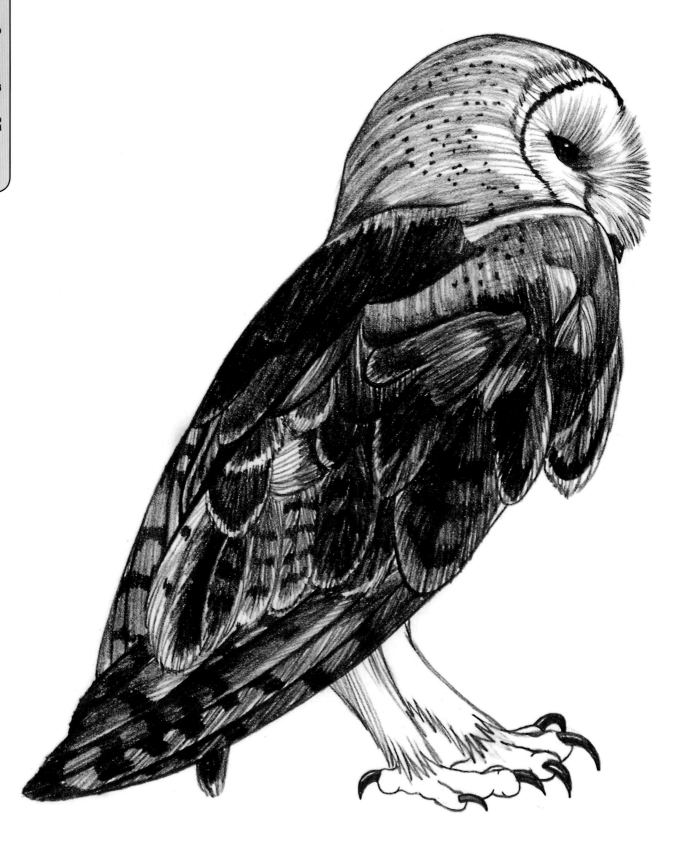

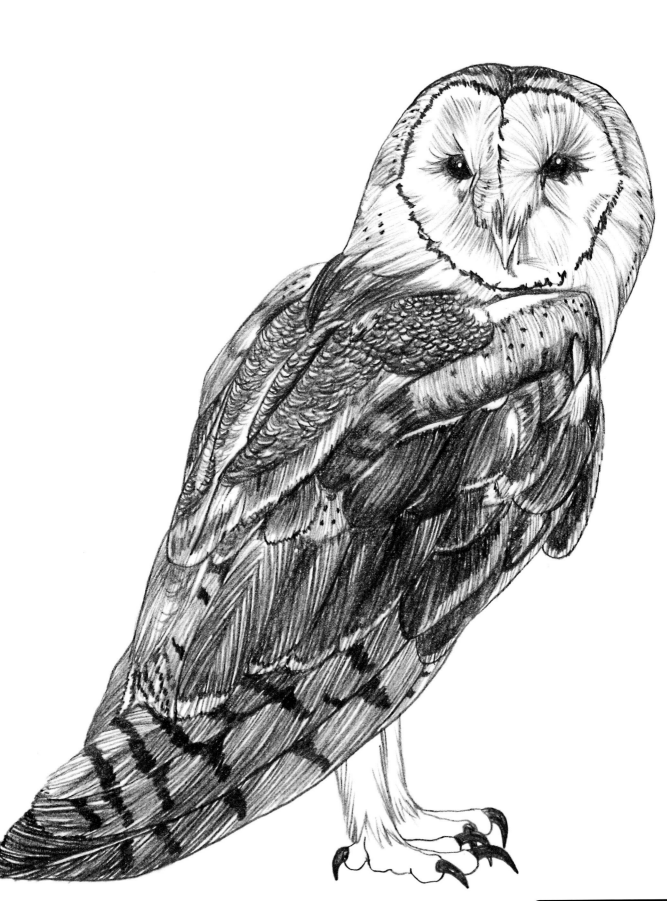

Denny Rogers

© Copyright 2008

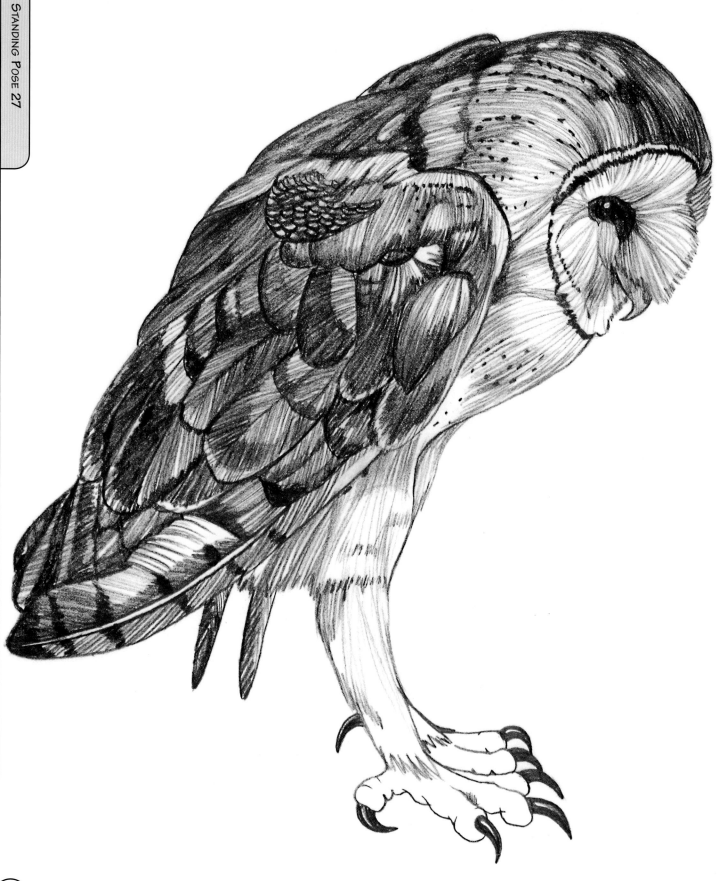

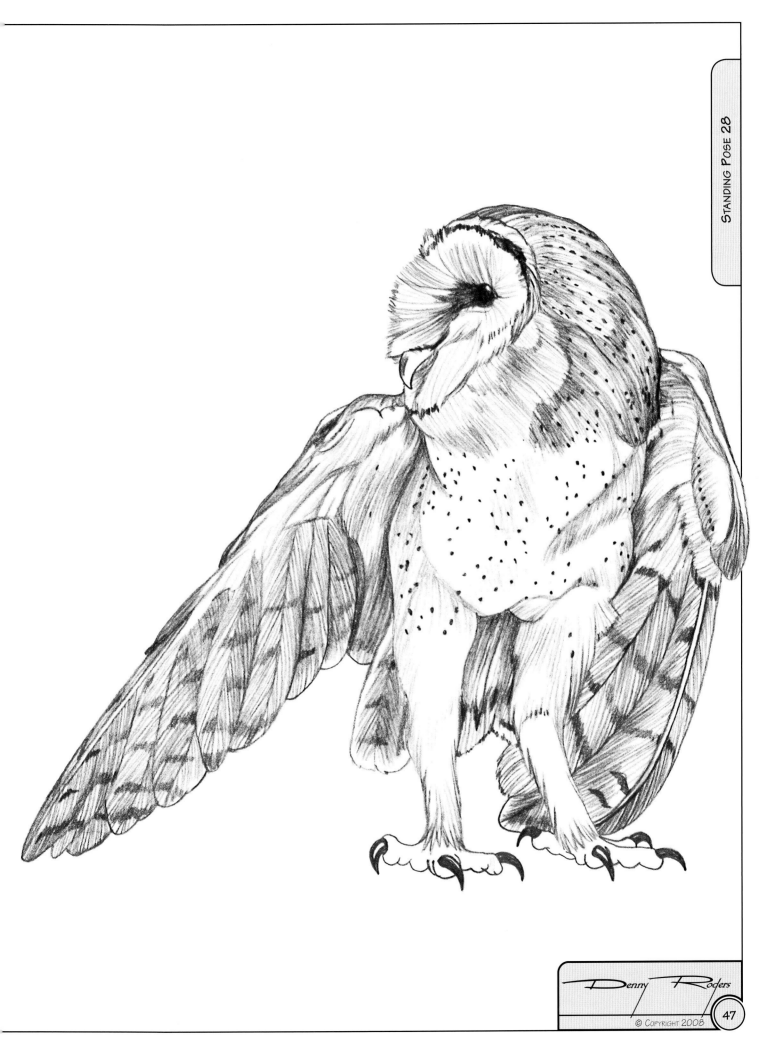

© Copyright 2008

Denny Roders

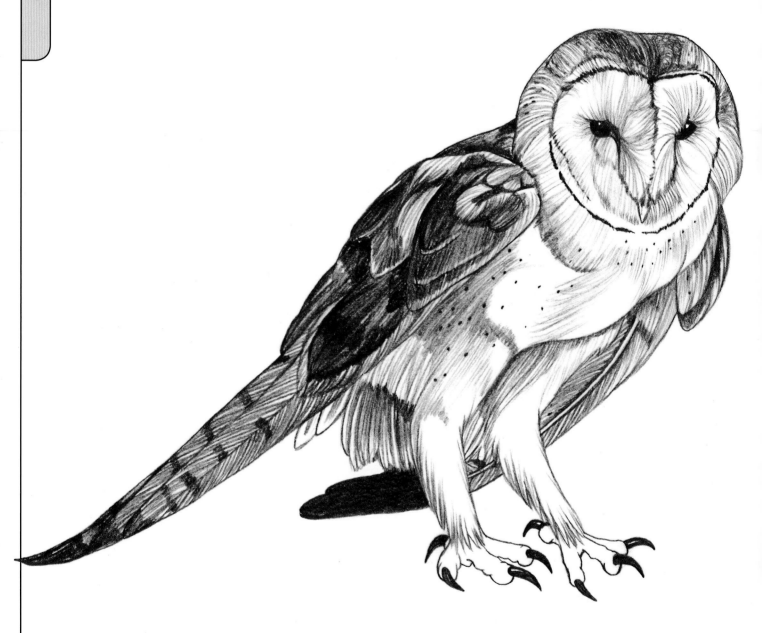

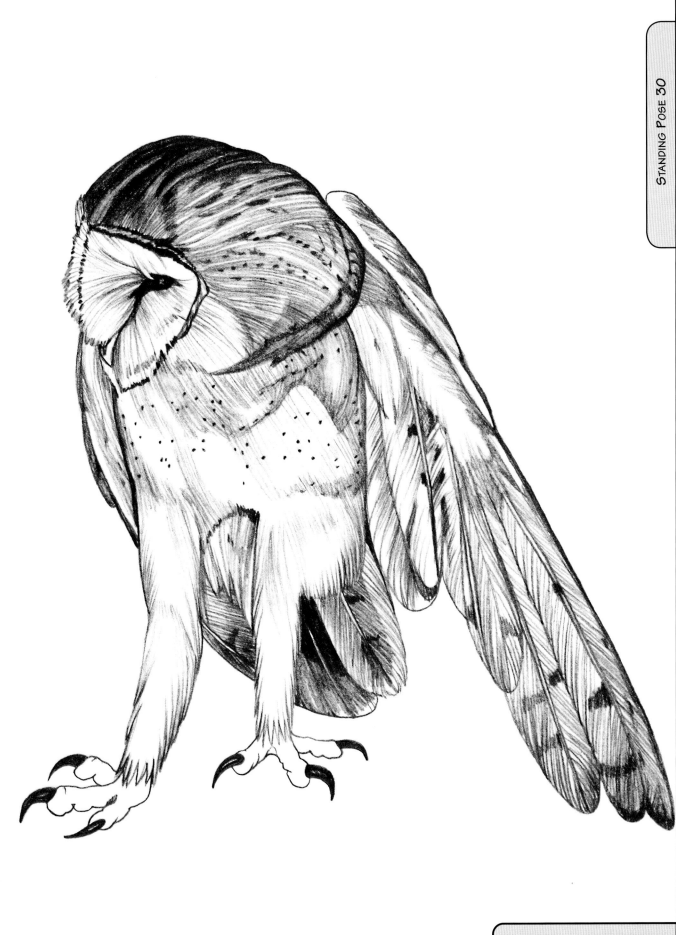

© COPYRIGHT 2008

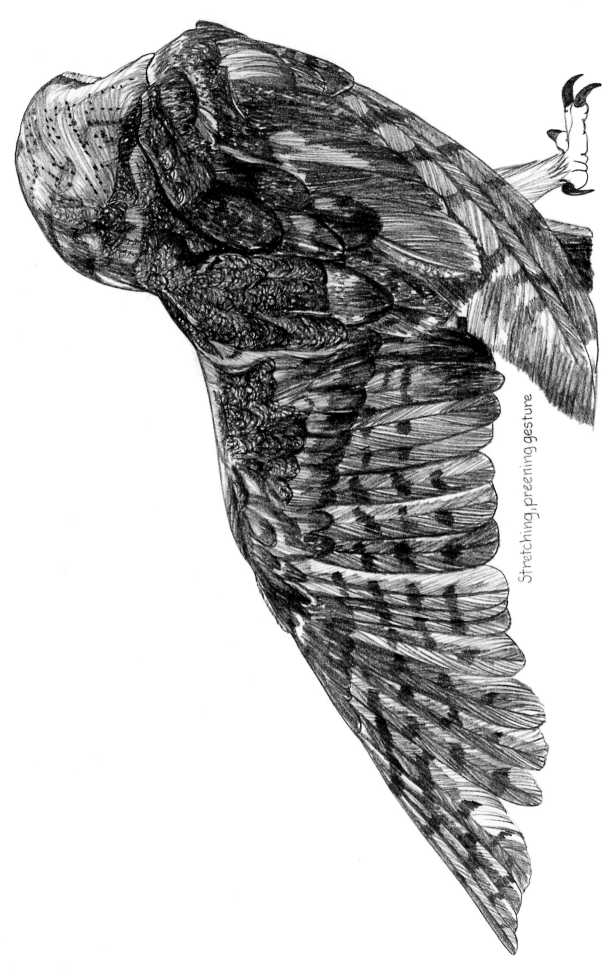

Stretching, preening gesture

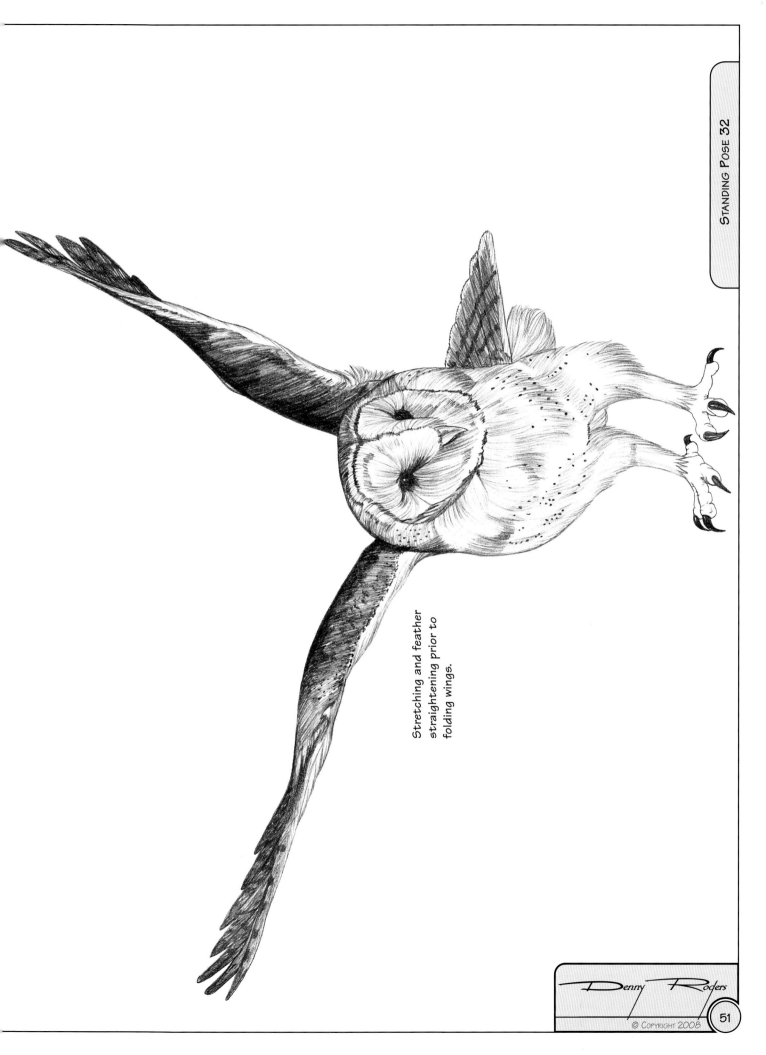

Stretching and feather straightening prior to folding wings.

Denny Rogers

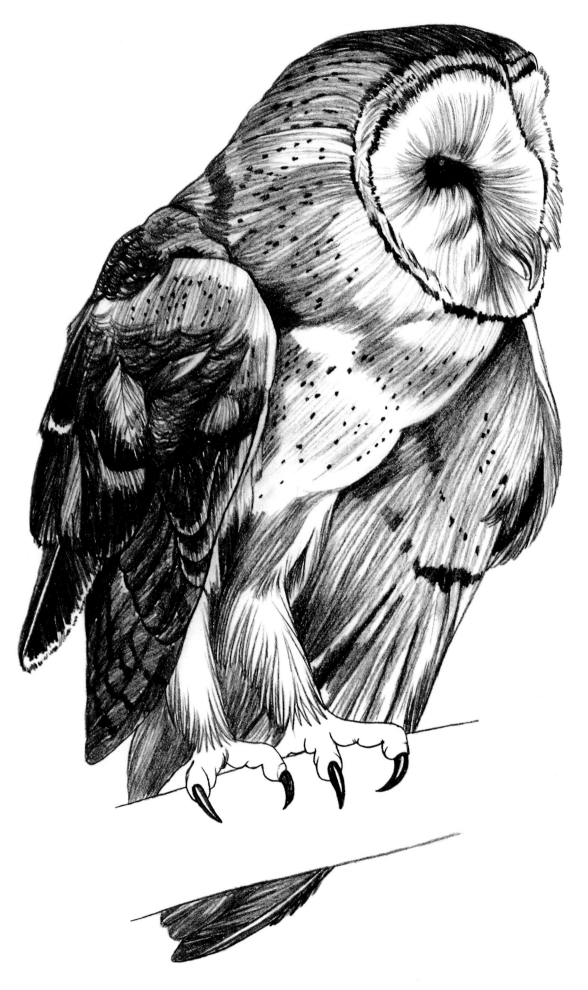

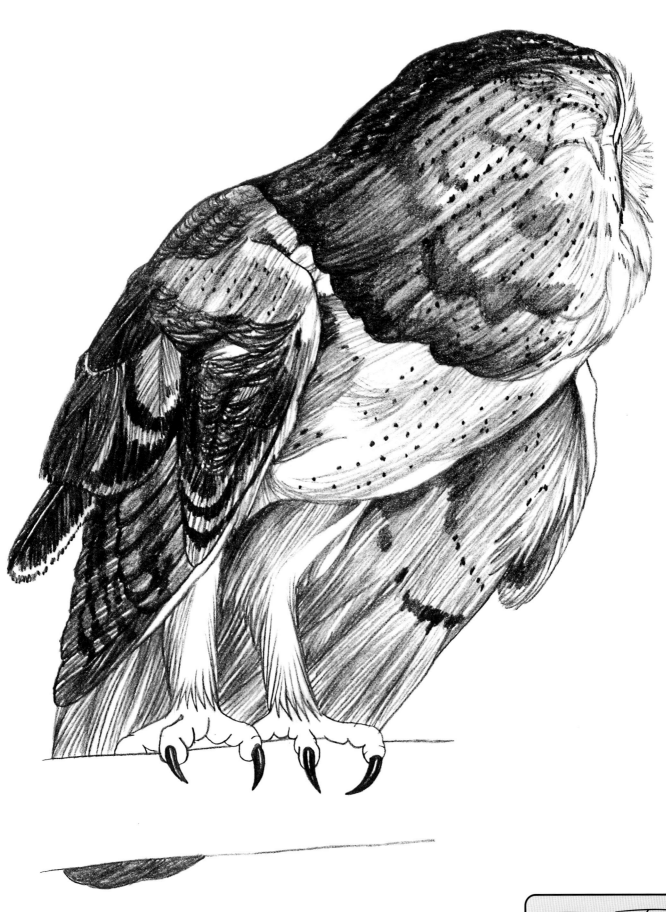

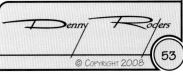

© COPYRIGHT 2008

53

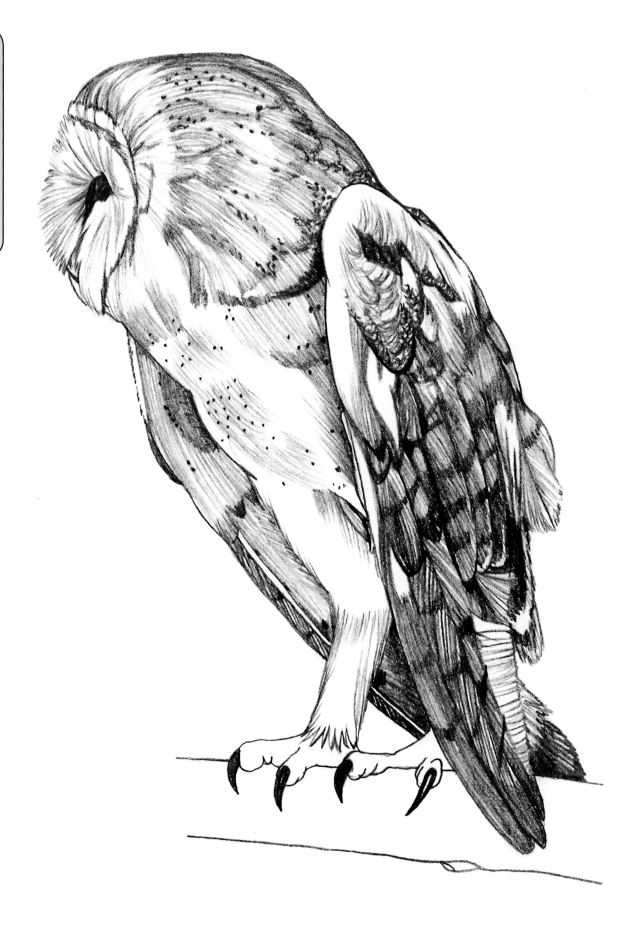

Denny Rogers

© Copyright 2008

55

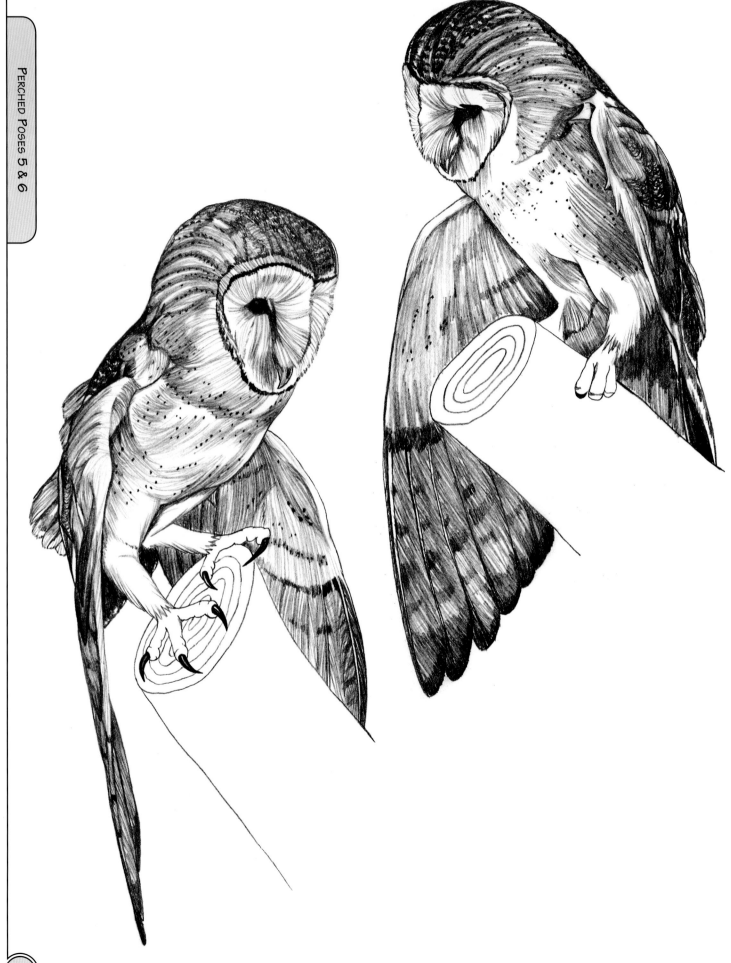

Denny Rogers

© Copyright 2008

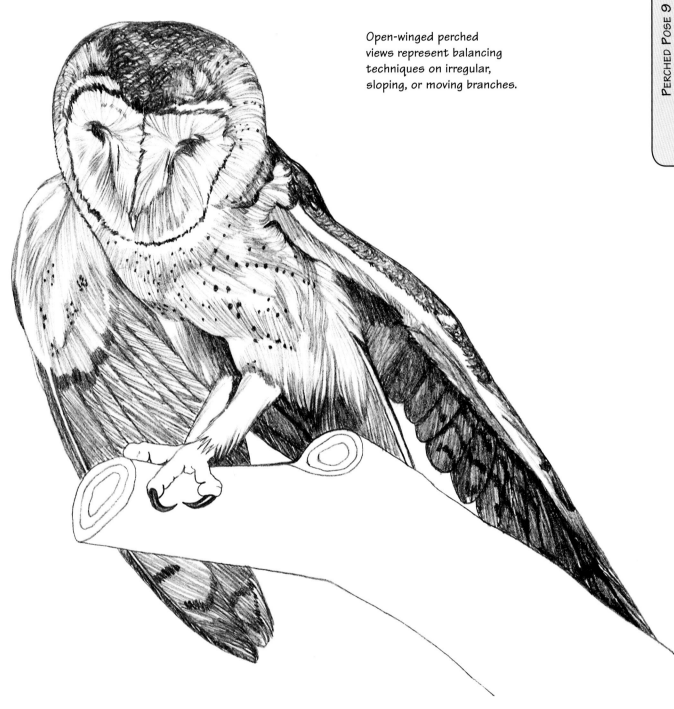

Open-winged perched
views represent balancing
techniques on irregular,
sloping, or moving branches.

Denny Rogers

© Copyright 2008

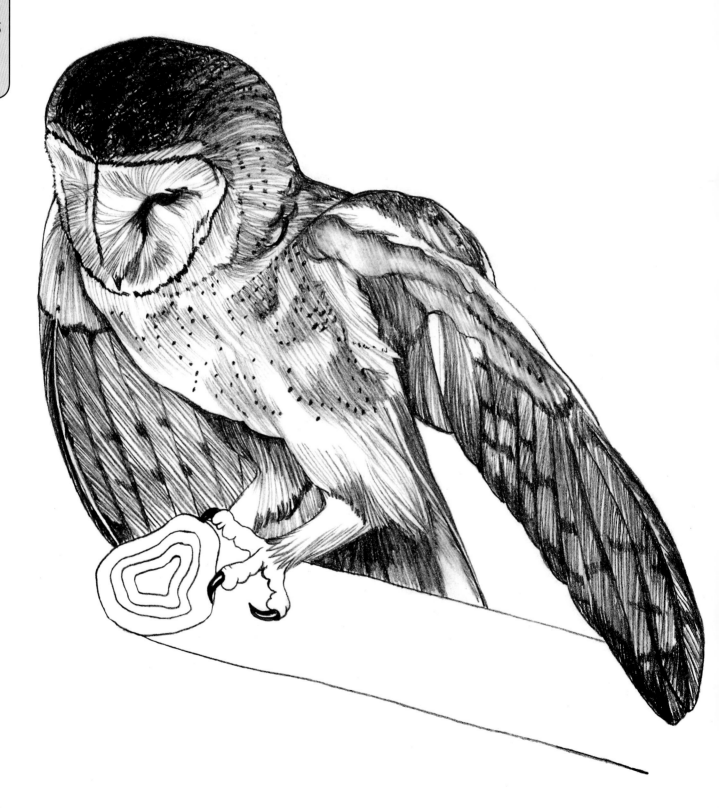

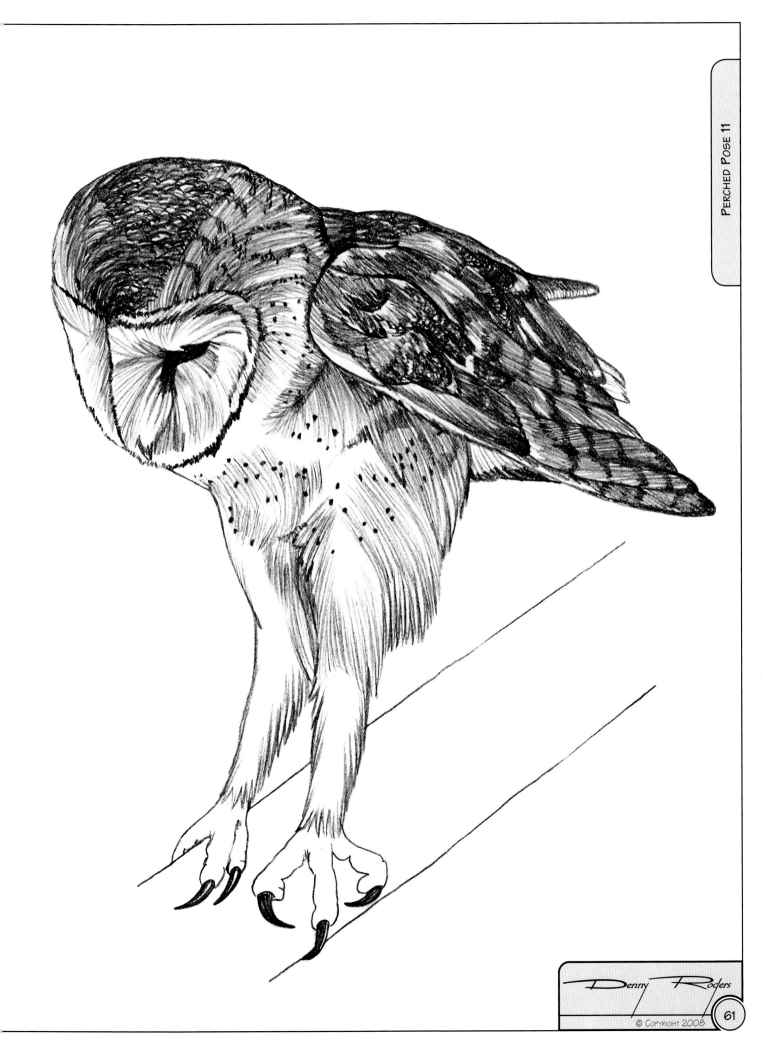

Denny Rogers

© COPYRIGHT 2008

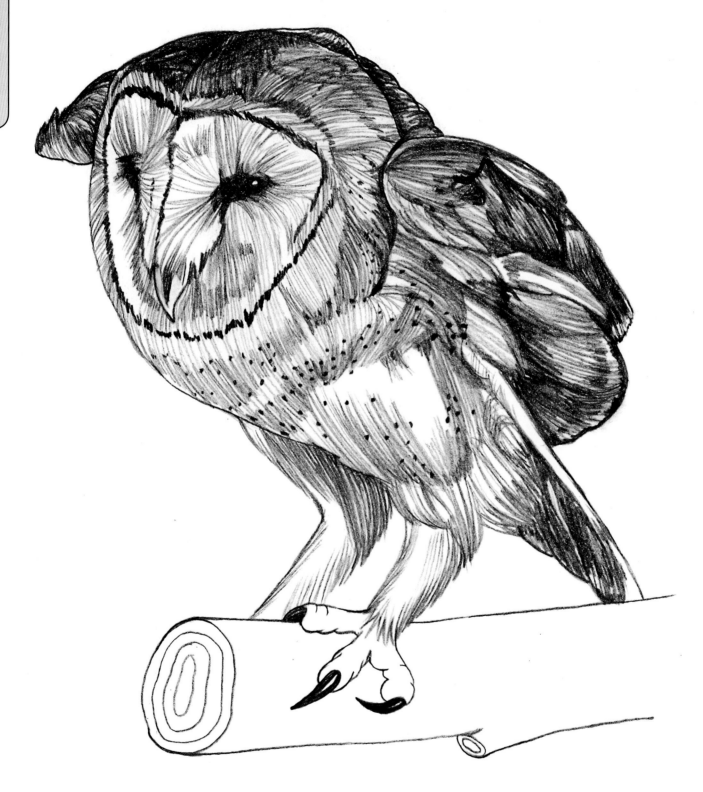

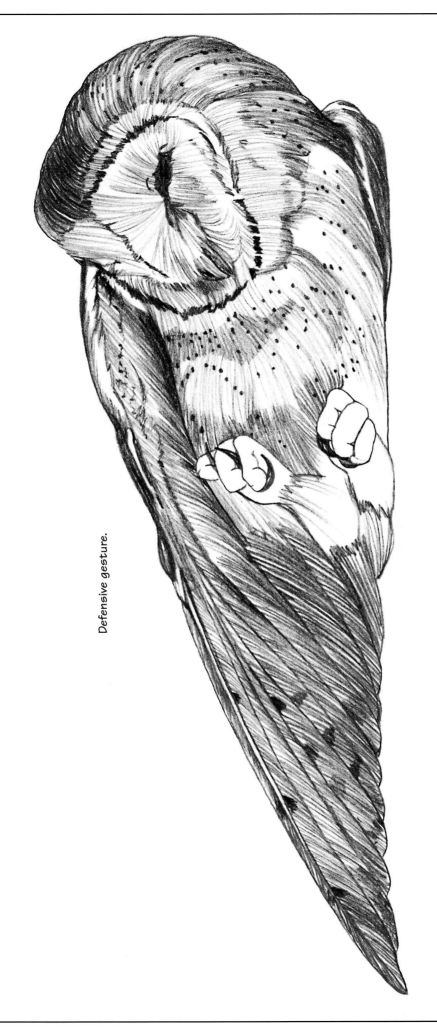

Defensive gesture.

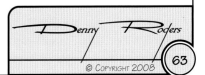

Denny Roders

© Copyright 2008

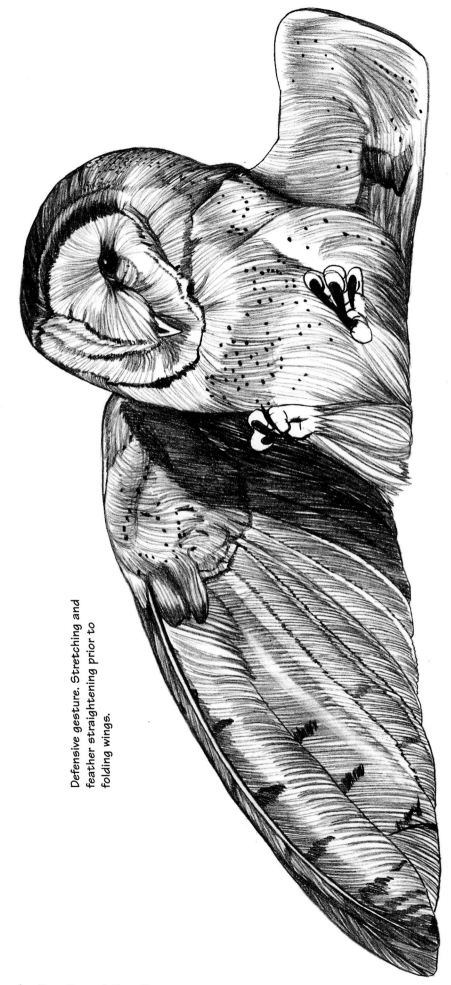

Defensive gesture. Stretching and feather straightening prior to folding wings.

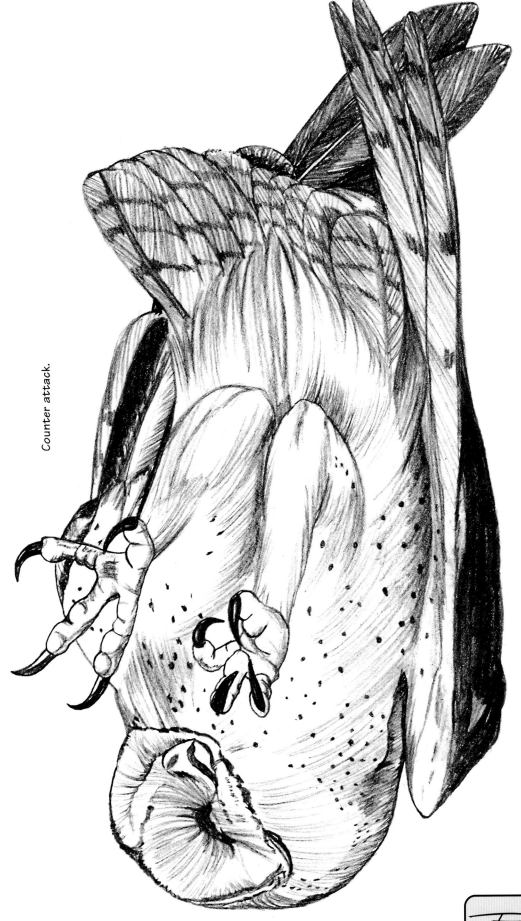

Counter attack.

Denny Rogers

© Copyright 2008

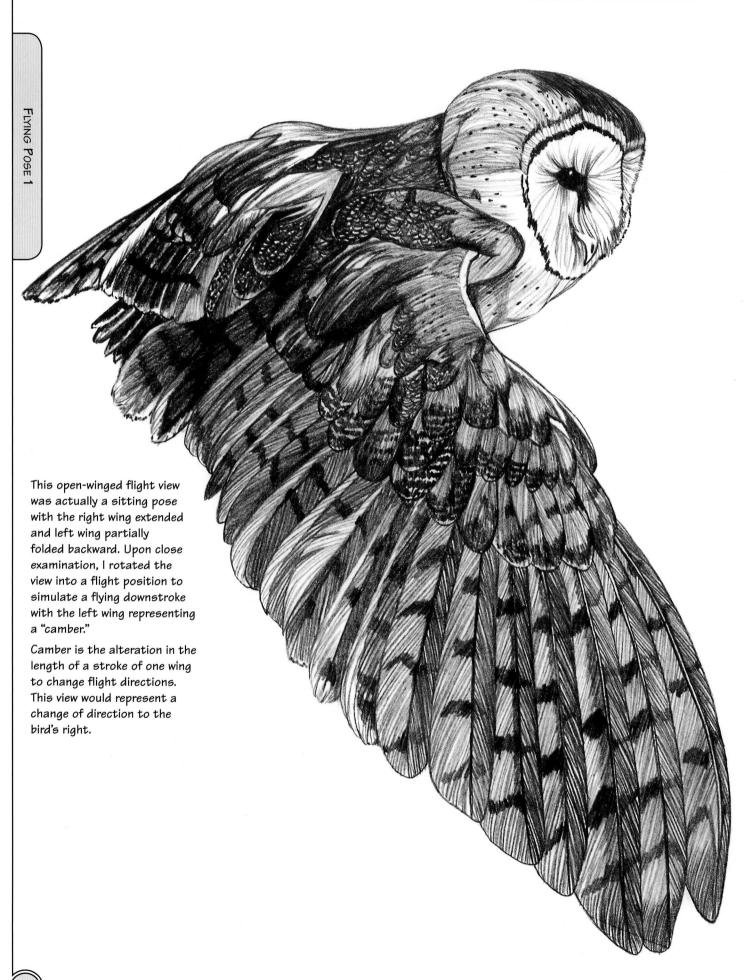

This open-winged flight view was actually a sitting pose with the right wing extended and left wing partially folded backward. Upon close examination, I rotated the view into a flight position to simulate a flying downstroke with the left wing representing a "camber."

Camber is the alteration in the length of a stroke of one wing to change flight directions. This view would represent a change of direction to the bird's right.

REFERENCE

Anyone who has ever heard the eerie rattles, clicks, and screams of the barn owl would surely understand why our ancestors built such rich folklore around this ethereal ruler of darkness. The barn owl is built for the night. Studies have shown that this owl can find prey in total darkness. Those clicks and rattles are thought to act as sonar, reflecting back to highly sensitive offset ear cavities hidden under deeply concave facial disks specially designed to pick up the faintest sounds. Couple that with serrated, rippled, and fringed flight feathers and soft loose contour feathers, and you have a near-silent hunter and a rodent's worst nightmare.

Despite its knock-kneed and sometimes gangly appearance, I think the barn owl is one of the most beautiful owls. I love the fine dark vermiculations and dots on the rich golds and white. Pay close attention to the shape, location, and values of these markings, as they vary not only in individuals, but also by sex. The males are overall "cleaner" and less heavily marked, giving them an overall lighter appearance than the females.

Despite the simple color palette I have provided, you can create incredible softness and variation simply by varying the values of the mixes and using the glazing colors randomly.

Denny has provided detail here not found in any other printed reference. Supplant this with additional reference photos, and you'll be limited only by your imagination to create something beautiful.

—Lori Corbett

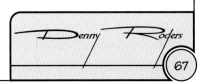

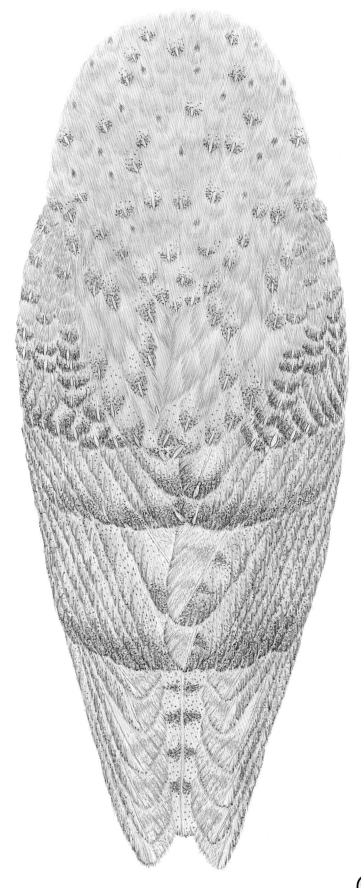

BARN OWL

COLOR LIST:
RAW UMBER (PBR 7)
ULTRAMARINE BLUE (PB 29)
TITANIUM WHITE (PW 6)
TITAN BUFF, ALSO CALLED TITANIUM BUFF,
 UNBLEACHED TITANIUM (PW 6)
YELLOW OCHRE (PY 43)
DIOXAZINE PURPLE (PV 23)

GLAZING COLORS:
TRANSPARENT YELLOW IRON OXIDE (PY 42)
ZINC WHITE (PW 4)
*QUINACRIDONE GOLD (PO 48/PO 49)

*GOLDEN'S VERSION OF QUINACRIDONE GOLD IS A MIXTURE. OTHER BRANDS MAY BE A SINGLE PIGMENT COLOR. EITHER IS ACCEPTABLE.

THESE GLAZING PIGMENTS, WITH THE EXCEPTION OF ZINC WHITE, ARE POWERFUL COLORS. A LITTLE BIT GOES LONG WAY. USE CAUTION—IT'S BEST TO APPLY A DILUTED LAYER AND ADD ANOTHER IF NECESSARY. ONCE THESE PIGMENTS ARE APPLIED, IT'S VERY DIFFICULT TO DISGUISE THEM IF TOO MUCH IS USED.

DO NOT SUBSTITUTE OTHER WHITES, SUCH AS TITANIUM WHITE, WHEN ZINC WHITE IS CALLED FOR. ZINC WHITE IS A TRANSPARENT WHITE AND IS ABSOLUTELY ESSENTIAL FOR THE TECHNIQUE DESCRIBED. THIS WILL ALLOW UNDERLYING DETAILS TO SHOW THROUGH WHILE SOFTENING THE OVERALL AREA. AN OPAQUE WHITE (TITANIUM WHITE) WILL OBSCURE THE UNDERLYING DETAIL TOO MUCH AND ALSO GIVE THE AREA A CHALKY EFFECT, RATHER THAN A SOFT COLOR CHANGE. THIS IS TRUE IN ALL INSTANCES OF ZINC WHITE BEING CALLED FOR IN THESE INSTRUCTIONS.

MAKE A LARGE QUANTITY OF MIXES 1 AND 2 AND STORE IN AN AIRTIGHT CONTAINER. MIX 2 IS A BASE MIX FOR OTHER MIXES.

NOTE: AN IMPORTANT PART OF ACHIEVING SOFTNESS FOR THE COMPLEX FEATHER DETAIL OF THE BARN OWL IS TO ESTABLISH VARIATIONS IN VALUE DURING THE BASE COATING STAGE. ONCE DETAIL AND TONING GLAZES HAVE BEEN LAID OVER THE BASE, THE VALUES WILL BE TIED TOGETHER, BUT STILL DISCERNABLE. REMEMBER—NOT EVERY FEATHER SHOULD BE IDENTICAL IN VALUE OR PATTERN. YOUR EYE SHOULD BLEND THESE TOGETHER TO CREATE THE OVERALL LOOK, BUT UPON CLOSE SCRUTINY, INDIVIDUAL DIFFERENCES CAN BE SEEN—THIS IMPORTANT FEATURE IS THE KEY TO TRANSFORMING THE ART FROM STATIC AND BORING TO REALISTIC AND DYNAMIC.

MIX 1
TITAN BUFF = 70%
YELLOW OCHRE = 30%

MIX 2
TITAN BUFF = 60%
DIOXAZINE PURPLE = 10%
QUINACRIDONE GOLD = 10%

MIX 3
TITANIUM WHITE = 80%
TITAN BUFF = 20%

FULL STRENGTH DILUTED

FULL STRENGTH DILUTED

MIX 4
TITANIUM WHITE = 70%
MIX 2 = 30%

MIX 5
MIX 2 = 60%
RAW UMBER = 40%

MIX 6
RAW UMBER = 40%
ULTRAMARINE BLUE = 40%
TITANIUM WHITE = 20%

SET 1 – TAIL, TOP SURFACE

1. CREATE RANDOM SHADOWS WITH MIX 2.
2. PULL RANDOM THIN ACCENT LINES THROUGHOUT WITH MIX 2.
3. WET BLEND OR AIRBRUSH RANDOM HIGHLIGHTS WITH MIX 3.
4. APPLY A DILUTED GLAZE OF QUINACRIDONE GOLD TO RANDOM AREAS.
5. PAINT THE DARK MARKINGS WITH MIX 2.
6. RANDOMLY ACCENT BETWEEN THESE DARK MARKINGS WITH MIX 1 AND/OR MIX 3.
7. PAINT THE SHAFTS WITH TITAN BUFF.

BOTTOM SURFACE (NOT SHOWN IN ILLUSTRATION):
THE BOTTOM SURFACE OF THE TAIL IS A LIGHTER VERSION OF THE TOP SURFACE WITH LESS CONTRAST BETWEEN DARK AND LIGHT BARRING.

UPPER TAIL COVERTS (NOT SHOWN IN ILLUSTRATION):
THERE ARE LITTLE TO NO MARKINGS ON THE OUTERMOST TAIL FEATHERS. THE MARKINGS INCREASE IN QUANTITY AND INTENSITY WITH EACH SUBSEQUENT FEATHER, WITH THE CENTRAL TWO FEATHERS THE DARKEST AND MOST HEAVILY MARKED.

SET 2 – FEET AND LEGS

THE FEATHERING ON THE LEGS IS TIGHT AND ENDS AT THE TOP OF THE TOES. IT IS NOT AS EXTENSIVE AS THAT ON MOST OTHER OWLS. THERE IS NO FEATHERING ON THE TOES, BUT SOMETIMES THERE ARE SPARSELY DISTRIBUTED WISPS OF LONG, SOFT QUILLS.

1. BASE COAT THE TALONS WITH MIX 6.
2. LIGHTEN THE UNDERSIDE OF THE TALONS WITH TITAN BUFF.
3. BASE COAT THE ENTIRE TOE WITH MIX 4.
4. BASE COAT THE LEGS WITH TITAN BUFF.
5. ACCENT RANDOM BARBS ON THE LEGS WITH MIX 2 AND TITANIUM WHITE TO CREATE VARIATION.
6. HIGHLIGHT THE SCALES AND BUMPS ON THE TOE PADS WITH TITAN BUFF AND TITANIUM WHITE.

SET 3 – ABDOMEN, FLANKS, BREAST, THROAT AREA, AND UNDER TAIL COVERTS

THE FEATHER GROUP IN THE THROAT AREA UNDER THE BEAK IS NORMALLY COMPRESSED—RESEMBLING A PINE CONE. THE REST OF THIS AREA IS VERY LOOSE AND ALMOST FUR-LIKE. THE COLOR WILL VARY FROM A LIGHT RUST-COLORED TINGE ON THE UPPER PORTIONS (USUALLY FOUND ON THE FEMALES) TO PURE WHITE (USUALLY ON THE MALES). THE MARKINGS WILL ALSO VARY IN QUANTITY AND INTENSITY—THE FEMALES BEING MORE HEAVILY MARKED. I CHOSE TO PAINT THE SPARSELY MARKED, LIGHT-COLORED BREAST AREA OF A MALE.

1. BASE COAT WITH TITAN BUFF.
2. BASE COAT RANDOM SHADOWS WITH MIX 4.
3. ADD RANDOM THIN ACCENT STROKES THROUGHOUT (FOLLOWING THE FEATHER FLOW) WITH MIX 4.
4. APPLY A GLAZE OF ZINC WHITE TO SOFTEN THE DETAIL AND THE CONTRAST.
5. ACCENT THROUGHOUT WITH TITANIUM WHITE.
6. ADD SMALL MARKINGS ON THE BREAST USING MIX 1 FOR MALE OR MIX 2 FOR FEMALE. GO OVER RANDOM MARKINGS WITH DILUTED QUINACRIDONE GOLD AND TRANSPARENT YELLOW IRON OXIDE.

SET 4 – PRIMARIES, SECONDARIES, AND TERTIALS

THE INSIDE VANE OF THE FIRST TWO OR THREE PRIMARIES ARE HEAVILY RIPPLED FROM THE TIP FOR ABOUT 2 INCHES.

INSIDE VANES:
1. BASE COAT THE INSIDE VANES WITH TITAN BUFF.
2. SHADE THE LOW AREAS OF THE RIPPLES WITH MIX 2.
3. PULL RANDOM THIN ACCENT LINES THROUGHOUT WITH MIX 2.
4. ACCENT THE INSIDE VANES WITH TITANIUM WHITE.
5. APPLY A GLAZE OF ZINC WHITE TO THE INSIDE VANES.
6. PAINT THE DARK MARKINGS WITH MIX 2.
7. RANDOMLY ACCENT BETWEEN THESE DARK MARKINGS WITH MIX 3 AND/OR TITANIUM WHITE.

OUTSIDE VANES:
1. BASE COAT THE OUTSIDE VANES WITH MIX 1.
2. SHADE THE LOW AREAS OF THE RIPPLES WITH MIX 2.
3. PULL RANDOM THIN ACCENT LINES THROUGHOUT WITH MIX 2.
4. WET BLEND OR AIRBRUSH RANDOM HIGHLIGHTS WITH MIX 3.
5. HIGHLIGHT RANDOM AREAS OF THE OUTSIDE VANES WITH TITANIUM WHITE.
6. APPLY A DILUTED GLAZE OF QUINACRIDONE GOLD TO THE OUTSIDE VANES.
7. PAINT THE DARK MARKINGS WITH MIX 5.
8. RANDOMLY ACCENT BETWEEN THESE DARK MARKINGS WITH MIX 1 AND/OR MIX 3.
9. PAINT THE SHAFTS WITH TITAN BUFF.

SET 5 – COVERTS

1. BASE COAT WITH MIX 1.
2. CREATE RANDOM SHADOWS WITH MIX 2.
3. PULL RANDOM THIN ACCENT LINES THROUGHOUT WITH MIX 2.
4. WET BLEND OR AIRBRUSH RANDOM HIGHLIGHTS WITH MIX 3.
5. APPLY A DILUTED GLAZE OF QUINACRIDONE GOLD TO RANDOM AREAS.
6. PAINT THE DARK MARKINGS WITH MIX 5.
7. RANDOMLY ACCENT BETWEEN THESE DARK MARKINGS WITH MIX 1 AND/OR MIX 3.

SET 6 – SCAPULARS, CAPE, AND HEAD

NOTE THAT THESE FEATHERS ARE VERY LOOSE WITH NO READILY DISCERNABLE FEATHER EDGES. THIS AREA RESEMBLES FUR MORE THAN IT DOES FEATHERS.

1. BASE COAT WITH MIX 1.
2. CREATE RANDOM SHADOWS WITH MIX 2.
3. PULL RANDOM THIN ACCENT LINES THROUGHOUT WITH MIX 2.
4. WET BLEND OR AIRBRUSH RANDOM HIGHLIGHTS WITH MIX 3.
5. APPLY A DILUTED GLAZE OF QUINACRIDONE GOLD TO RANDOM FEATHERS.
6. PAINT THE DARK MARKINGS WITH MIX 5.
7. RANDOMLY ACCENT BETWEEN THESE DARK MARKINGS WITH MIX 1 AND/OR MIX 3.

SET 7 – FACE

THE FEATHERS ON THE FACE ARE VERY LOOSE AND FUR-LIKE. THE EDGE OF THE DISK (CALLED A RUFF) HAS SEVERAL ROWS OF TINY FEATHERS THAT RESEMBLE A PINE CONE. THE FEMALE BARN OWL HAS A DARKER RUFF THAN THE MALE, WHOSE RUFF TENDS TO BE ALL WHITE EXCEPT FOR A WASH OF GOLD AT THE TOP OVER THE EYES.

1. BASE COAT THE BEAK WITH MIX 4. HIGHLIGHT WITH MIX 3.
2. BASE COAT IN THE FACIAL DISK AND THE RUFF AROUND THE DISK WITH TITAN BUFF.
3. BASE COAT THE DARK PATCH IN FRONT OF THE EYE WITH MIX 2.
4. BASE COAT RANDOM SHADOWS IN THE RUFF WITH MIX 2.
5. SPARINGLY ADD ACCENT STROKES TO THE FACIAL DISK FOLLOWING THE RADIAL GROWTH WITH MIX 4.
6. HIGHLIGHT BOTH THE FACIAL DISK AND THE RUFF WITH TITANIUM WHITE.
7. GLAZE THE TOP PORTION OF THE RUFF AND THE DARK PATCH IN FRONT OF THE EYE WITH DILUTED QUINACRIDONE GOLD.

FACE – SET 7

SCAPULARS, CAPE, AND HEAD – SET 6

COVERTS – SET 5

PRIMARIES, SECONDARIES, AND TERTIALS – SET 4

ABDOMEN, FLANKS, BREAST, THROAT AREA, AND UNDER TAIL COVERTS – SET 3

FEET AND LEGS – SET 2

TAIL, TOP SIDE – SET 1

Denny Rogers

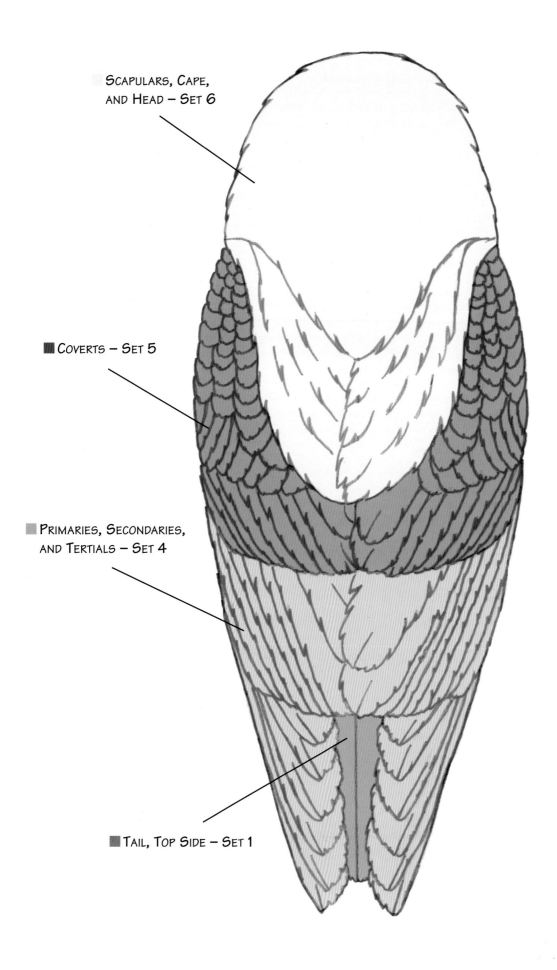

SCAPULARS, CAPE,
AND HEAD – SET 6

COVERTS – SET 5

PRIMARIES, SECONDARIES,
AND TERTIALS – SET 4

TAIL, TOP SIDE – SET 1

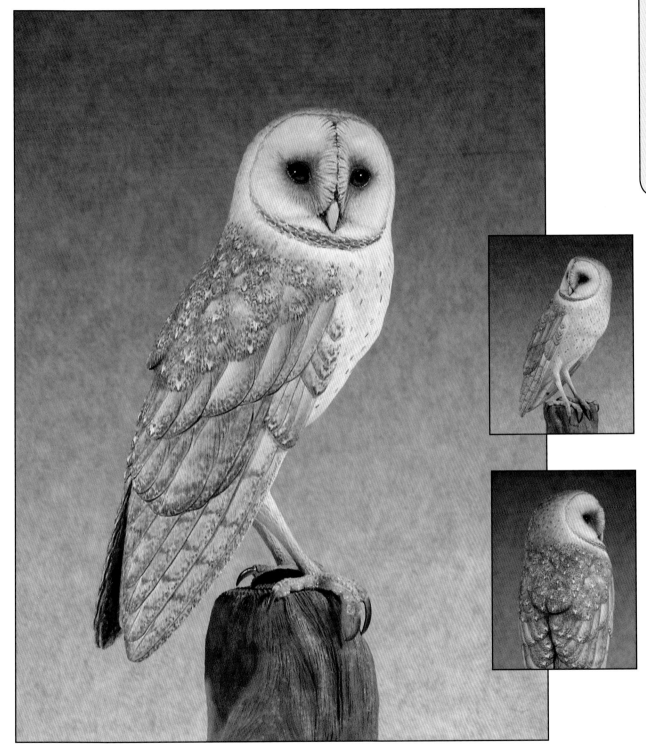

Rodents Beware

Barn owl

Jerry Simchuk

Tupelo and acrylic, 2006

13" x 8" x 8"

Artist's private collection. The artist undertook this project to teach his students how to carve and paint a barn owl. The subject is an older male, chosen in order to show off the rich and warm color tones that can otherwise be hidden by their dark markings. This half-life-size owl is portrayed in a farm setting, hunting from a perch of an old western-style post and rail fence.

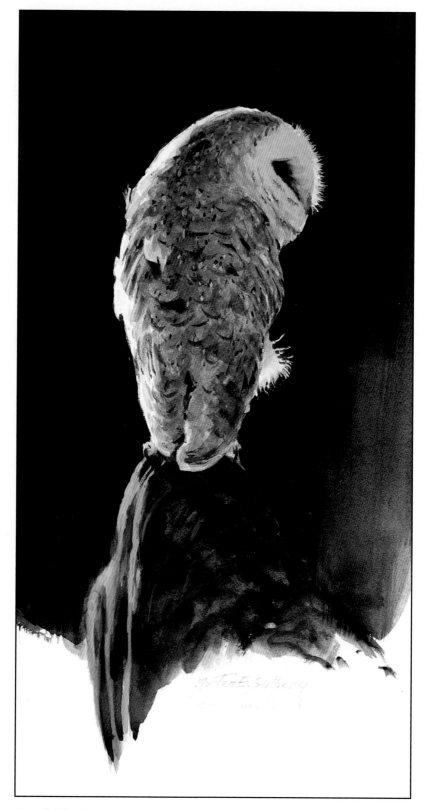

Barn Owl Study

Morten E. Solberg

Watercolor, 2007

10" x 6"

This was a study compiled from a series of photographs. Eventually, it will serve as a reference for a large painting done in acrylics. The goal was to create a simple value study without a lot of detail, keeping it fresh and contemporary. The artist left the bottom of the piece unfinished, which he felt added the fresh feel he wanted.

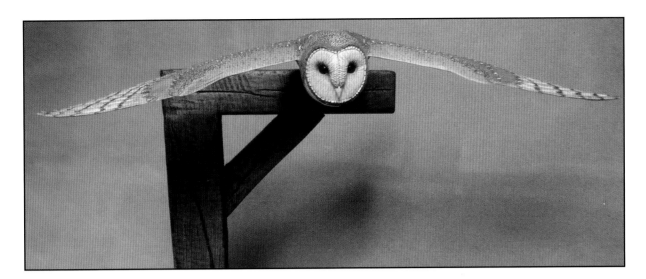

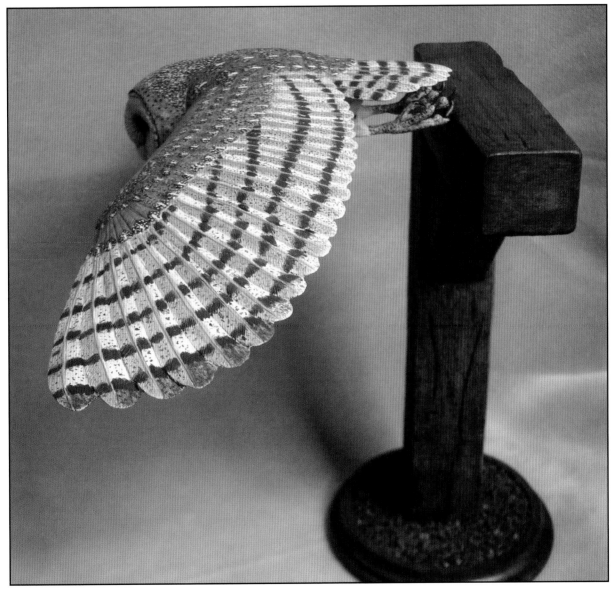

Silent Flight

Tim McEachern

Oil and tupelo wood, 2007

Artist's private collection. The artist's goal was to create the illusion of the owl leaping off the barn beam effortlessly and gracefully to his next meal, which he has spotted below.

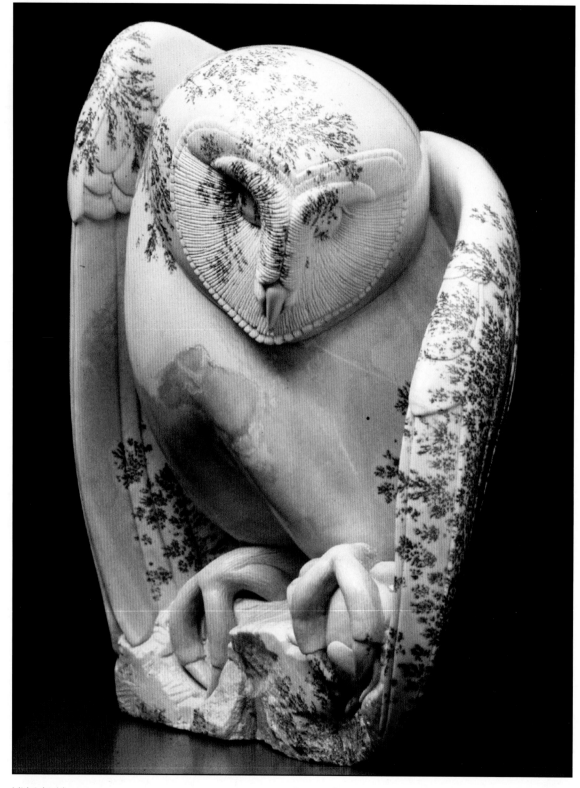

Midnight Mouser

Clarence P. Cameron

Montana dendritic soapstone and slate/dark-stained cherry base, 1996

14" high

Permanent collection of the Leigh Yawkey Woodson Art Museum, Wausau, Wisconsin.
This chunk of soapstone sat on the artist's desk for two years, never revealing what it
contained. Then one day, while washing his hands, the artist glanced over his shoulder and
there it was! After a few lines were applied with a wax pencil, the barn owl was carved as it
was originally envisioned that day.

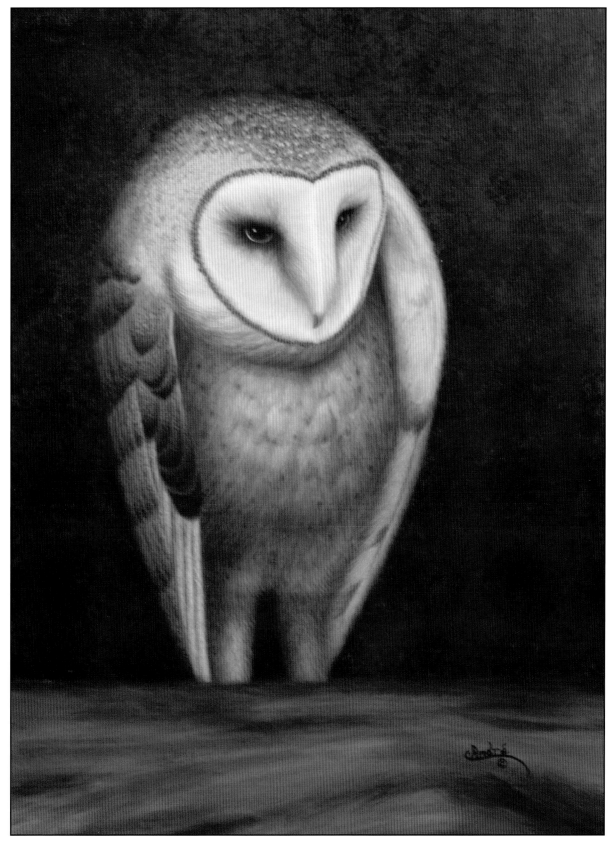

Barn Owl

Carol André

Acrylic on masonite, 2007

This owl is a conglomerate of several rescued birds; the artist utilizes as much reference materials as possible to create each piece. The artist's goal was to capture the face of the bird and the essence of the species.

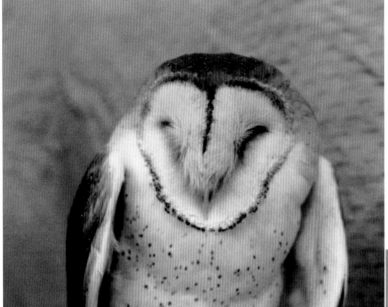

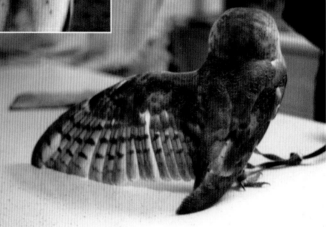

Notice the pronounced facial ring that hides the beak and eyes. The eyes are recessed behind the fuzzy facial feathers.

Top right: An erect, full standing pose from the side.

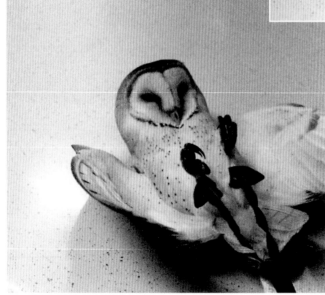

Observe the gradations of color on the back and the wing, which is opened in the natural cooling posture.

This owl is demonstrating a defensive posture. Also, observe the subtle change from a pure white breast area to a tawny side area.

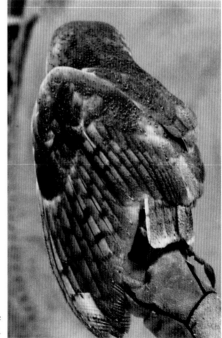

A typical limb-sitting position. Observe the short tail as compared to other birds.

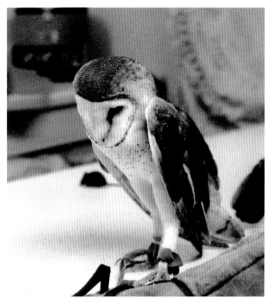

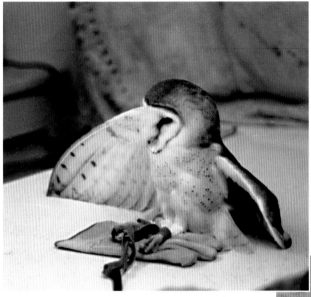

This owl, demonstrating a typical standing posture on a flat surface, is focused on a mouse it just noticed on the other side of the table.

The spreading wings illustrate the beginnings of the defensive posture. Also, note the spotting on the breast.

Observe the length of the legs, as well as the extended talons. This owl is about to snatch up the mouse it has been watching.

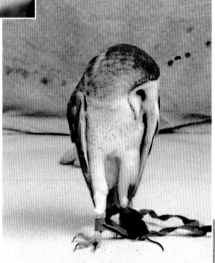

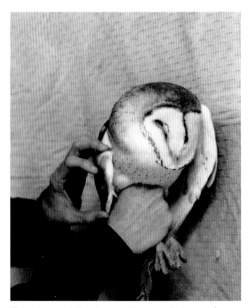

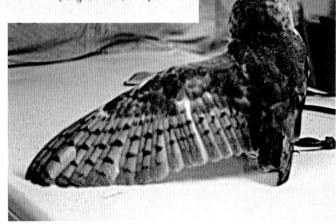

This alert owl illustrates the round shape of a barn owl's head.

Note the color patterns of this fully extended wing.

© COPYRIGHT 2008

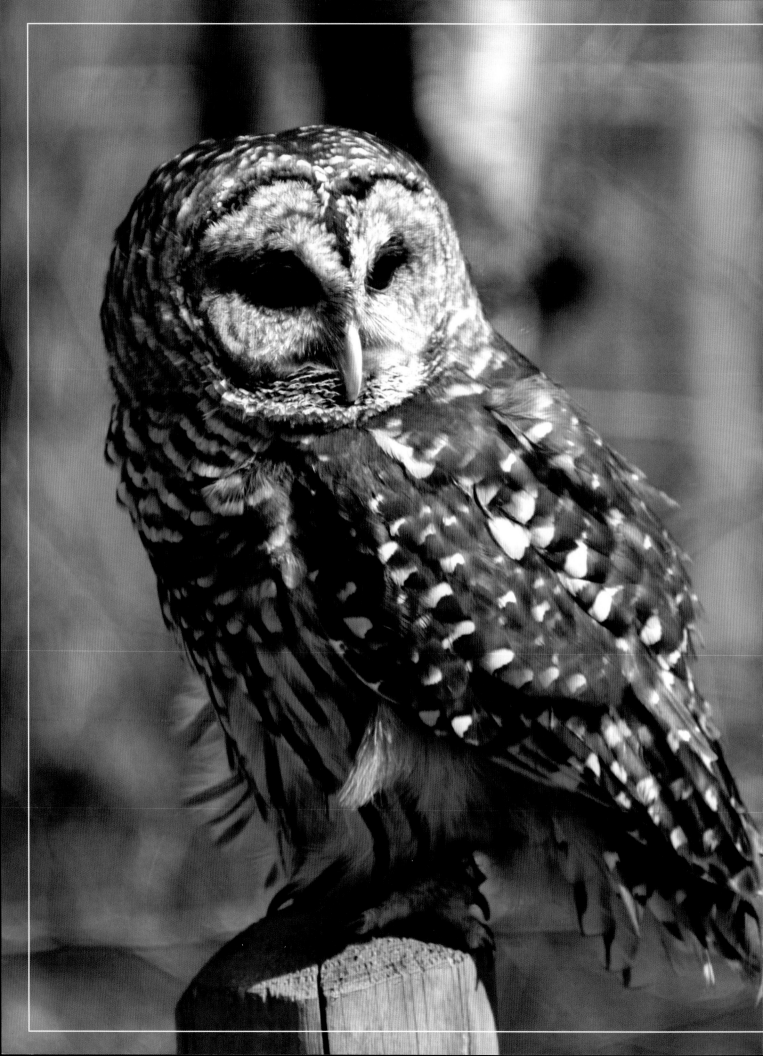

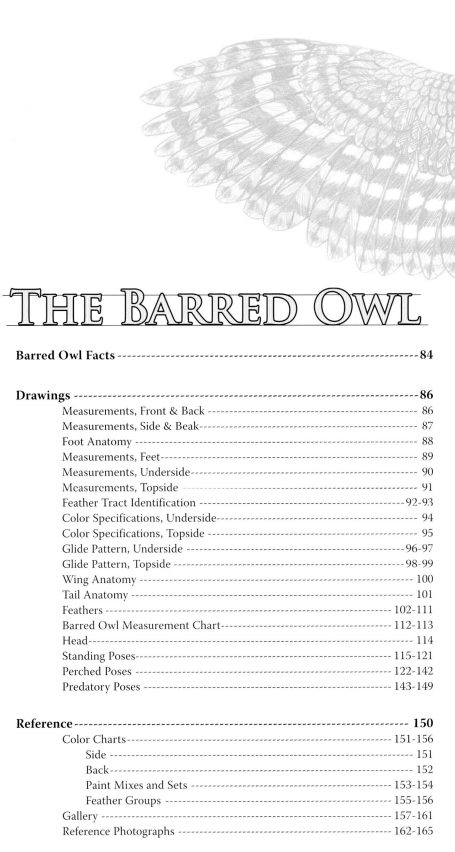

THE BARRED OWL

Denny Rogers

© Copyright 2008

Barred Owl Facts

The barred owl's (*Strix varia*) range in North America is from Nova Scotia and Newfoundland across southern Canada to British Columbia, and from east of the Rocky Mountains south to the Gulf Coast. Many owls migrate south from the northern ranges in winter and will go as far south as the mountains of Mexico and into Central America. The barred owl is 17 to 24 inches (43 to 61 centimeters) in length with a wingspread of 40 to 50 inches (102 to 127 centimeters). The average weight of a male is 22 ounces (630 grams), while the female's is 28 ounces (800 grams). The barred owl is also known as the black-eyed owl, bottom owl, crazy owl, hoot owl, laughing owl, old folks' owl, rain owl, round-headed owl, swamp owl, and wood owl.

It is a large, gray-brown bird with bars and spots, and has buff, dark brown, and white markings. The patterns on the body consist of barring crosswise on the breast, elongated-spear streaking on the belly, and white spots on the back. It has a round head with a pale face and no ear tufts. The barred owl's dark brown eyes are unusual when compared to most owls in the United States, which have yellow eyes. Its eyesight is especially keen, and, while mostly nocturnal, it is the North American owl most likely to become active during daylight hours on cloudy days, and at dawn and dusk.

The call of the barred owl is noisy and can be heard by day or night. It hoots but has a higher-pitched call more emphatic than that of the great horned owl. The call is a series of eight accent hoots ending in oo-aw, with a lower pitch at the end; a common interpretation of the barred owl's call is "who cooks for you, who cooks for you all?"

The barred owl lives approximately 10 to 12 years in the wild. Barred owls are killed by traffic, illegal shootings, starvation, and great horned owls. One captured owl was reported to have lived for 23 years.

Diet and Habitat

The barred owl most commonly eats voles, mice, and shrews, but will also hunt chipmunks, squirrels, minks, opossums, weasels, rabbits, bats, snakes, amphibians, scorpions, and crickets. Its hearing is very acute, and the barred owl will locate small prey from great distances by hearing alone. This owl swoops down on its prey from a high perch or while flying through the trees. Doves, grouse, quails, jays, pigeons, and other birds are caught when settling into their nightly roosts. The barred owl also wades into water to catch fish, frogs, and other aquatic prey; in fact, some barred owls eat so many crayfish that their breast feathers turn slightly pink. Campfires often attract the barred owl, where they hunt the large insects drawn to the flames. The only natural predator of the barred owl is the great horned owl.

The barred owl is abundant in the deep woods and swamp forests of the Southeast but is slowly expanding its range westward. Its counterpart in the West is the spotted owl; however, the more aggressive barred owl is gradually taking over the territory of the spotted owl, as well as interbreeding. The genetics of these two owls are so similar that many believe the spotted is merely a subspecies of the barred.

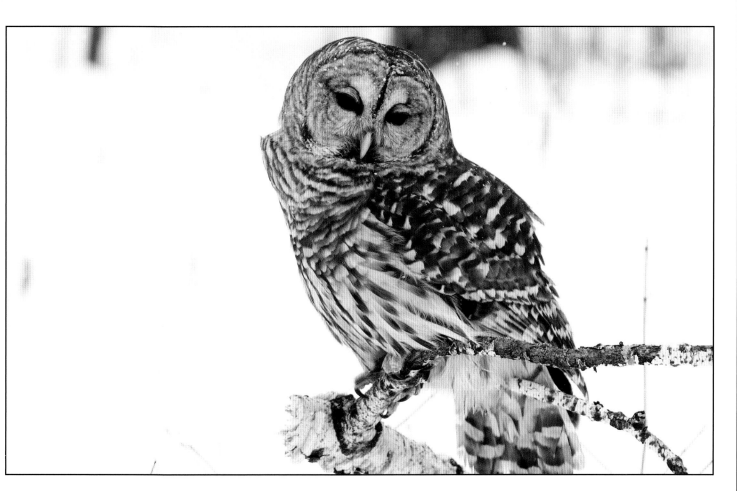

Nesting

The barred owl will use the same nest site for many years. It nests in tree cavities, abandoned hawk, crow, and squirrel nests, nest boxes, and broken-off tree limbs, usually near marshes, ponds, and lakes. It can lay between one and five eggs, but usually lays two or three. The pure white eggs are laid from January to June, depending on the owl's location in the U.S. The male and female both sit on the eggs, but the female does the majority of the incubating. The eggs hatch in 28 days, and the young fly 42 days after hatching.

Flight

The flight of the barred owl is buoyant and noiseless, and it glides skillfully through forests. For more information on the mechanics and physics of flight, please see the Flight section on pages 232 through 237.

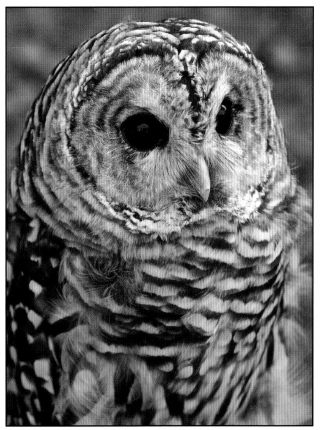

© Copyright 2008

DRAWINGS

Chest width

4.0" AAA

(Female)

BBB 7.0"

CCC 11.0"

DDD 9.0"

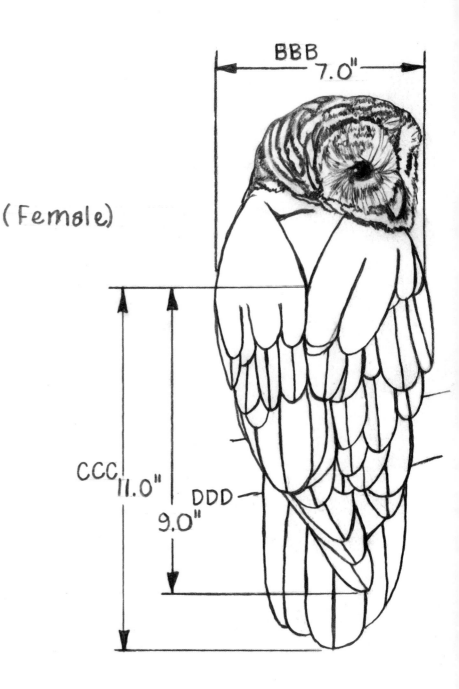

See the chart on pages 112 through 113 for a listing of the measurements. Also included are nine additional scales showing each measurement reduced proportionately so that accurate patterns can be laid out in any size.

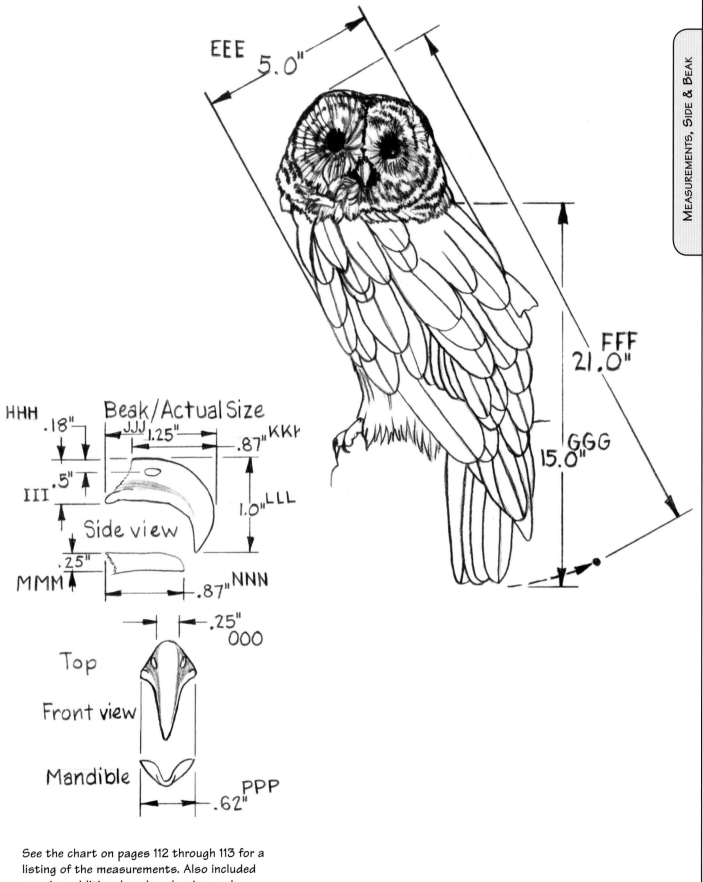

EEE 5.0"

FFF 21.0"

GGG 15.0"

Beak/Actual Size

HHH .18"

III .5"

JJJ 1.25"

.87" KKI

1.0" LLL

Side view

.25" MMM

.87" NNN

.25" OOO

Top

Front view

Mandible

.62" PPP

See the chart on pages 112 through 113 for a listing of the measurements. Also included are nine additional scales showing each measurement reduced proportionately so that accurate patterns can be laid out in any size.

Denny Rogers

© COPYRIGHT 2008

Inside of left foot

Outside of right foot

Inside of right foot

Outside of left foot

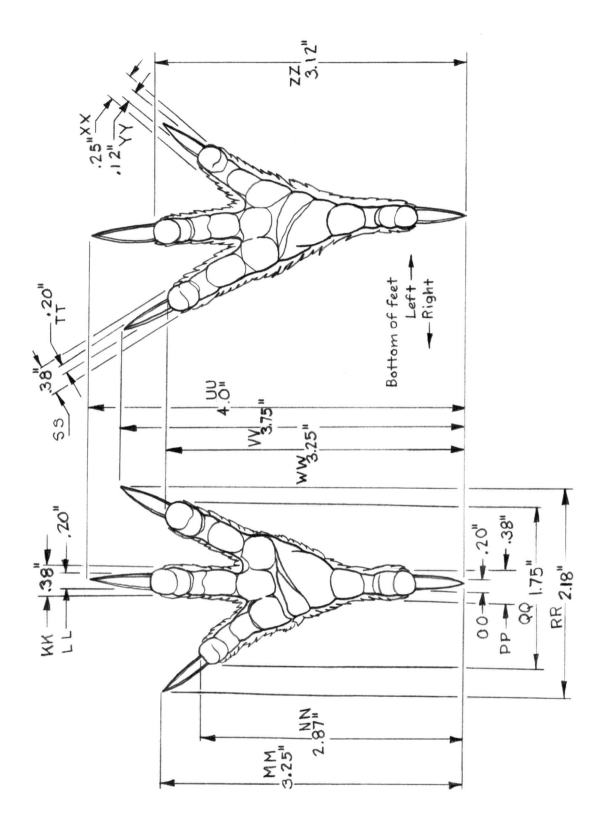

ZZ 3.12"

.25" XX
.12" YY

.20" TT

.38" SS

Bottom of feet
Left →
→ Right

UU 4.0"

VV 3.75"

WW 3.25"

.20" LL

.38" KK

.20" OO

.38" PP

QQ 1.75"

RR 2.18"

NN 2.87"

MM 3.25"

See the chart on pages 112 through 113 for a
listing of the measurements. Also included
are nine additional scales showing each
measurement reduced proportionately so that
accurate patterns can be laid out in any size.

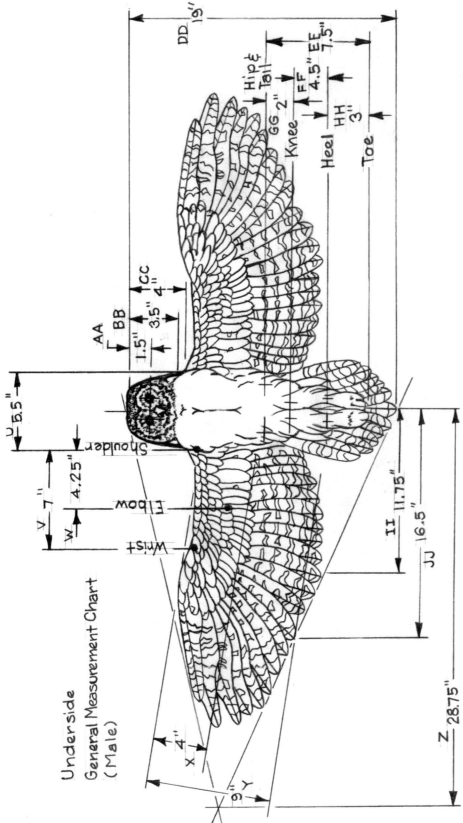

Underside
General Measurement Chart
(Male)

DD 19"

Hip & Tail

EE 7.5"

FF 4.5"

GG 2"

Knee

Heel

HH 3"

Toe

CC 4"

BB 3.5"

AA 1.5"

U 5.5"

Shoulder

V 7"

W 4.25"

Elbow

Wrist

II 11.75"

JJ 16.5"

Z 28.75"

X 4"

Y 6"

See the chart on pages 112 through 113 for a
listing of the measurements. Also included
are nine additional scales showing each
measurement reduced proportionately so that
accurate patterns can be laid out in any size.

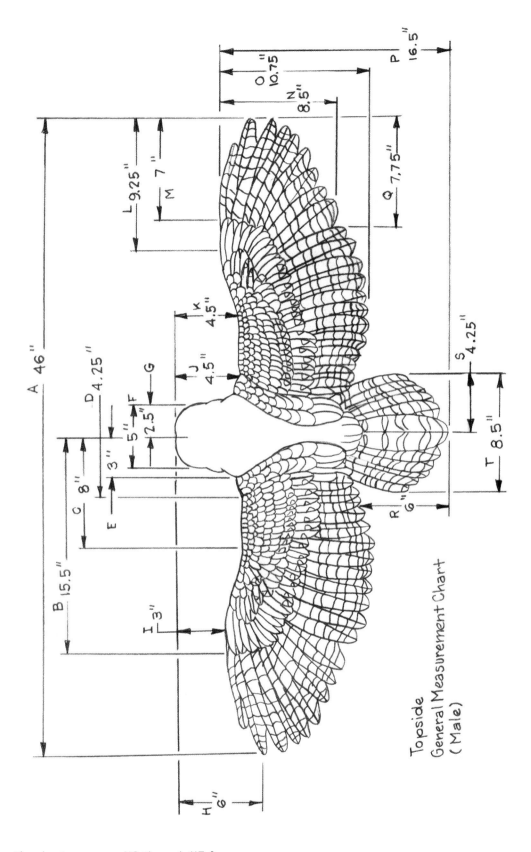

Topside
General Measurement Chart
(Male)

See the chart on pages 112 through 113 for a
listing of the measurements. Also included
are nine additional scales showing each
measurement reduced proportionately so that
accurate patterns can be laid out in any size.

Denny Rogers
© Copyright 2008

UNDERSIDE

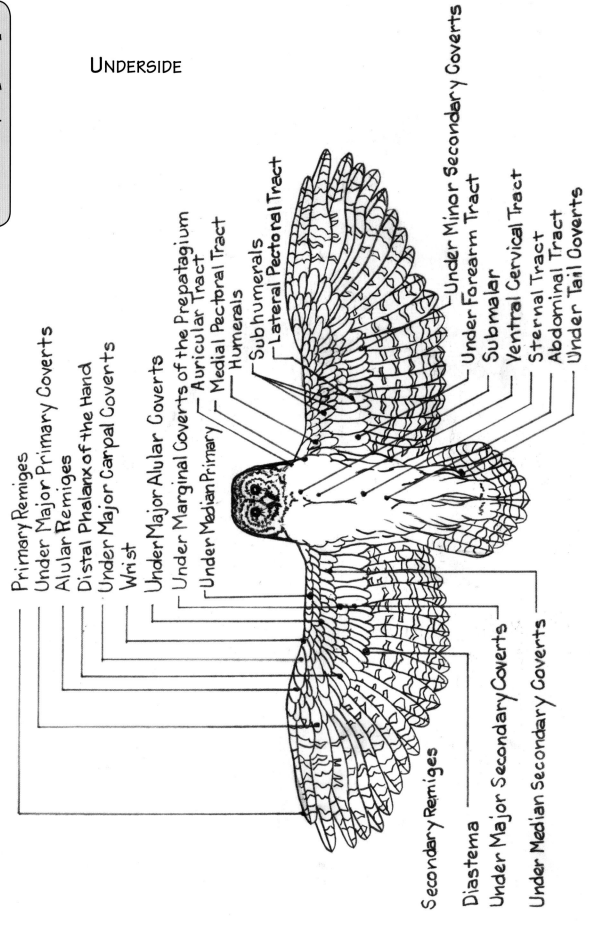

Primary Remiges
Under Major Primary Coverts
Alular Remiges
Distal Phalanx of the Hand
Under Major Carpal Coverts
Wrist
Under Major Alular Coverts
Under Marginal Coverts of the Prepatagium
Auricular Tract
Medial Pectoral Tract
Under Median Primary
Humerals
Subhumerals
Lateral Pectoral Tract
Under Minor Secondary Coverts
Under Forearm Tract
Submalar
Ventral Cervical Tract
Sternal Tract
Abdominal Tract
Under Tail Coverts

Secondary Remiges
Diastema
Under Major Secondary Coverts
Under Median Secondary Coverts

Underside Feather Tract Identification

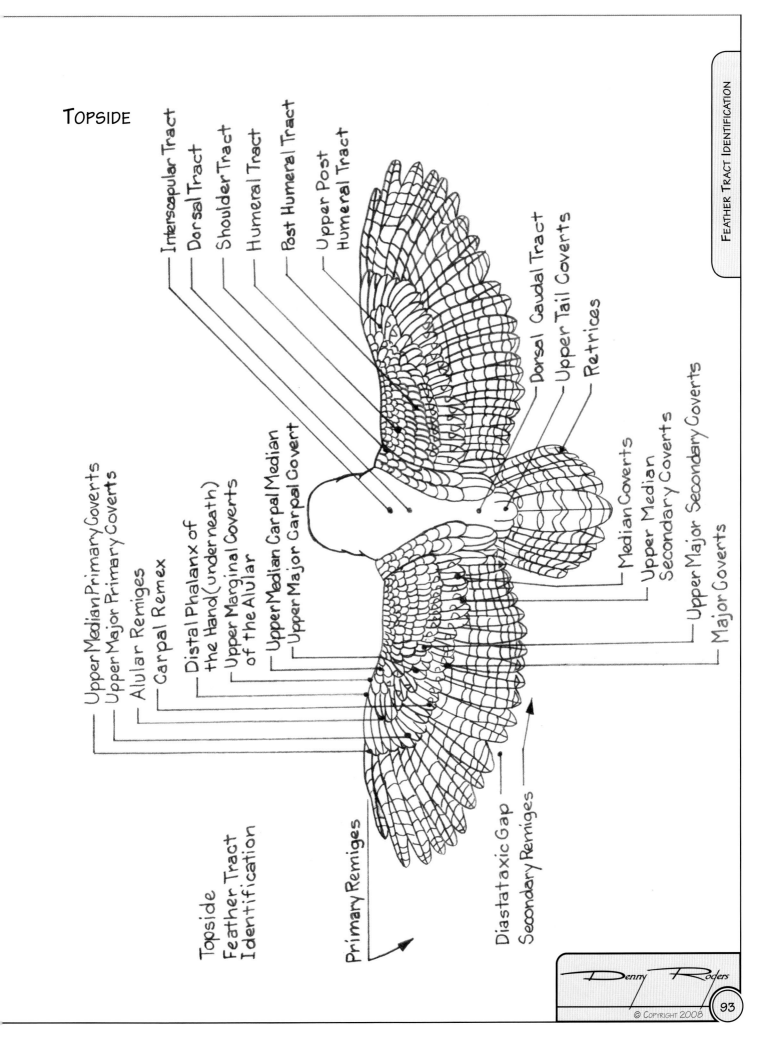

TOPSIDE

Intrascapular Tract
Dorsal Tract
Shoulder Tract
Humeral Tract
Post Humeral Tract
Upper Post Humeral Tract

Dorsal Caudal Tract
Upper Tail Coverts
Retrices

Upper Median Primary Coverts
Upper Major Primary Coverts
Alular Remiges
Carpal Remex

Distal Phalanx of the Hand (underneath)
Upper Marginal Coverts of the Alular
Upper Median Carpal Median
Upper Major Carpal Covert

Median Coverts
Upper Median Secondary Coverts
Upper Major Secondary Coverts
Major Coverts

Topside
Feather Tract Identification

Primary Remiges

Diastataxic Gap
Secondary Remiges

Denny Rogers
© COPYRIGHT 2008

Head is chocolate brown and off white barring. Face is off white buff with light brown enhancement rings.

Lower abdomen is vertical spears.
Under tail is offwhite/yellowish down.

Legs are yellowish white and buff.

All underwing secondary feather group is off white with a yellowish cast.

Neck and chest, down to ribcage, is dark chocolate brown and offwhite barring.

All primary, secondary, and tail retrices are the same. Stripes are dark chocolate brown. The light stripes are offwhite, or eggshell. All feather's light areas have a light brown cast toward the ends.

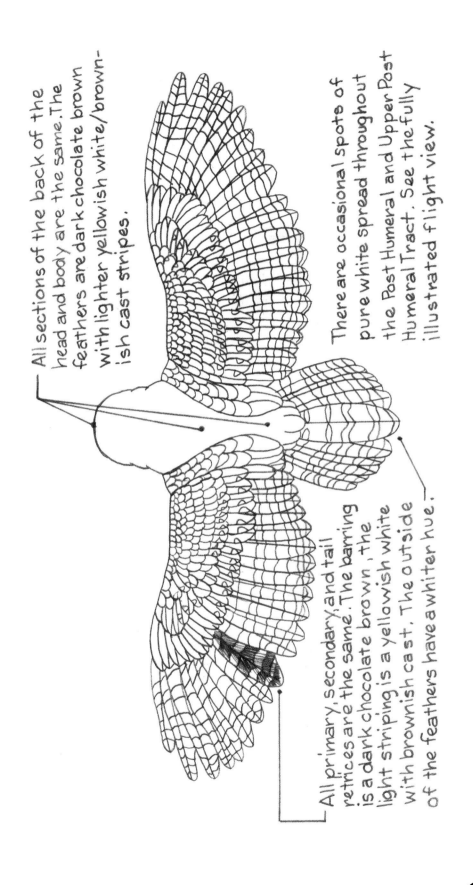

All sections of the back of the head and body are the same. The feathers are dark chocolate brown with lighter yellowish white/brownish cast stripes.

There are occasional spots of pure white spread throughout the Post Humeral and Upper Post Humeral Tract. See the fully illustrated flight view.

All primary, secondary, and tail retrices are the same. The barring is a dark chocolate brown, the light striping is a yellowish white with brownish cast. The outside of the feathers have a whiter hue.

© COPYRIGHT 2008

TO MATCH THE DIMENSION ON PAGES 90 AND 91, ENLARGE TO 310%. HOWEVER, AS DESCRIBED ON PAGE 84, WINGSPANS CAN VARY FROM 45 TO 50 INCHES. A SIMPLE STEP TO ENLARGE THIS PATTERN FOR EXACT MEASUREMENTS WOULD BE TO TAKE THE BOOK TO A LOCAL COPY SHOP, CREATE A PHOTOCOPY OF PAGES 96 AND 97, CUT APART, TAPE THE BODY TOGETHER, ASSIGN THE ENLARGED PERCENTAGE, AND RUN A LIFE-SIZE COPY TO THE DESIRED WINGSPAN FOR YOUR PROJECT. ALL DIMENSIONS WILL ENLARGE PROPORTIONATELY ON AN ENGINEERING PRINT MACHINE.

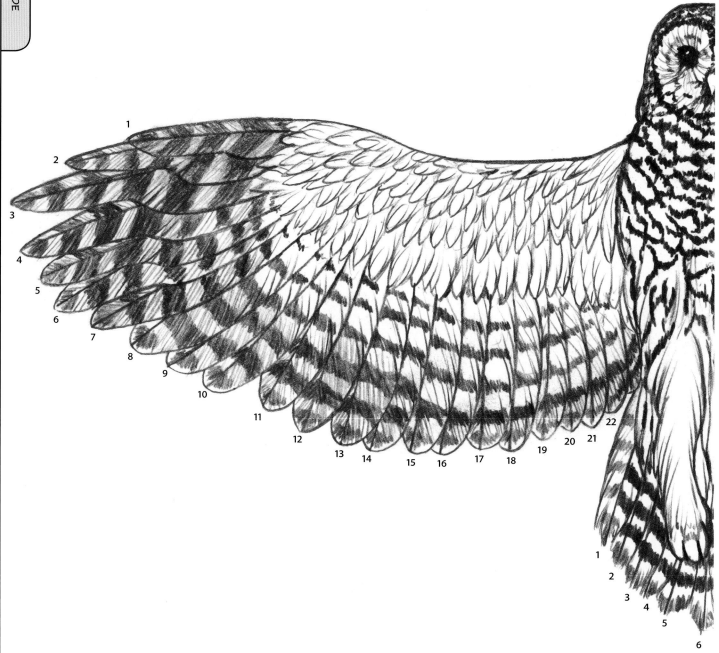

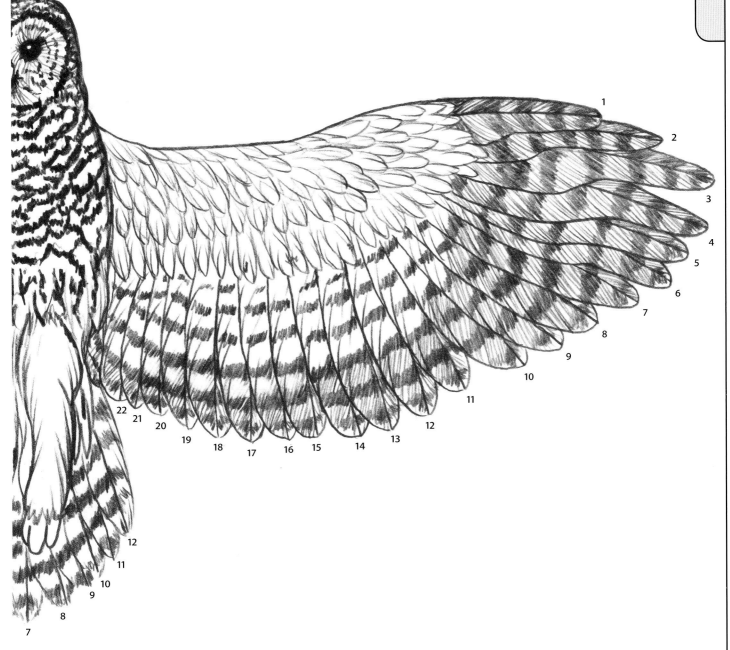

1
2
3
4
5
6
7
8
9
10
11
12
13
14
15
16
17
18
19
20
21
22

7
8
9
10
11
12

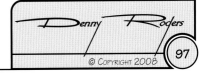

Denny Roders

97

© Copyright 2008

TO MATCH THE DIMENSION ON PAGES 90 AND 91, ENLARGE TO 310%. HOWEVER, AS DESCRIBED ON PAGE 84, WINGSPANS CAN VARY FROM 45 TO 50 INCHES. A SIMPLE STEP TO ENLARGE THIS PATTERN FOR EXACT MEASUREMENTS WOULD BE TO TAKE THE BOOK TO A LOCAL COPY SHOP, CREATE A PHOTOCOPY OF PAGES 98 AND 99, CUT APART, TAPE THE BODY TOGETHER, ASSIGN THE ENLARGED PERCENTAGE, AND RUN A LIFE-SIZE COPY TO THE DESIRED WINGSPAN FOR YOUR PROJECT. ALL DIMENSIONS WILL ENLARGE PROPORTIONATELY ON AN ENGINEERING PRINT MACHINE.

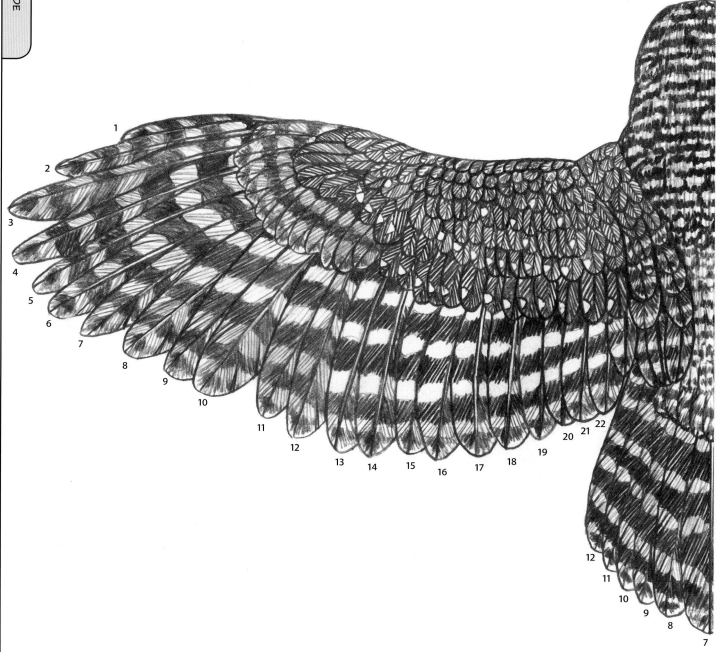

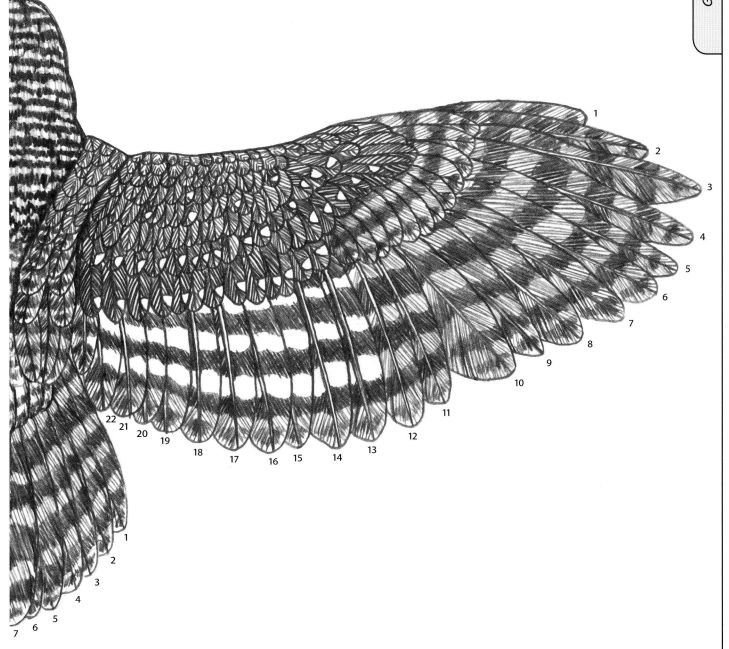

© COPYRIGHT 2008

Topside/ Right Wing

Underside/ Left Wing

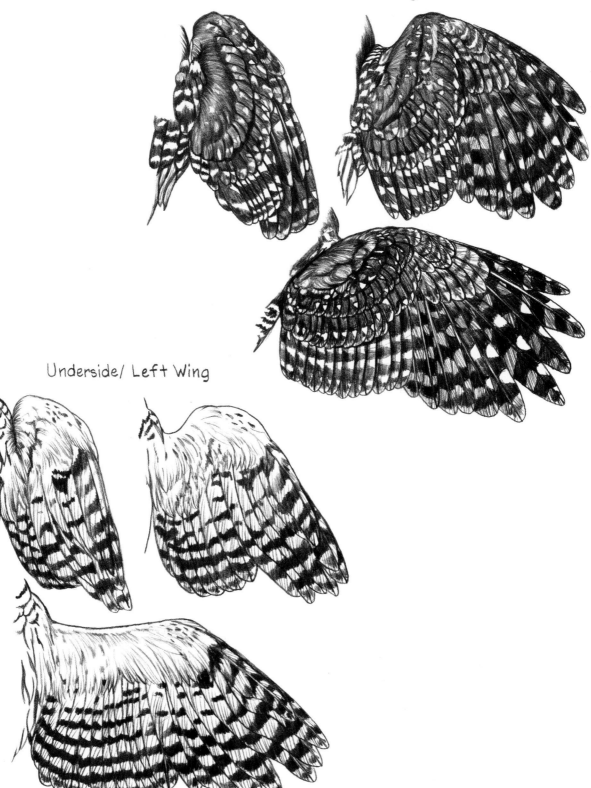

TOPSIDE

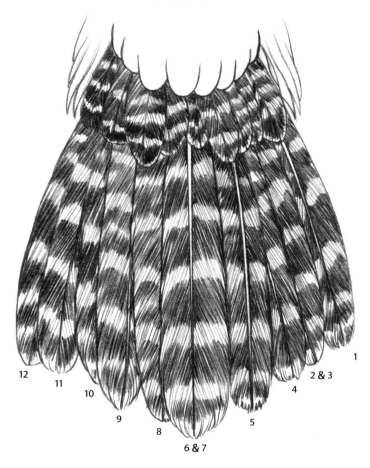

12 11 10 9 8 6 & 7 5 4 2 & 3 1

UNDERSIDE

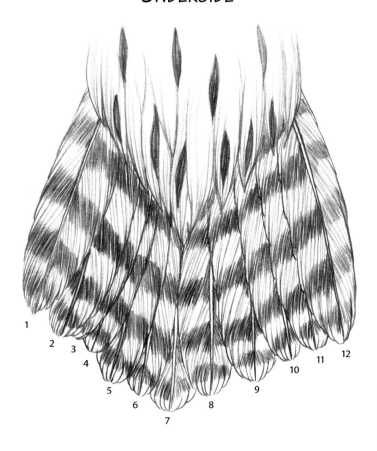

1 2 3 4 5 6 7 8 9 10 11 12

Denny Rogers

© COPYRIGHT 2008

Tail / Underside

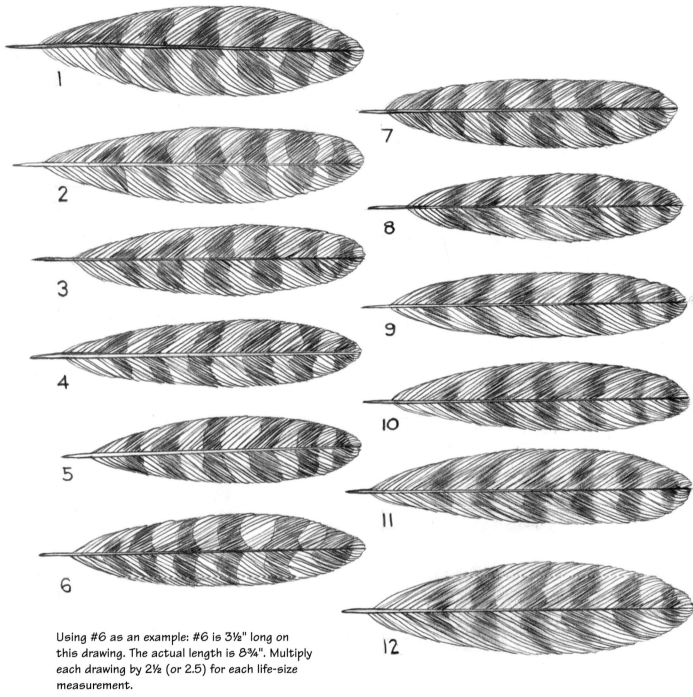

Using #6 as an example: #6 is 3½" long on this drawing. The actual length is 8¾". Multiply each drawing by 2½ (or 2.5) for each life-size measurement.

Sample: 2½ x 3½" = 8¾"

Or in decimals:
```
    3.5
  x 2.5
   1.75
 +7.00
   8.75
```

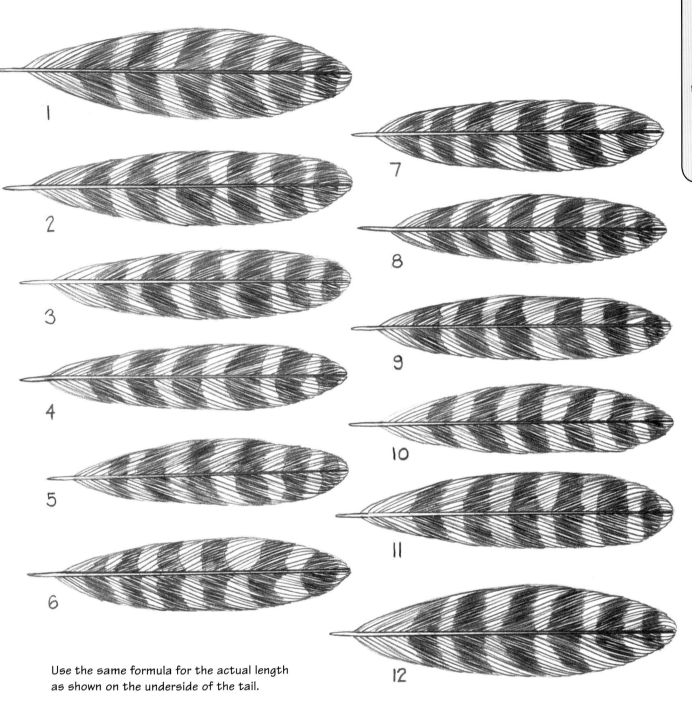

Use the same formula for the actual length
as shown on the underside of the tail.

Denny Roders

© Copyright 2008

RIGHT WING / UNDERSIDE

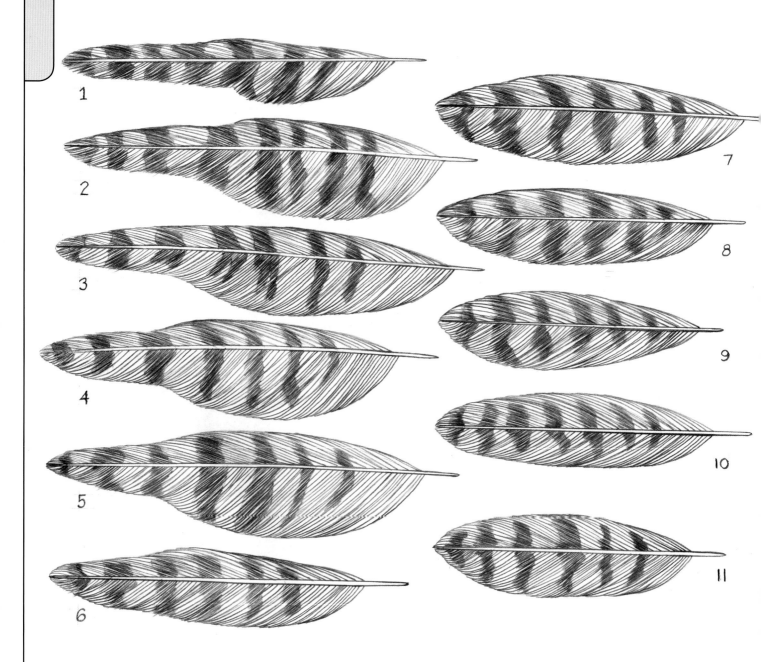

1

2

3

4

5

6

7

8

9

10

11

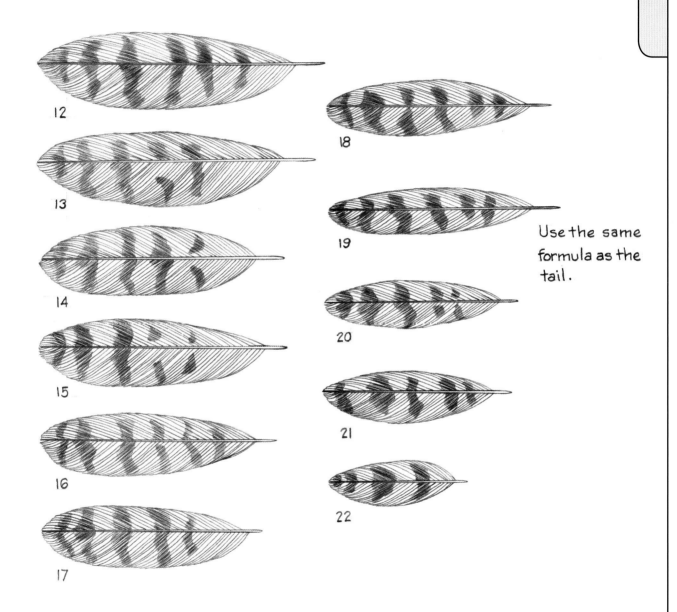

12

13

14

15

16

17

18

19

Use the same
formula as the
tail.

20

21

22

© COPYRIGHT 2008

LEFT WING / UNDERSIDE

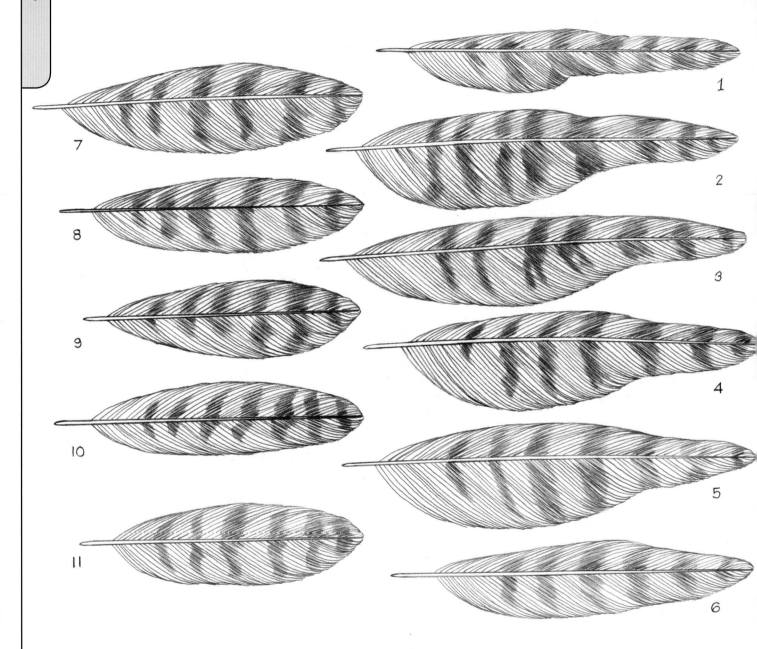

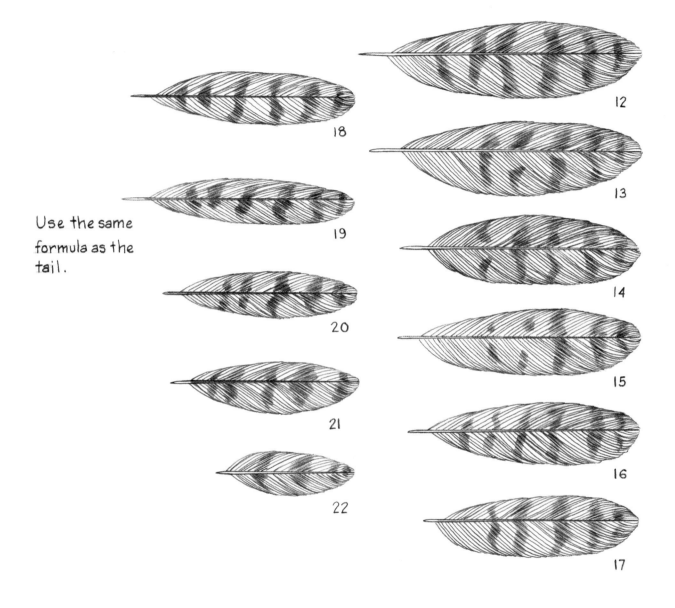

Use the same
formula as the
tail.

18

19

20

21

22

12

13

14

15

16

17

RIGHT WING / TOPSIDE

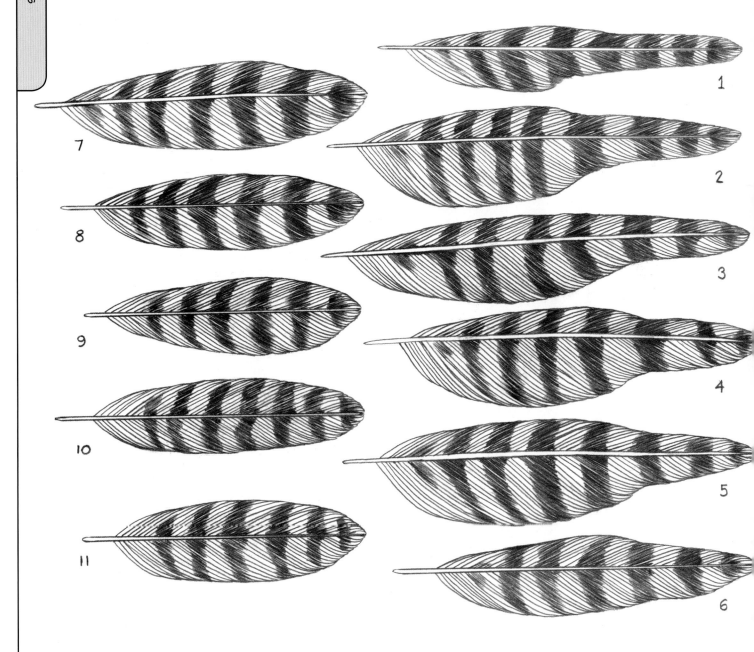

7

8

9

10

11

1

2

3

4

5

6

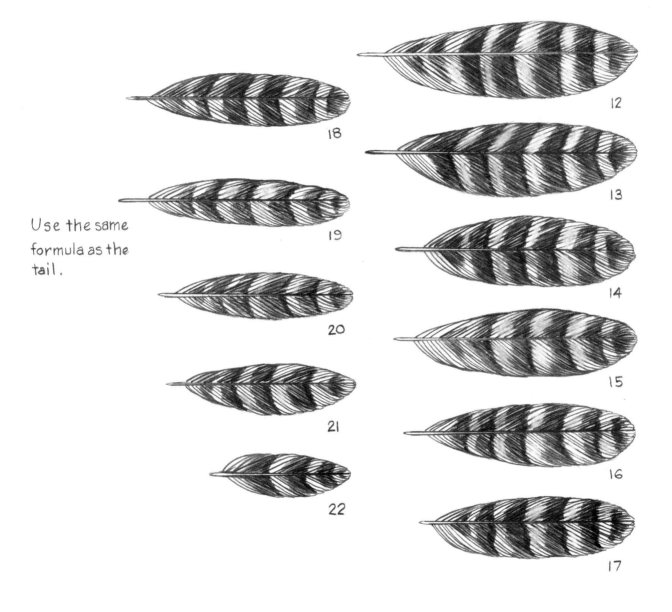

Use the same
formula as the
tail.

© COPYRIGHT 2008

Denny Rodgers

LEFT WING / TOPSIDE

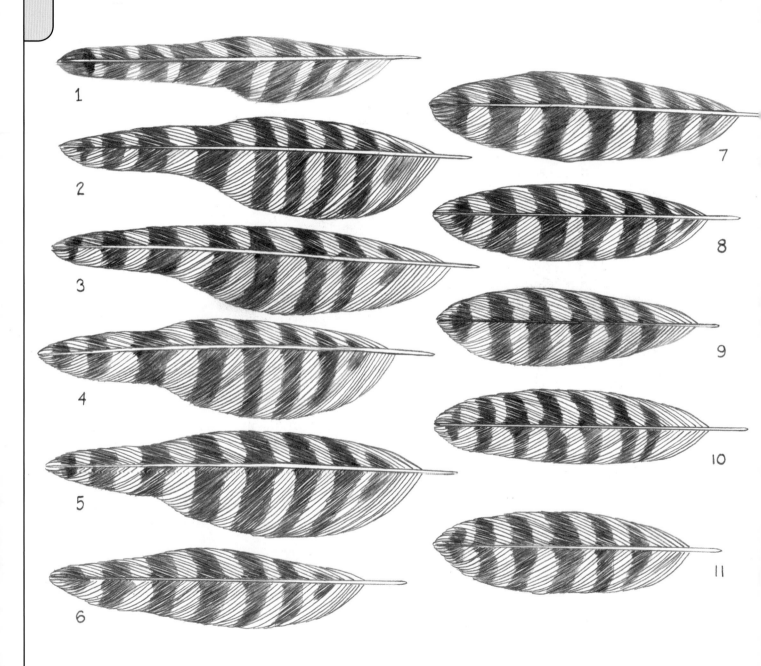

1

2

3

4

5

6

7

8

9

10

11

LEFT WING / TOPSIDE

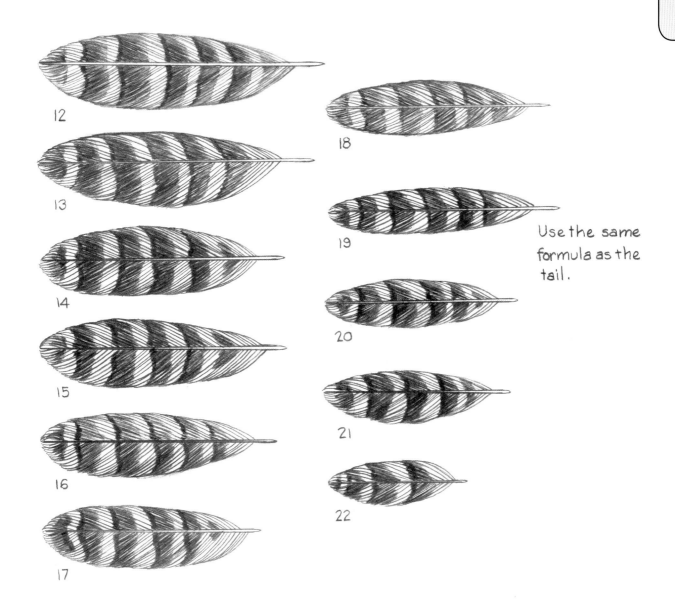

12

13

14

15

16

17

18

19

20

21

22

Use the same formula as the tail.

Denny Rogers

© COPYRIGHT 2008

Barred Owl Measurement Chart

Each measurement on this chart is coded from A to PPP. These letters correspond with the measurements on pages 86-87 and 89-91. Also listed are nine additional scales that show each measurement reduced proportionately so that patterns can be laid out in any size. The scales contain decimal equivalents.

	Full Scale	9/10 Scale	4/5 Scale	7/10 Scale	3/5 Scale	1/2 Scale	2/5 Scale	3/10 Scale	1/5 Scale	1/10 Scale
A	46.00	41.40	36.80	32.20	27.60	23.00	18.40	13.80	9.20	4.60
B	15.50	13.95	12.40	10.85	9.30	7.75	6.20	4.65	3.10	1.55
C	8.00	7.20	6.40	5.60	4.80	4.00	3.20	2.40	1.60	0.80
D	4.25	3.83	3.40	2.98	2.55	2.13	1.70	1.28	0.85	0.43
E	3.00	2.70	2.40	2.10	1.80	1.50	1.20	0.90	0.60	0.30
F	5.00	4.50	4.00	3.50	3.00	2.50	2.00	1.50	1.00	0.50
G	2.50	2.25	2.00	1.75	1.50	1.25	1.00	0.75	0.50	0.25
H	6.00	5.40	4.80	4.20	3.60	3.00	2.40	1.80	1.20	0.60
I	3.00	2.70	2.40	2.10	1.80	1.50	1.20	0.90	0.60	0.30
J	4.50	4.05	3.60	3.15	2.70	2.25	1.80	1.35	0.90	0.45
K	4.50	4.05	3.60	3.15	2.70	2.25	1.80	1.35	0.90	0.45
L	9.25	8.33	7.40	6.48	5.55	4.63	3.70	2.78	1.85	0.93
M	7.00	6.30	5.60	4.90	4.20	3.50	2.80	2.10	1.40	0.70
N	8.50	7.65	6.80	5.95	5.10	4.25	3.40	2.55	1.70	0.85
O	10.75	9.68	8.60	7.53	6.45	5.38	4.30	3.23	2.15	1.08
P	16.50	14.85	13.20	11.55	9.90	8.25	6.60	4.95	3.30	1.65
Q	7.75	6.98	6.20	5.43	4.65	3.88	3.10	2.33	1.55	0.78
R	6.00	5.40	4.80	4.20	3.60	3.00	2.40	1.80	1.20	0.60
S	4.25	3.83	3.40	2.98	2.55	2.13	1.70	1.28	0.85	0.43
T	8.50	7.65	6.80	5.95	5.10	4.25	3.40	2.55	1.70	0.85
U	5.50	4.95	4.40	3.85	3.30	2.75	2.20	1.65	1.10	0.55
V	7.00	6.30	5.60	4.90	4.20	3.50	2.80	2.10	1.40	0.70
W	4.25	3.83	3.40	2.98	2.55	2.13	1.70	1.28	0.85	0.43
X	4.00	3.60	3.20	2.80	2.40	2.00	1.60	1.20	0.80	0.40
Y	9.00	8.10	7.20	6.30	5.40	4.50	3.60	2.70	1.80	0.90
Z	28.75	25.88	23.00	20.13	17.25	14.38	11.50	8.63	5.75	2.88
AA	1.50	1.35	1.20	1.05	0.90	0.75	0.60	0.45	0.30	0.15
BB	3.50	3.15	2.80	2.45	2.10	1.75	1.40	1.05	0.70	0.35
CC	4.00	3.60	3.20	2.80	2.40	2.00	1.60	1.20	0.80	0.40
DD	19.00	17.10	15.20	13.30	11.40	9.50	7.60	5.70	3.80	1.90
EE	7.50	6.75	6.00	5.25	4.50	3.75	3.00	2.25	1.50	0.75
FF	4.50	4.05	3.60	3.15	2.70	2.25	1.80	1.35	0.90	0.45
GG	2.00	1.80	1.60	1.40	1.20	1.00	0.80	0.60	0.40	0.20
HH	3.00	2.70	2.40	2.10	1.80	1.50	1.20	0.90	0.60	0.30

	Full Scale	9/10 Scale	4/5 Scale	7/10 Scale	3/5 Scale	1/2 Scale	2/5 Scale	3/10 Scale	1/5 Scale	1/10 Scale
II	11.75	10.58	9.40	8.23	7.05	5.88	4.70	3.53	2.35	1.18
JJ	16.50	14.85	13.20	11.55	9.90	8.25	6.60	4.95	3.30	1.65
KK	0.38	0.34	0.30	0.27	0.23	0.19	0.15	0.11	0.08	0.04
LL	0.20	0.18	0.16	0.14	0.12	0.10	0.08	0.06	0.04	0.02
MM	3.25	2.93	2.60	2.28	1.95	1.63	1.30	0.98	0.65	0.33
NN	2.87	2.58	2.30	2.01	1.72	1.44	1.15	0.86	0.57	0.29
OO	0.20	0.18	0.16	0.14	0.12	0.10	0.08	0.06	0.04	0.02
PP	0.38	0.34	0.30	0.27	0.23	0.19	0.15	0.11	0.08	0.04
QQ	1.75	1.58	1.40	1.23	1.05	0.88	0.70	0.53	0.35	0.18
RR	2.18	1.96	1.74	1.53	1.31	1.09	0.87	0.65	0.44	0.22
SS	0.38	0.34	0.30	0.27	0.23	0.19	0.15	0.11	0.08	0.04
TT	0.20	0.18	0.16	0.14	0.12	0.10	0.08	0.06	0.04	0.02
UU	4.00	3.60	3.20	2.80	2.40	2.00	1.60	1.20	0.80	0.40
VV	3.75	3.38	3.00	2.63	2.25	1.88	1.50	1.13	0.75	0.38
WW	3.25	2.93	2.60	2.28	1.95	1.63	1.30	0.98	0.65	0.33
XX	0.25	0.23	0.20	0.18	0.15	0.13	0.10	0.08	0.05	0.03
YY	0.12	0.11	0.10	0.08	0.07	0.06	0.05	0.04	0.02	0.01
ZZ	3.12	2.81	2.50	2.18	1.87	1.56	1.25	0.94	0.62	0.31
AAA	4.00	3.60	3.20	2.80	2.40	2.00	1.60	1.20	0.80	0.40
BBB	7.00	6.30	5.60	4.90	4.20	3.50	2.80	2.10	1.40	0.70
CCC	11.00	9.90	8.80	7.70	6.60	5.50	4.40	3.30	2.20	1.10
DDD	9.00	8.10	7.20	6.30	5.40	4.50	3.60	2.70	1.80	0.90
EEE	5.00	4.50	4.00	3.50	3.00	2.50	2.00	1.50	1.00	0.50
FFF	21.00	18.90	16.80	14.70	12.60	10.50	8.40	6.30	4.20	2.10
GGG	15.00	13.50	12.00	10.50	9.00	7.50	6.00	4.50	3.00	1.50
HHH	0.18	0.16	0.14	0.13	0.11	0.09	0.07	0.05	0.04	0.02
III	0.50	0.45	0.40	0.35	0.30	0.25	0.20	0.15	0.10	0.05
JJJ	1.25	1.13	1.00	0.88	0.75	0.63	0.50	0.38	0.25	0.13
KKK	0.87	0.78	0.70	0.61	0.52	0.44	0.35	0.26	0.17	0.09
LLL	1.00	0.90	0.80	0.70	0.60	0.50	0.40	0.30	0.20	0.10
MMM	0.25	0.23	0.20	0.18	0.15	0.13	0.10	0.08	0.05	0.03
NNN	0.87	0.78	0.70	0.61	0.52	0.44	0.35	0.26	0.17	0.09
OOO	0.25	0.23	0.20	0.18	0.15	0.13	0.10	0.08	0.05	0.03
PPP	0.62	0.56	0.50	0.43	0.37	0.31	0.25	0.19	0.12	0.06

© Copyright 2008

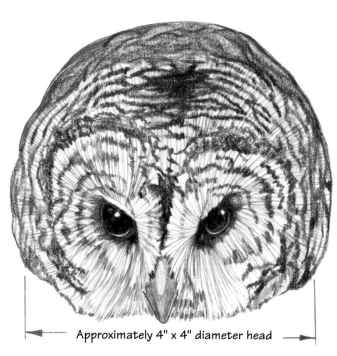

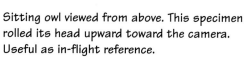

Approximately 4" x 4" diameter head

Sitting owl viewed from above. This specimen rolled its head upward toward the camera. Useful as in-flight reference.

Top of head—looking downward—in a sitting position. Darker outlined area is the back, shoulder, and wing contour.

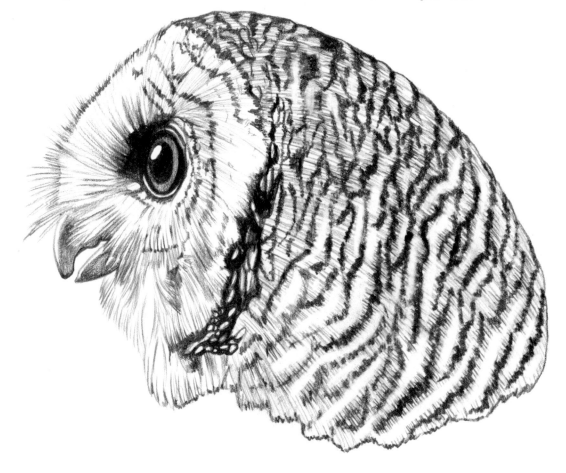

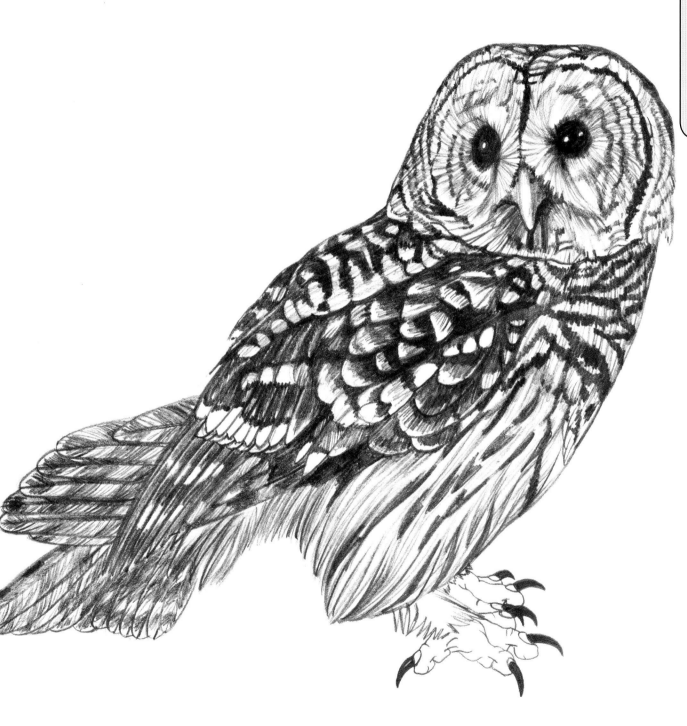

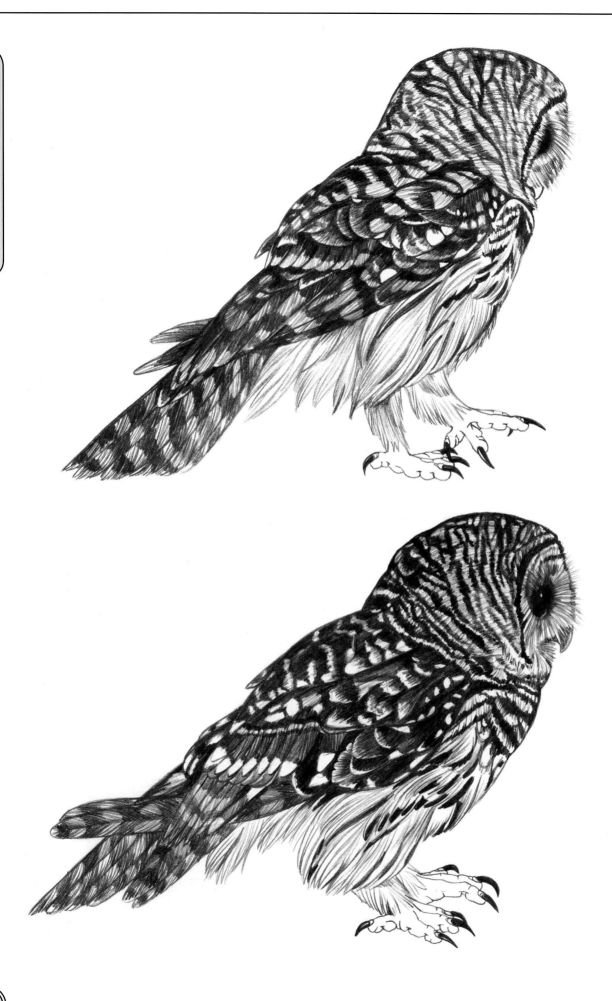

Denny Rogers

© Copyright 2008

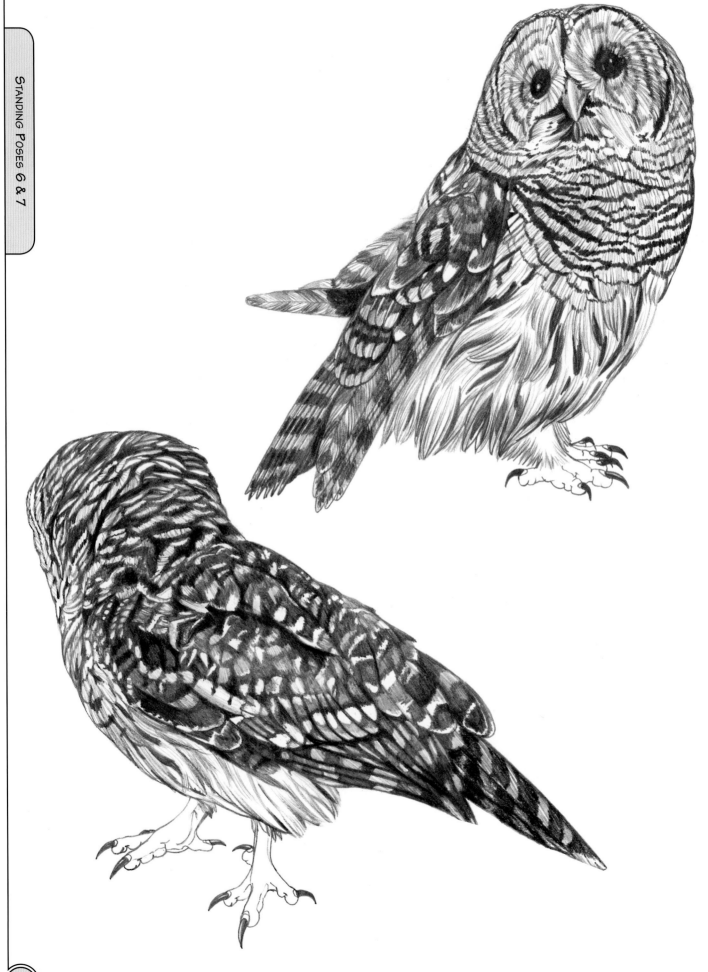

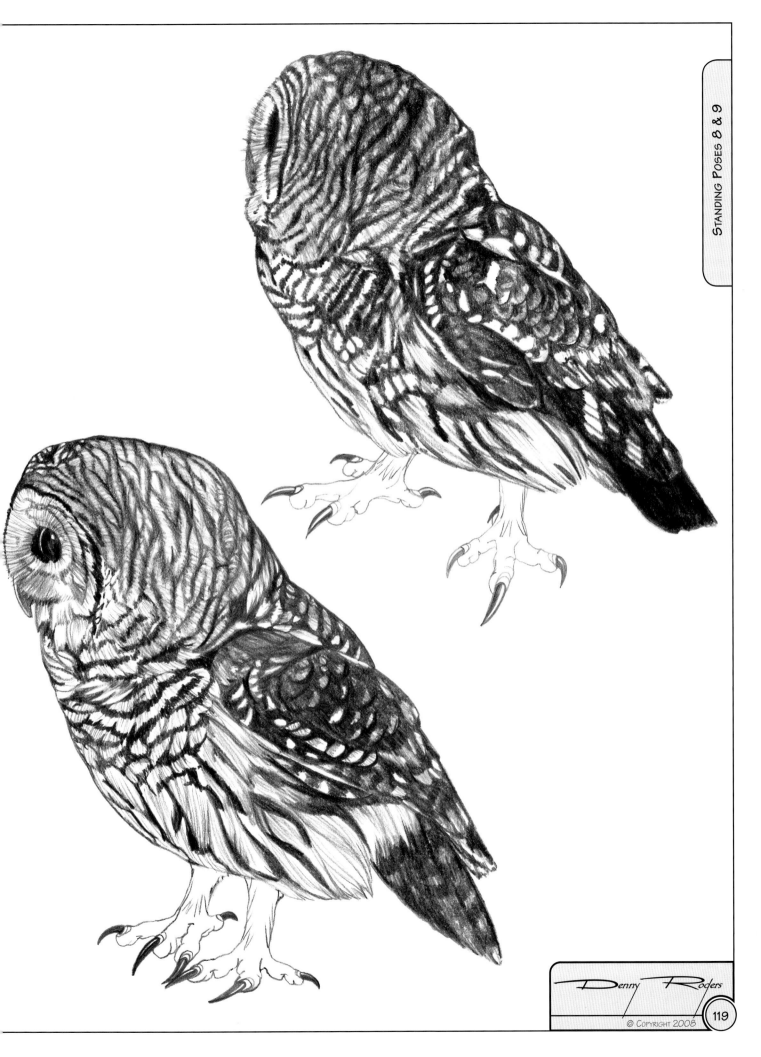

Denny Rogers
© Copyright 2008

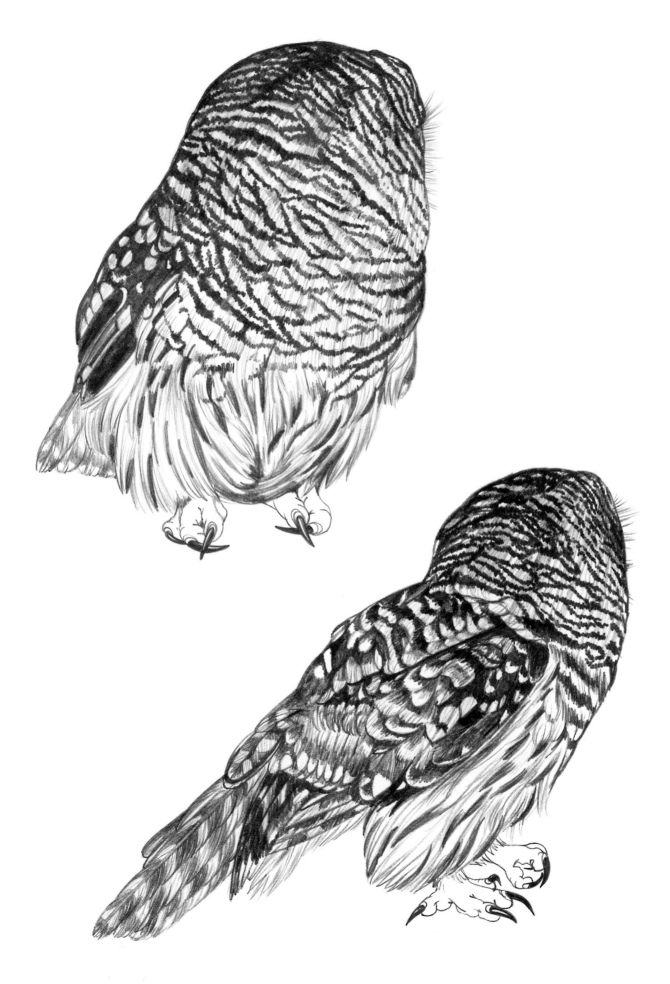

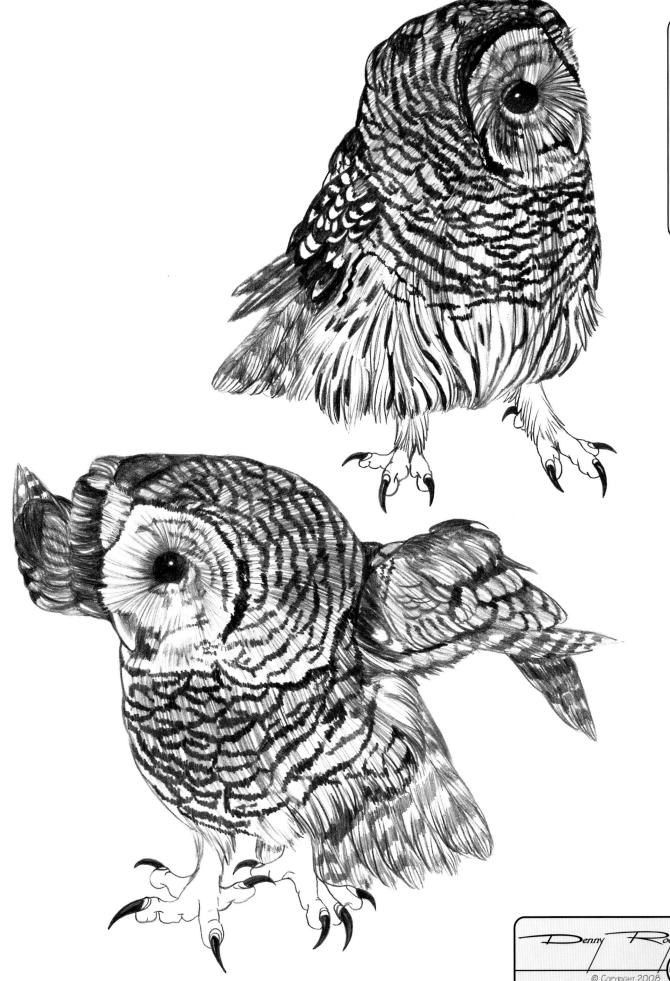

Denny Rogers

© COPYRIGHT 2008

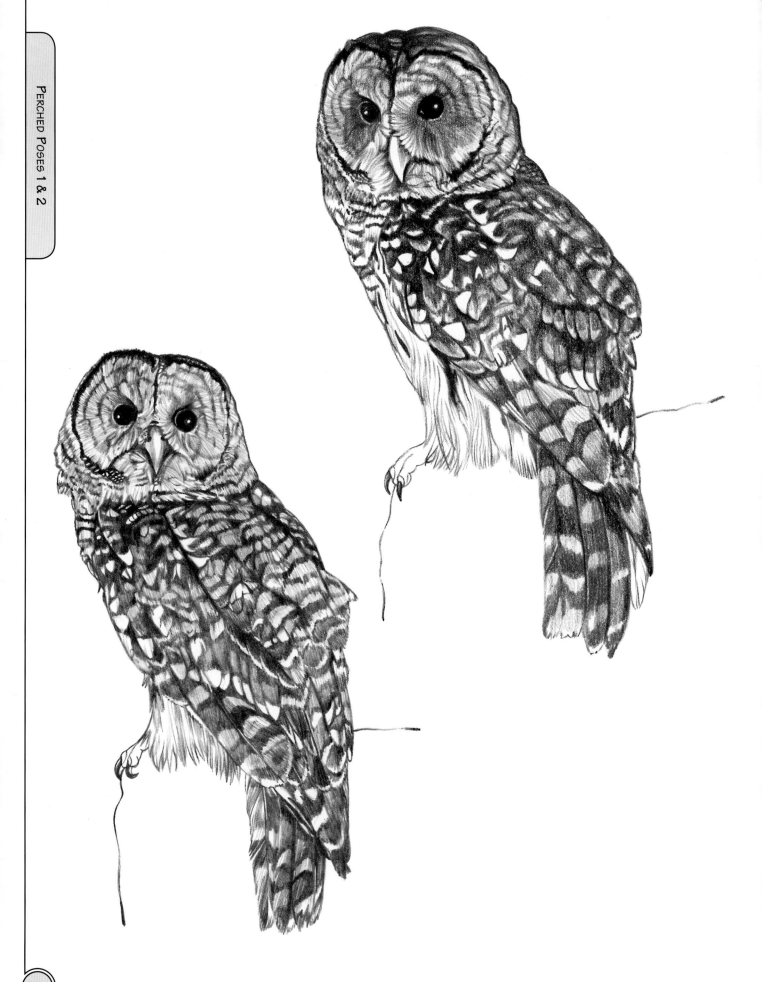

Denny Rogers

© COPYRIGHT 2008

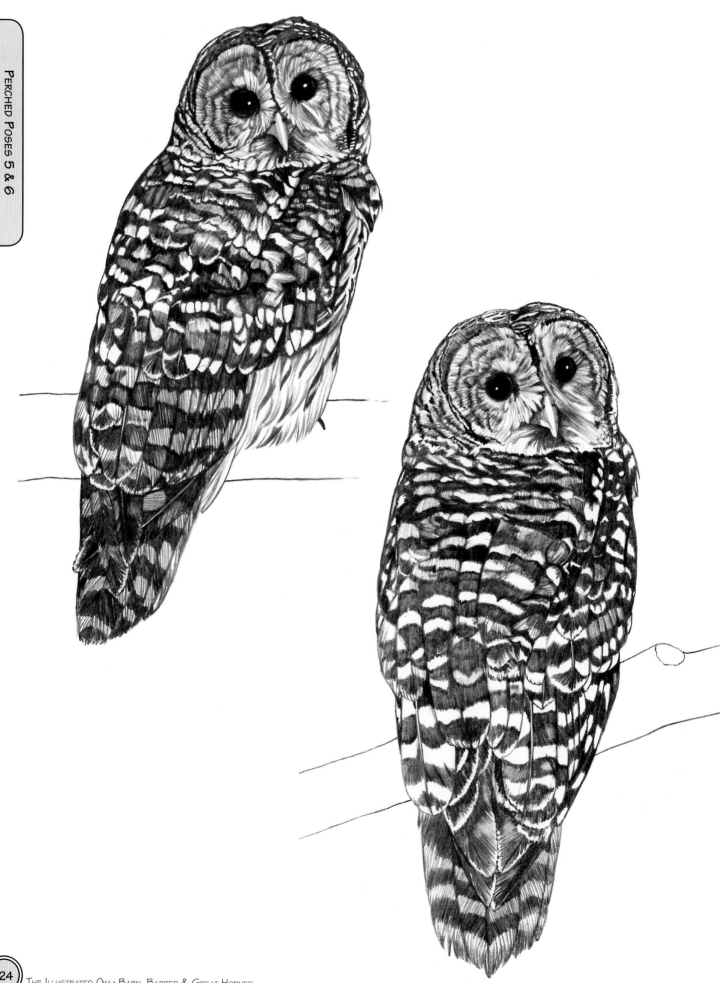

© COPYRIGHT 2008

Denny Rogers

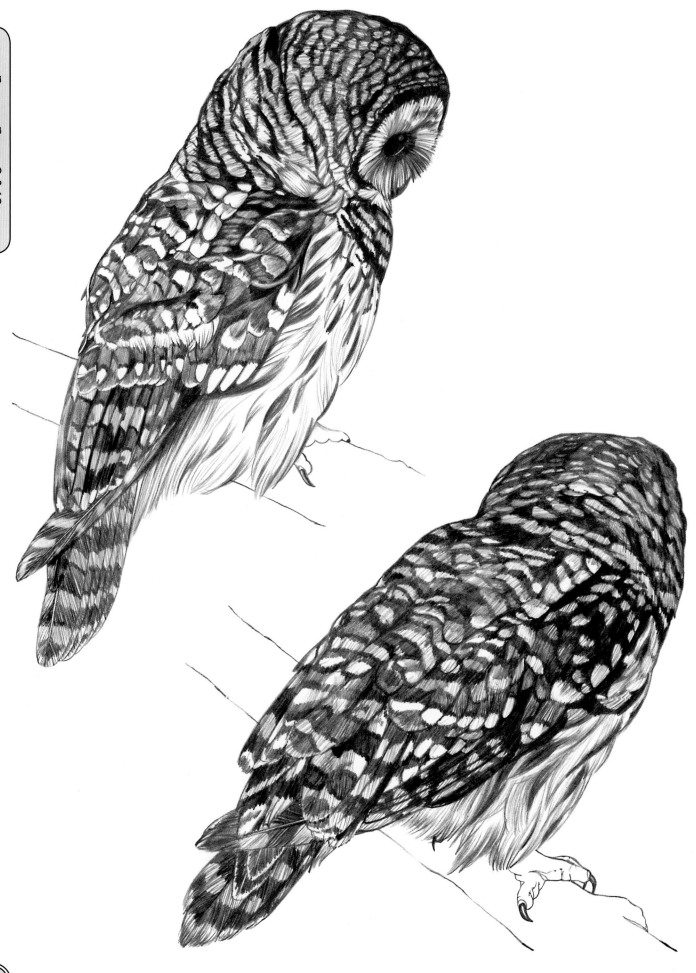

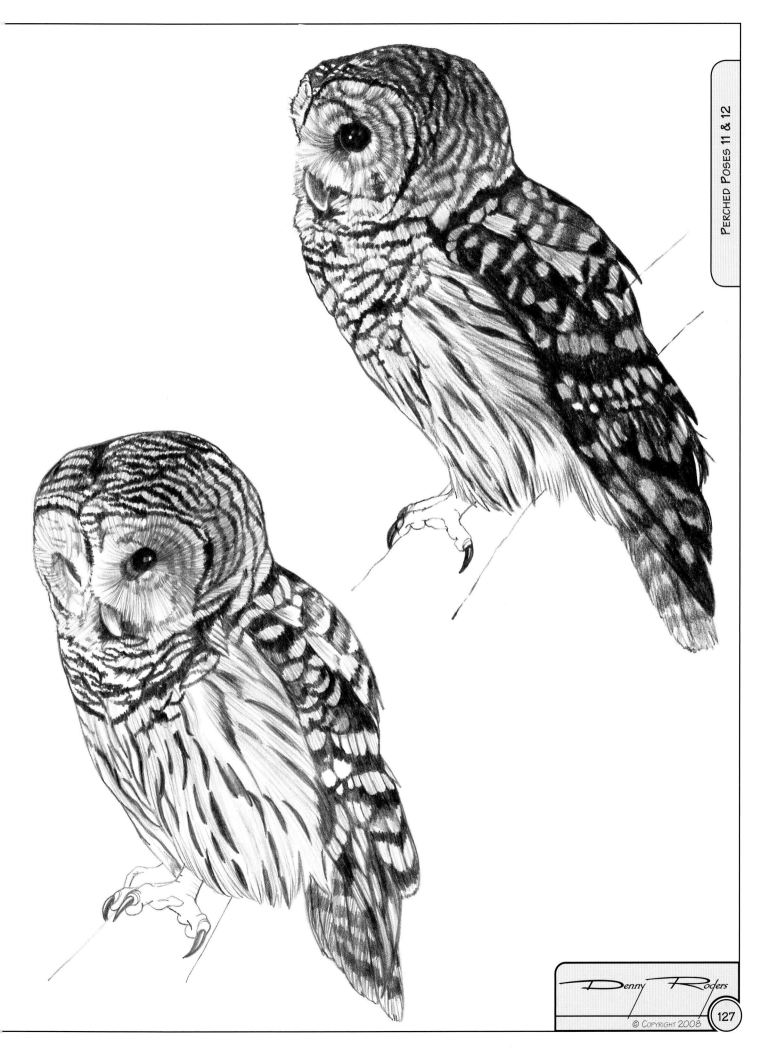

Denny Rogers

© COPYRIGHT 2008

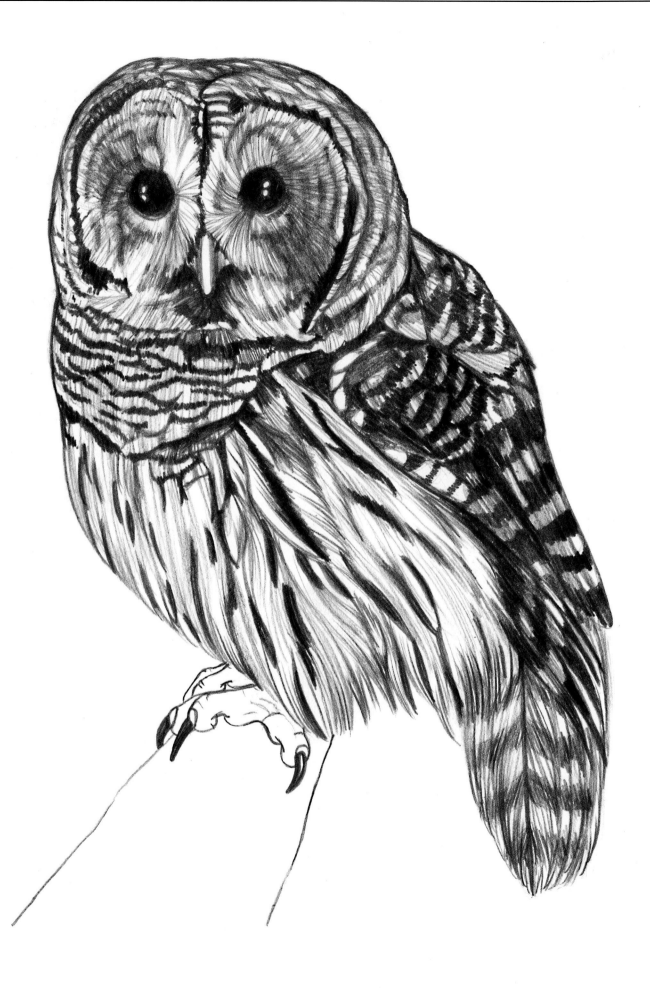

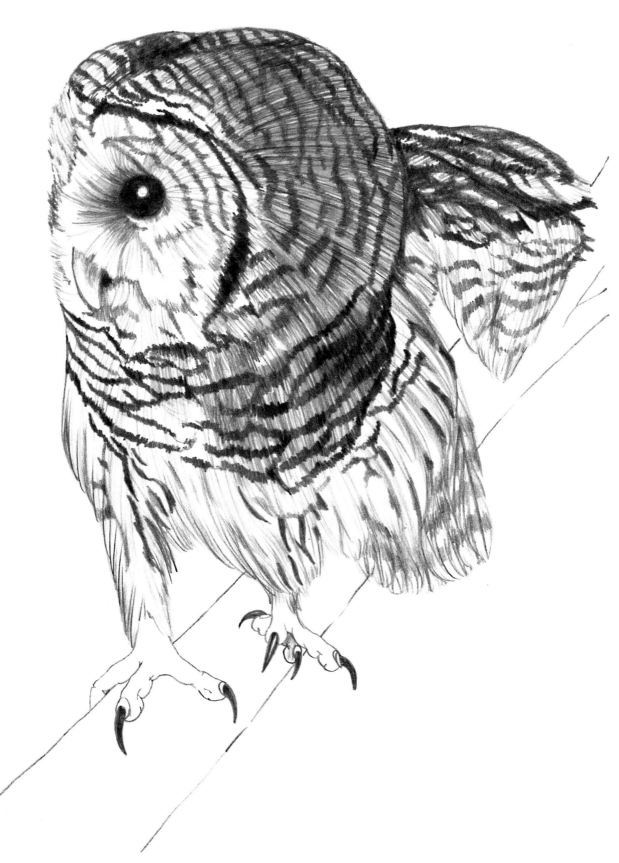

Denny Rogers

© COPYRIGHT 2008

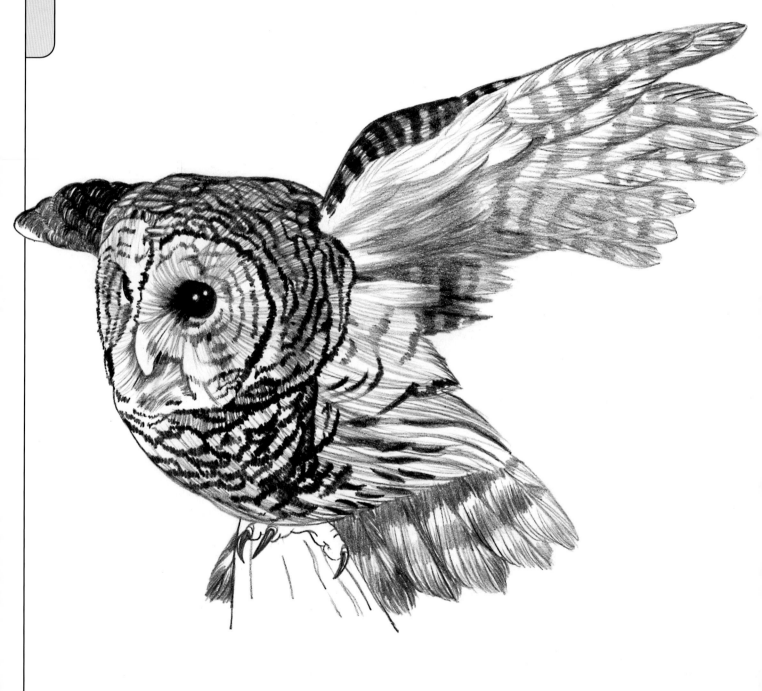

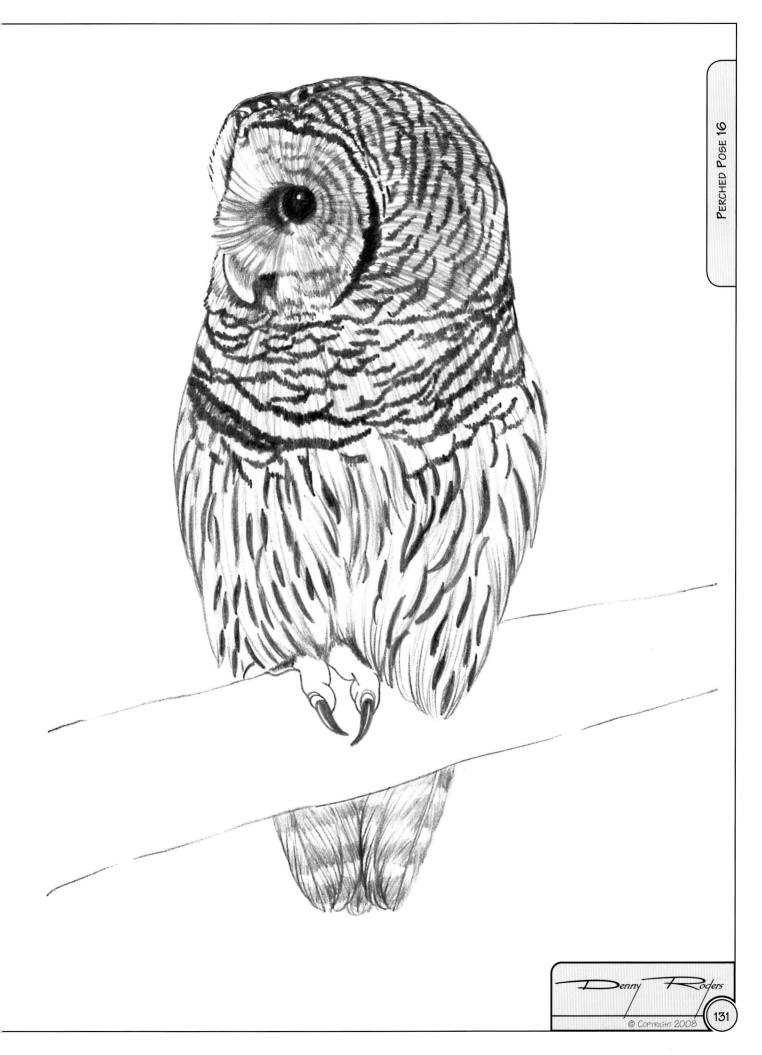

Denny Roders
© COPYRIGHT 2008

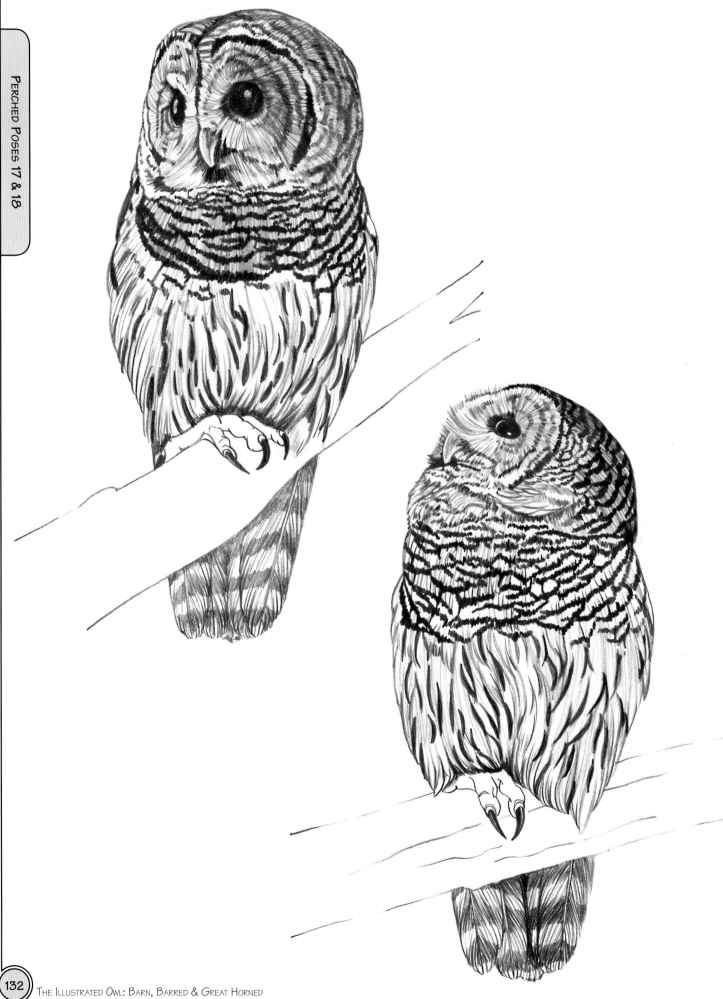

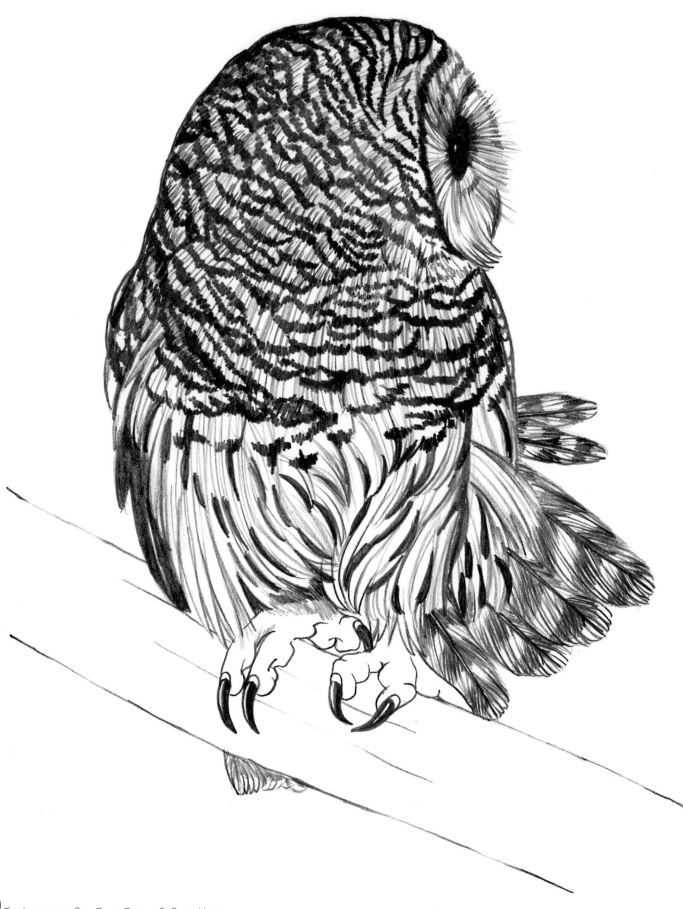

Denny Rogers

© Copyright 2008

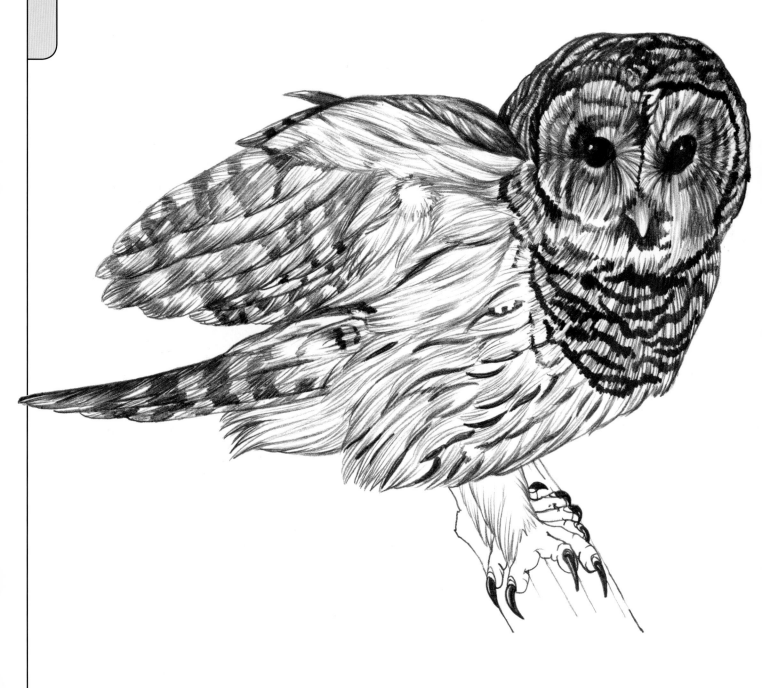

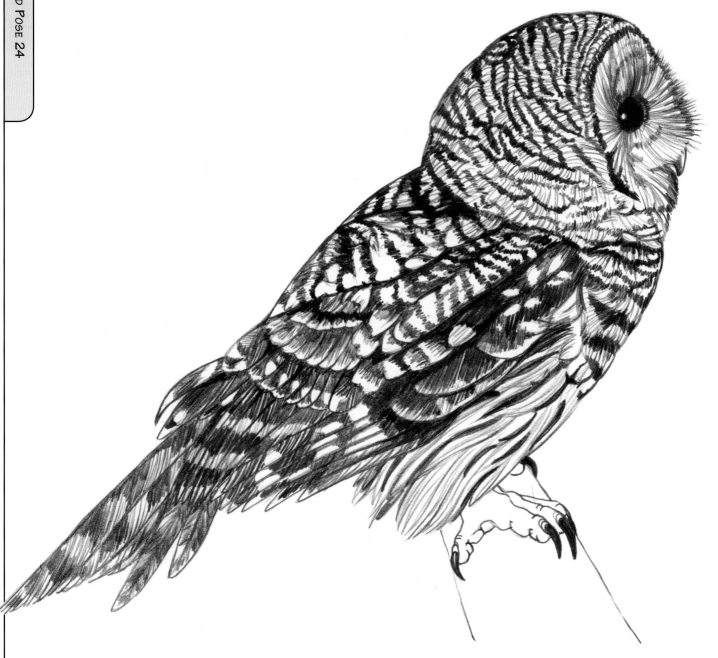

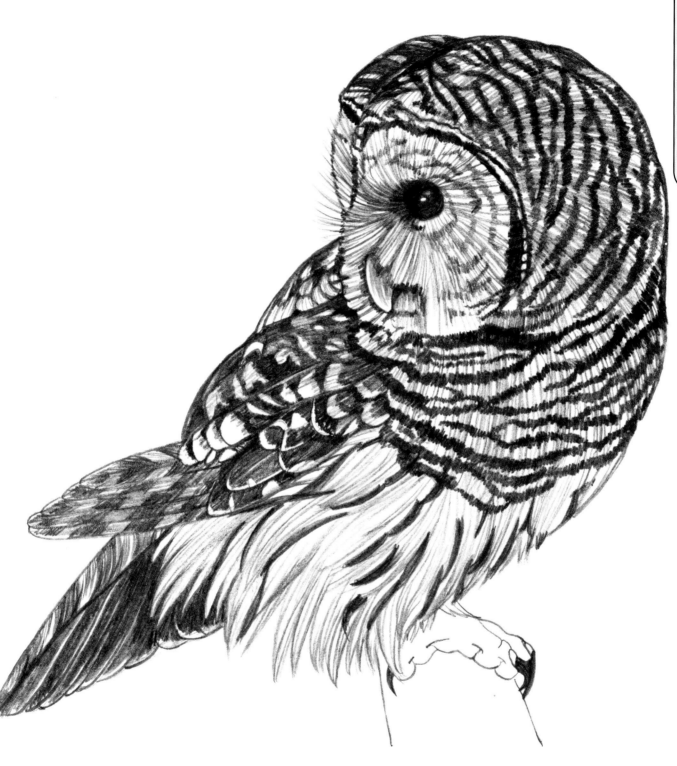

Denny Roders

© COPYRIGHT 2008

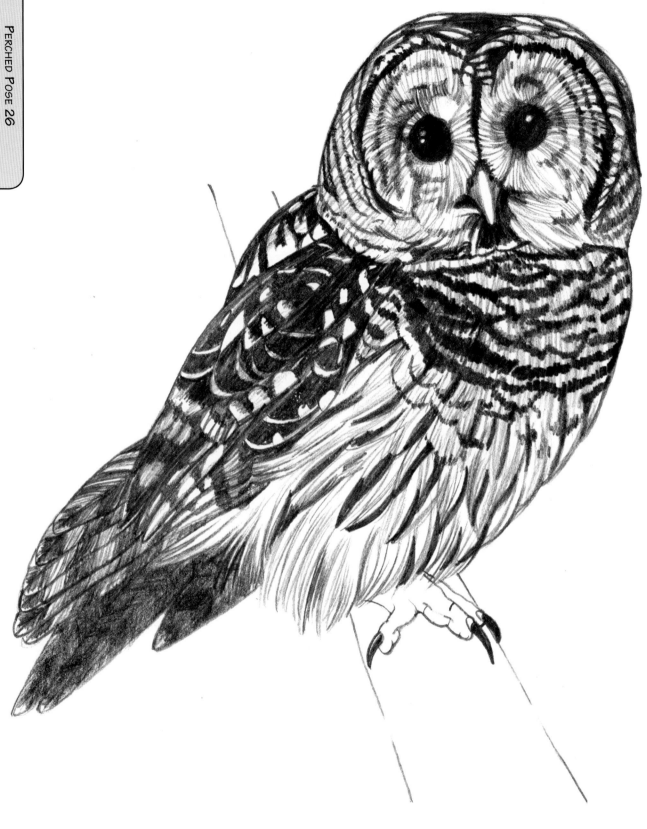

Denny Rogers

© Copyright 2008

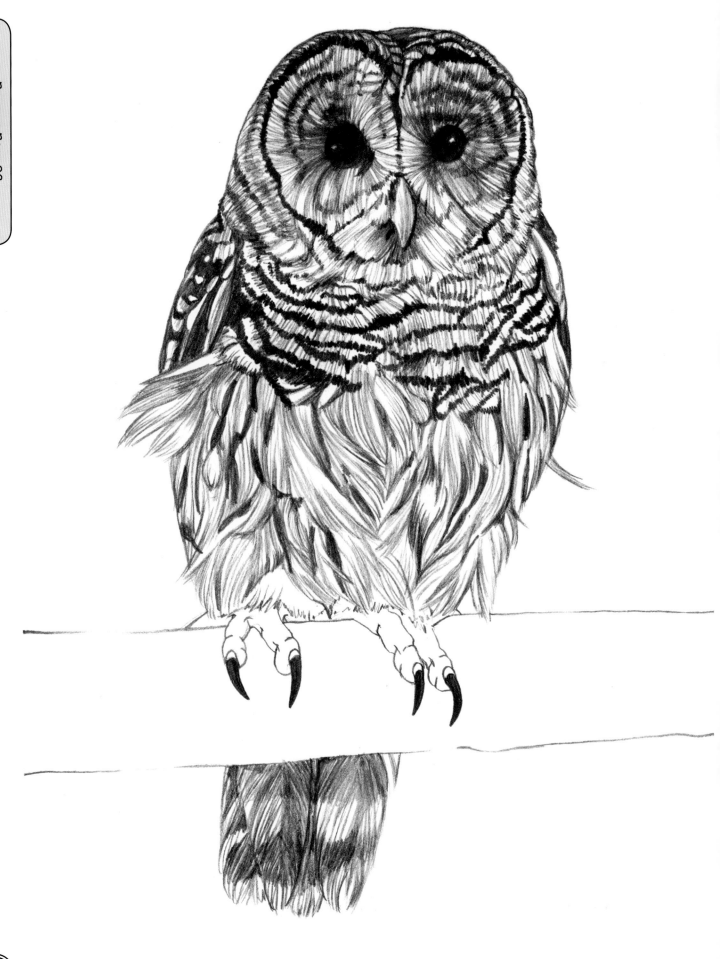

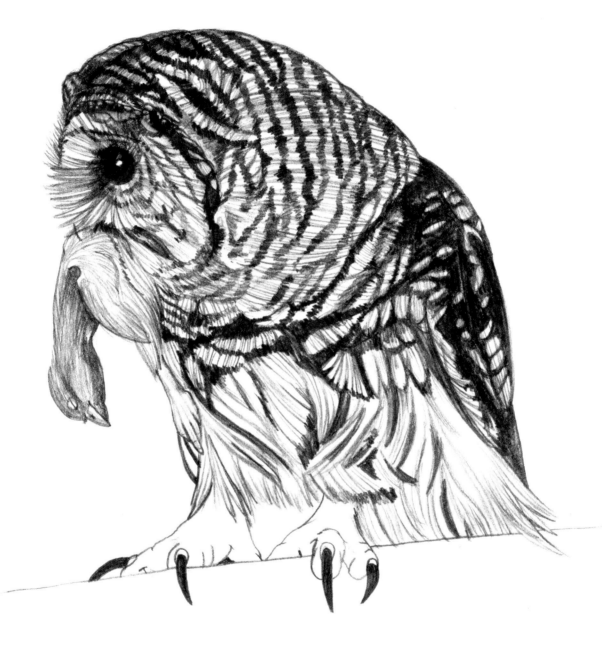

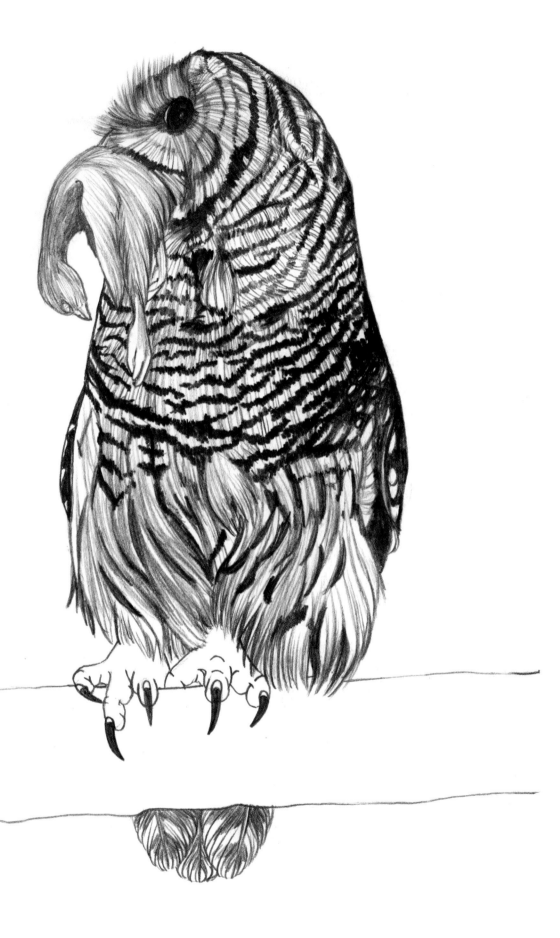

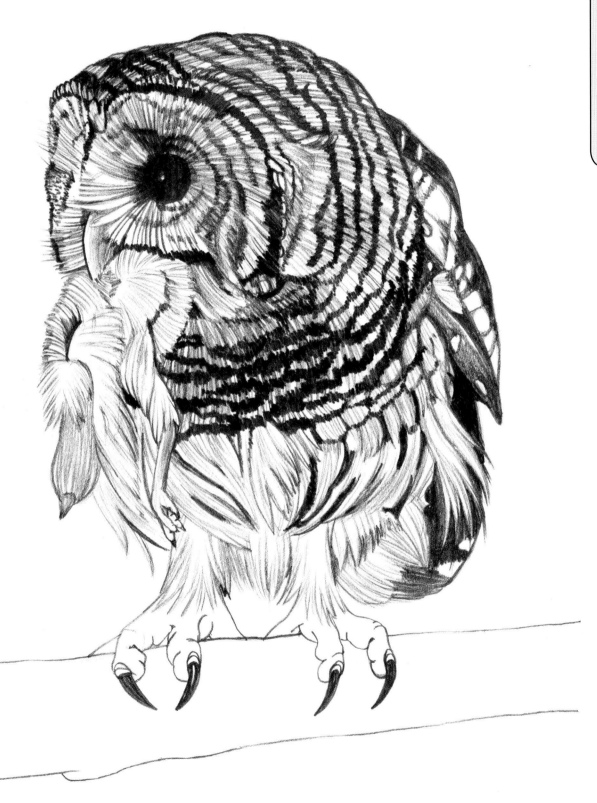

Denny Rogers

© COPYRIGHT 2008

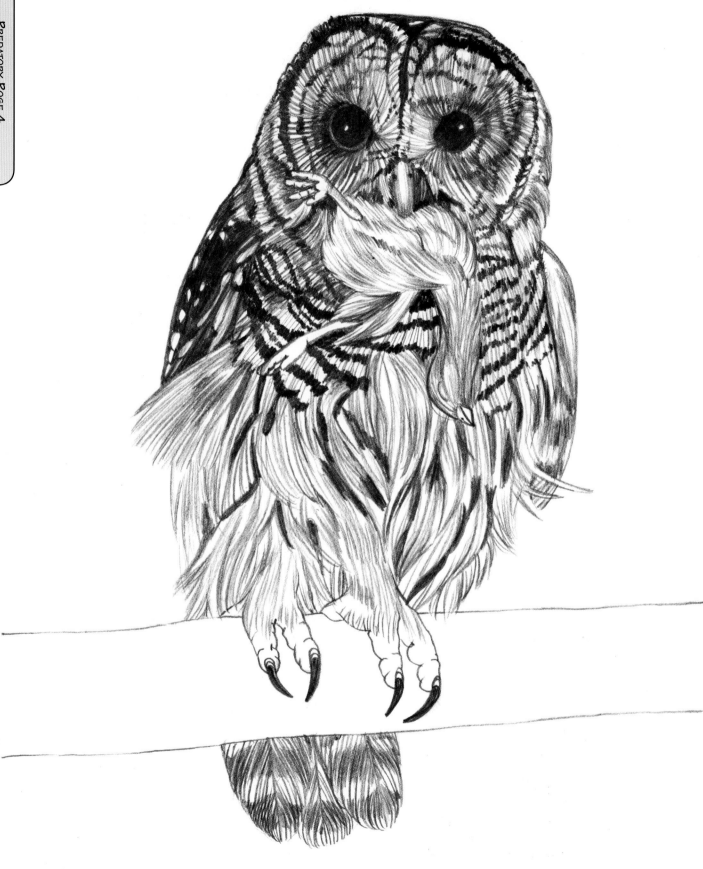

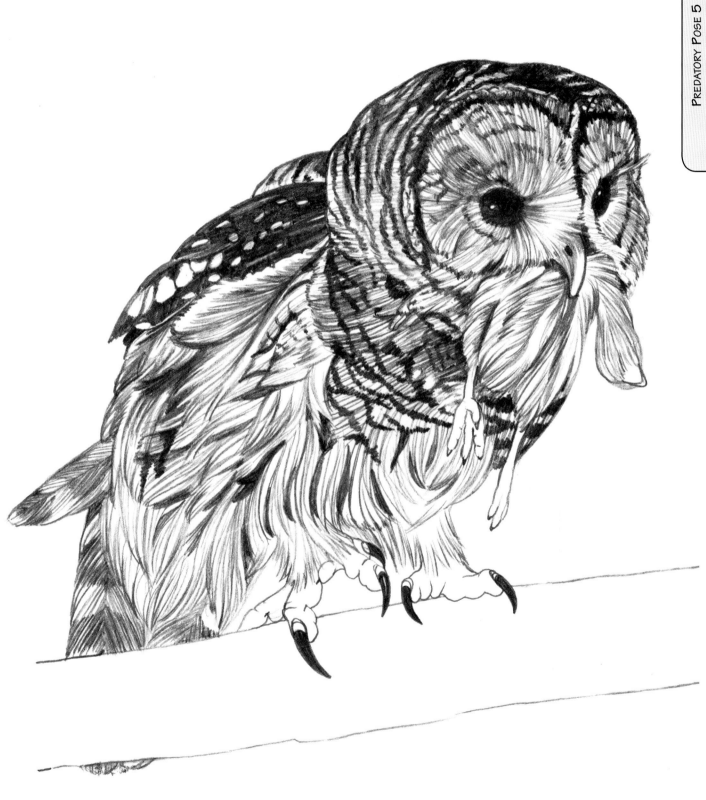

Denny Rogers

© COPYRIGHT 2008

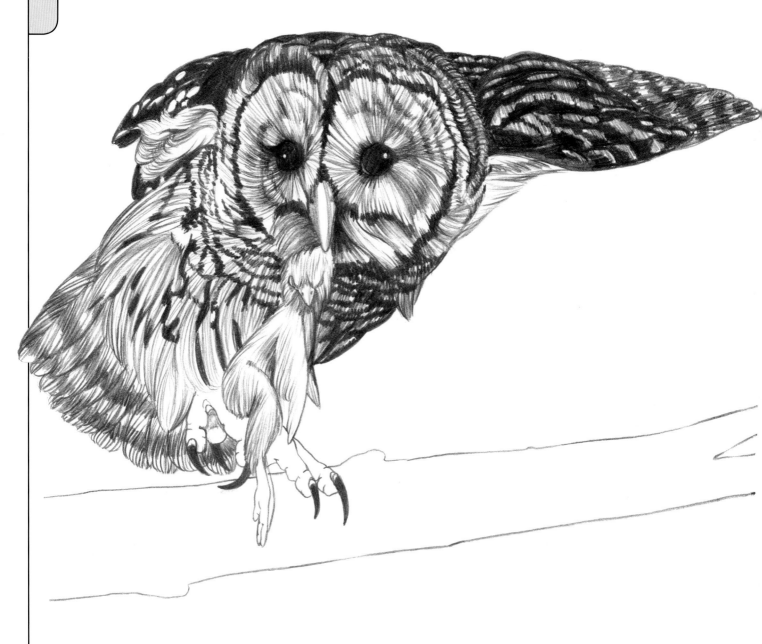

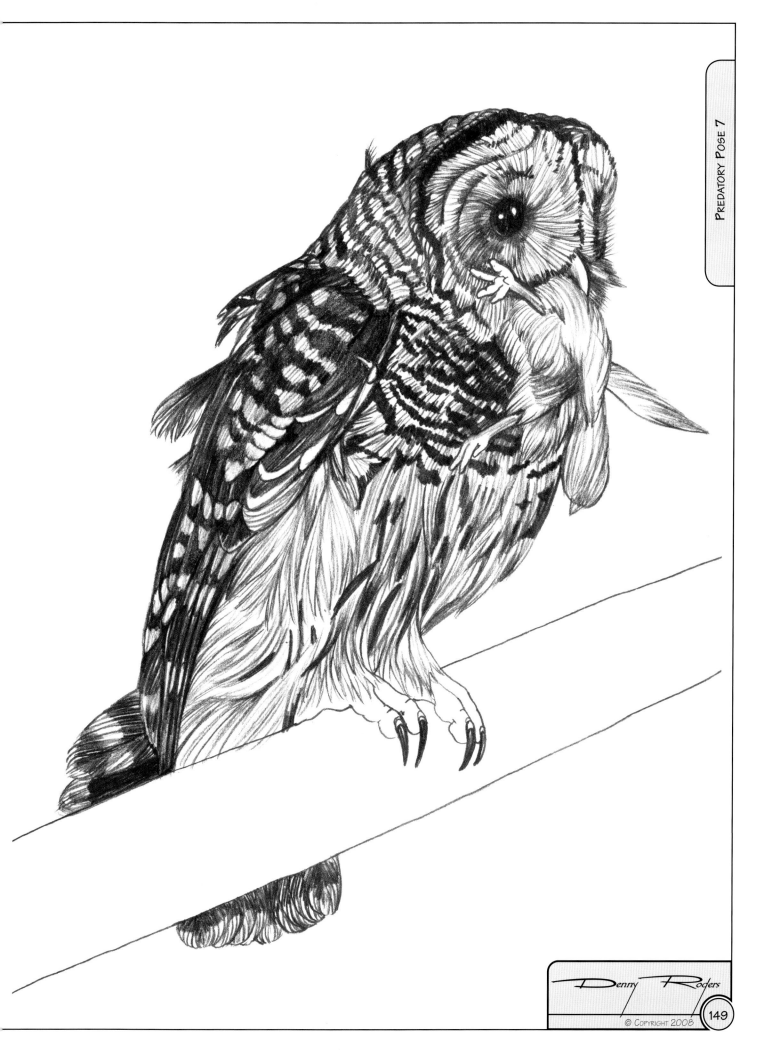

Denny Rogers

149

© Copyright 2008

REFERENCE

To me, one of the most striking features of the barred owl is its dark, deep-set eyes. This is a feature that I suggest spending a lot of time on to get right. The eyes give the owl a gentle expression that belies the way it makes its living. Primarily a nocturnal hunter, there are few small creatures not on its menu—snakes, frogs, birds, rodents, and other small mammals are all featured. If the barred owl can catch it, it will eat it.

The barred owl is a study of soft browns and grays. This is the perfect camouflage to sleep away the day in dense tangles of branches and vines. Pay close attention to the feather markings—certain groups have dark tips, while other groups have light tips.

My simple palette will enable you to achieve a lot of variation in value and tone with a few simple adjustments to the mixes using the colors listed. Don't paint every feather the same exact color, or with the same markings in the same places. This creates a uniformity that results in a static appearance. Instead, create the impression of uniformity—it doesn't take a lot of variation to break up the regimentation while still maintaining the overall orderliness of the barred patterning.

Denny has provided you with a wealth of solid anatomical reference. Couple this with these paint instructions and your own observations to achieve a work that is truly your own.

—Lori Corbett

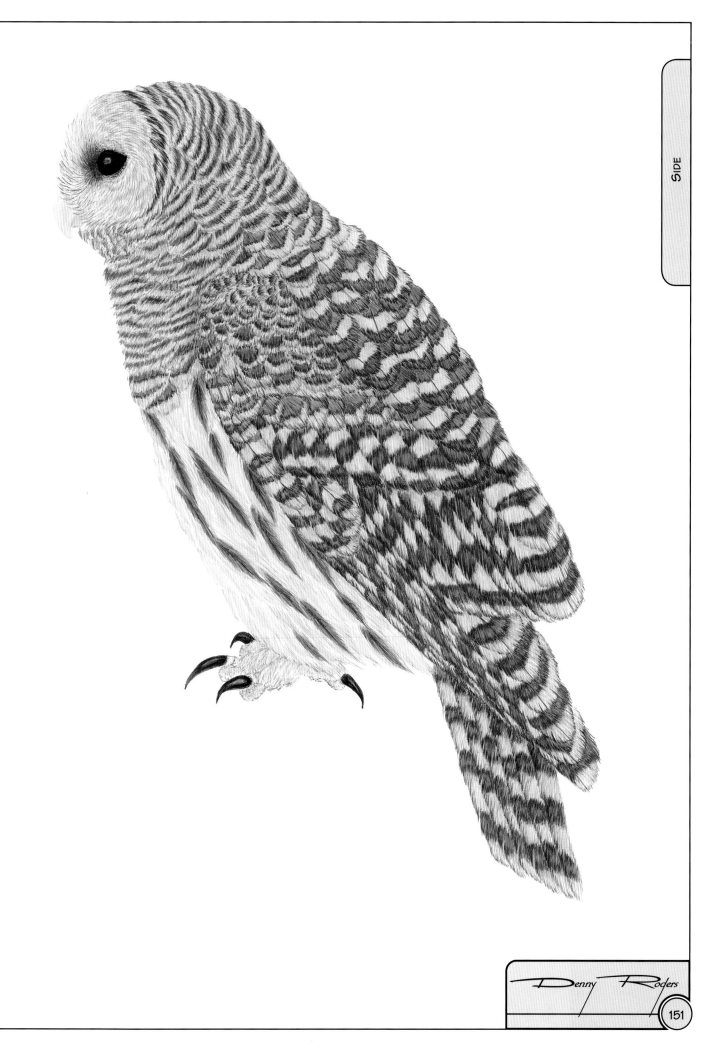

Denny Rogers

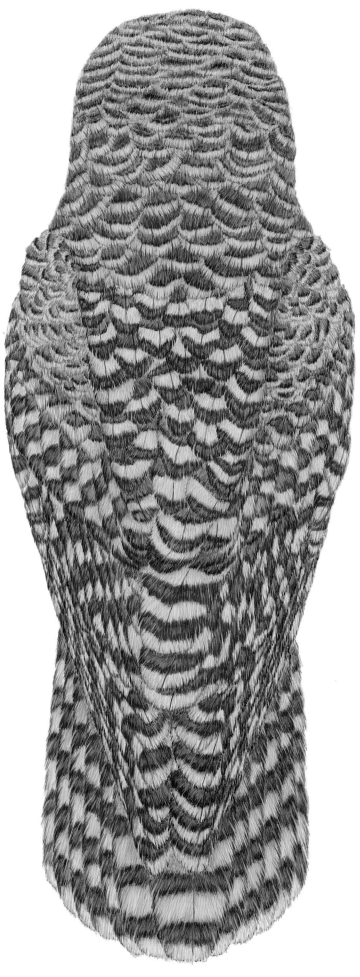

Barred Owl

COLOR LIST:
Raw umber (Pbr 7)
Ultramarine blue (PB 29)
Titanium white (PW 6)
Titanium buff (PW 6), also
 known as unbleached titanium
Zinc white (PW 4)
Yellow ochre (PY 43)

GLAZING COLORS:
Transparent yellow iron oxide (PY 42)

These glazing pigments, with the exception of zinc white, are powerful colors. A little bit goes long way. Use caution—it's best to apply a diluted layer and add another if necessary. Once these pigments are applied, it's very difficult to disguise them if too much is used.

Do not substitute other whites, such as titanium white, when zinc white is called for. Zinc white is a transparent white and is absolutely essential for the technique described. This will allow underlying details to show through, while softening the overall area. An opaque white (titanium white) will obscure the underlying detail too much and also give the area a chalky effect, rather than a soft color change. This is true in all instances of zinc white being called for in these instructions.

Notes: The overall appearance of the barred owl is grayish brown and off-white. Look closer, and you will see variations in value in these, as well as some random areas of a yellowish color. An important part of achieving softness for the complex feather detail is to establish variations in value during the base coating stage. Once detail and toning glazes have been laid over the base, the values will be tied together, but still discernable. Remember—not every feather should be identical in value or pattern. Your eye should blend these together to create the overall look, but upon close scrutiny, individual differences can be seen—this important feature is the key to transforming the art from static and boring to realistic and dynamic.

Full Strength Diluted

Mix 1
Titanium buff – 60%
Titanium white = 40%

Mix 2
Titanium buff = 40%
Raw umber = 40%
Yellow ochre = 20%

Mix 3
Transparent yellow iron
 oxide = 40%
Zinc white = 60%

Full Strength Diluted

Mix 4
Titanium buff = 90%
Yellow ochre = 10%

Mix 5
Ultramarine blue = 50%
Raw umber = 50%

Set 1 – Tail, Top Surface

1. Base in the dark barring with Mix 2.
2. Base the entire area (including over the dark barring) with Mix 1.
3. Highlight high points of ripples with Mix 1.
4. Shadow the low points of the ripples with Mix 2.
5. Pull thin random accent lines throughout with Mix 1 and Mix 2.
6. Strengthen the dark barring with a glaze of Mix 2.
7. Highlight the central regions of the white barring with a diluted glaze of zinc white.
8. The dark barring is darkest at its edges where it butts up to the light barring. Create this effect with a glaze of raw umber.
9. Create random yellowish areas within the white barring with a diluted glaze of Mix 3.

Tail, Bottom Surface (Not shown in illustration)
The bottom surface of the tail is a lighter version of the top surface with less contrast between the dark and light barring.

Upper Tail Coverts (Not shown in illustration)
1. Paint in the same manner and with the same mixes as the Tail (Set 1).

Set 2 – Feet and Legs

The toes are covered on the top surface with very fine feathers, almost resembling fur. The feathering ends just above the last joint above the talon.

1. Base coat the talons with Mix 5.
2. Apply zinc white near the tips of the talons.
3. Base the entire toe with Mix 1.
4. Accent random barbs with Mix 2 and titan buff to create variation.

Set 3 – Abdomen, Breast, Throat, Flanks, and Under Tail Coverts

The feathers in the throat area under the beak are normally compressed, resembling a pinecone. Paint the upper breast and throat in the same manner as the Tail (Set 1).

1. Base coat with Mix 1.
2. Add the dark centers with Mix 2.
3. Add random thin line accents throughout with Mix 1, and with Mix 2.
4. Darken the very centers of the dark markings with raw umber.
5. Glaze random areas with Mix 3. Don't glaze every feather or an entire feather.

Set 4 – Primaries, Secondaries, and Tertials

Note that the greater secondary coverts have dark tips, whereas all the other coverts have light tips.

1. Paint in the same manner and with the same mixes as the Tail (Set 1).

Set 5 – Coverts

Note that the greater secondary coverts have dark tips, whereas all the other coverts have light tips.

1. Paint in the same manner and with the same mixes as the Tail (Set 1).

Set 6 – Scapulars, Cape, and Head

Note the cape feathers have dark tips, whereas the rest of the feathers in this group have light tips.

1. Paint in the same manner and with the same mixes as the Tail (Set 1).

Set 7 – Facial Disks

Close examination of the face reveals that the barbs on the facial disks crisscross each other.

1. Base coat the beak with Mix 4. Highlight with zinc white.
2. Base coat in the dark band at the edge of the disk and in front of the eye with Mix 2.
3. Base coat in the light band behind the facial disk with Mix 1.
4. Base coat shading between the radial bands with Mix 2. Do not add as much shading in front of the eye over the beak—this should stay fairly light.
5. Base coat the entire facial disk with Mix 1. Paint over the shadow areas, but not the dark patch in front of the eye or the dark disk edge.
6. Accent/highlight the white areas with straight titanium white strokes.
7. Add the rictal bristles (whiskers) in front of the eye with raw umber.
8. Darken the dark band at the edge of the disk with raw umber.

Facial Disks – Set 7

Scapulars, Cape, and Head – Set 6

Coverts – Set 5

Primaries, Secondaries, and Tertials – Set 4

Abdomen, Breast, Throat, Flanks, and Under Tail Coverts – Set 3

Feet and Legs – Set 2

Tail, Top Surface – Set 1

Denny Rodgers

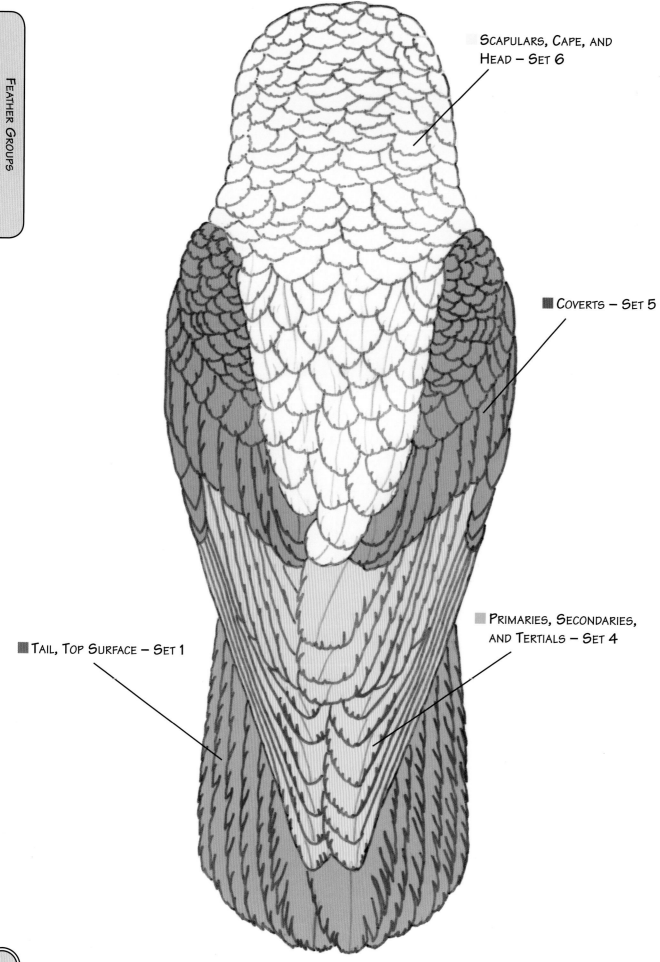

SCAPULARS, CAPE, AND
HEAD – SET 6

COVERTS – SET 5

PRIMARIES, SECONDARIES,
AND TERTIALS – SET 4

TAIL, TOP SURFACE – SET 1

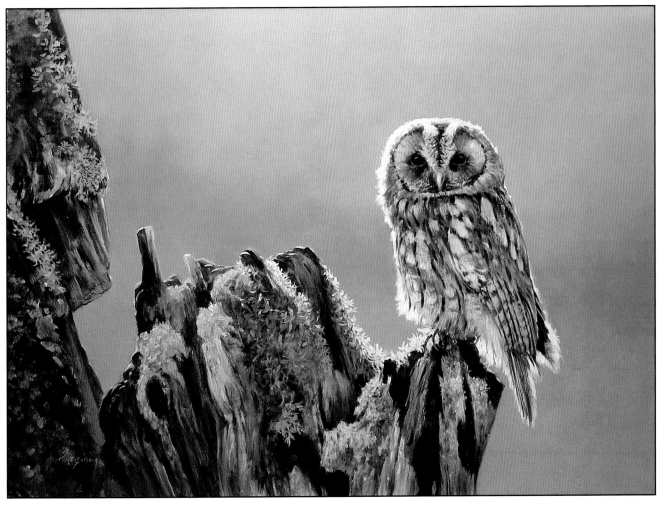

Autumn Gold

Morten E. Solberg

Acrylic, 2003

22" x 30"

This piece was created when the artist decided to paint a warm brown version of a photo in blues that he liked. *Autumn Gold* captures a moment at sunset—the time when the owl is preparing to adventure out into the night to find food for itself and its family. A fan brush was used to paint the sky.

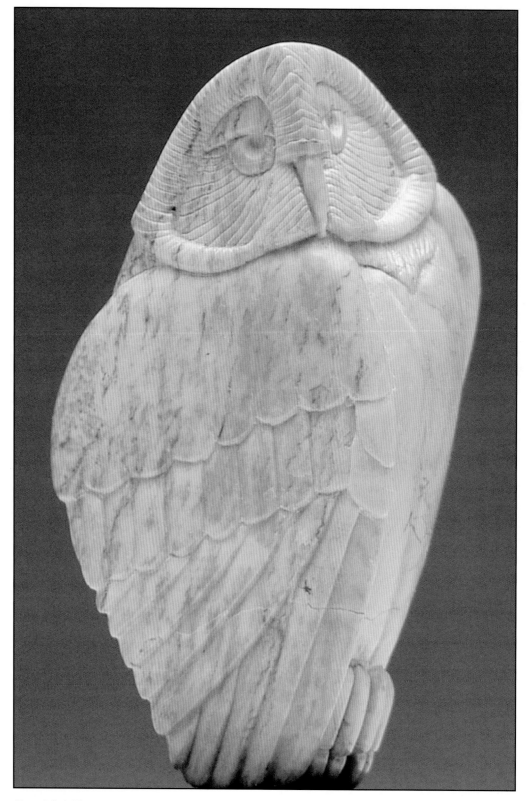

Barred Owl #5

Clarence P. Cameron

Montana dendritic soapstone and dark-stained oak base, 2003

6" high

Anonymous collection. The artist was amazed at the way the face of this owl evolved and took on an expression of its own with little planning on his part. This owl could be considered either a little sleepy or intently looking at something that has piqued its interest.

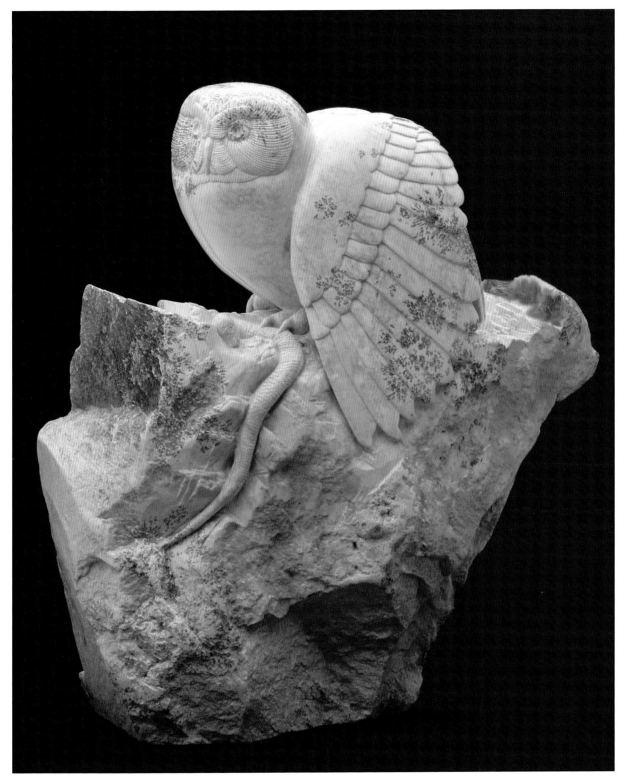

Dinner at the Hard Rock

Clarence P. Cameron

Montana dendritic soapstone, 2007

13" high

Collection of Scott and Marcia Corbett, Sarasota, Florida. When the artist cut off the bottom of a stone slab, this owl revealed itself. The title popped into the author's mind as he was brushing his teeth one morning.

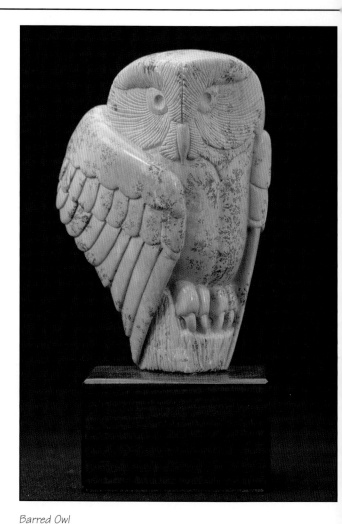

Barred Owl

Clarence P. Cameron

Montana dendritic soapstone and dark-stained oak base, 2005

7" high

Anonymous collection. The artist of this piece learned that stone really does talk, if one just listens; it will say what it contains, where to carve, and also when to stop. While the front of this owl is complete, the stone said, "No more," so the back is simply smooth and polished.

Barred Owl #4

Clarence P. Cameron

Montana dendritic soapstone and dark-stained oak base, 2004

5.5" high

Collection of James Ketchum, Bethesda, Maryland. Finding the owl in this irregularly shaped stone was both challenging and amusing for the artist. The owl's dramatic pose became even more pronounced in the photograph.

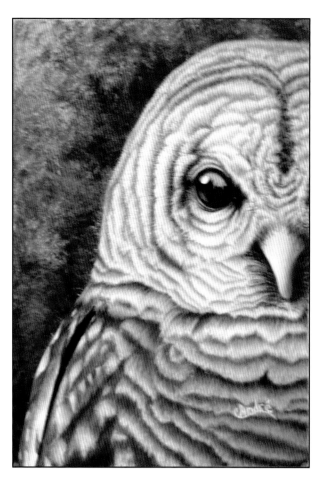

Evening Reflections

Carol André

Acrylic on masonite, 2006

The subject of this piece is the same as the piece to the left. The artist's goal here was to try an approach that went against the "rules" a bit; she was successful, as *Evening Reflections* has been a very popular piece, truly capturing the owl's personality.

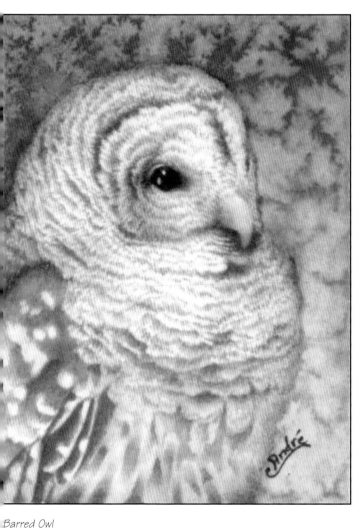

Barred Owl

Carol André

Watercolor on Arches paper, 2006

This miniature was created after doing a show with a wildlife rehabilitation center where this owl lived. He is missing one eye after having an argument with a tractor trailer, but except for that, what a beautiful little fellow!

This photograph demonstrates the barring of the underside as viewed from the ground during flight.

This owl is demonstrating an erect standing reverse pose. Observe the breast and body spear markings. The foot position indicates that the owl is about to walk.

Notice the small beak; half of it is covered by fluffy feathers. Also, note the small talons, which are sized to their small prey. Don't let their size fool you; barred owl feet are very powerful. This specimen put a talon through my hand!

Bottom left: Note the full color patterns on the top of this extended wing.

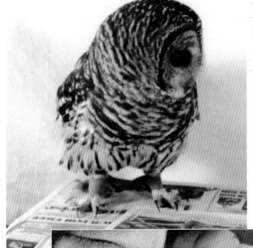

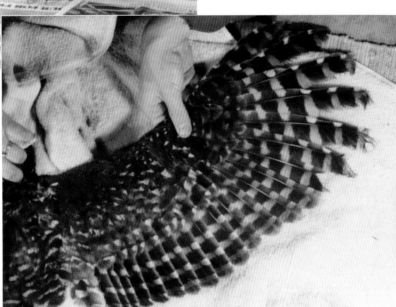

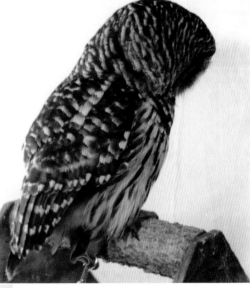

Observe the barring and color patterns on this perched owl.

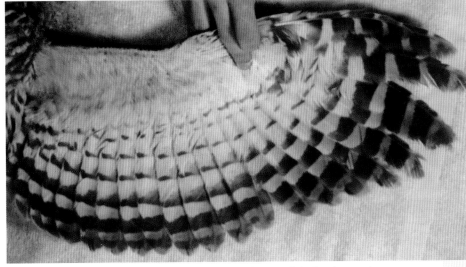

Notice how the barring is thick and heavily shaded on the tips of the feathers and thins towards the meat of the wing. This pose demonstrates the full underside of the wing—useful for examining the glide pattern.

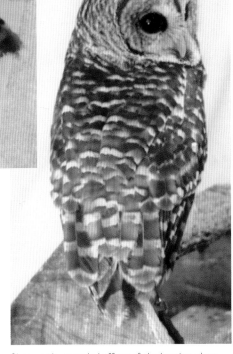

Observe the mottled effect of the barring when the owl is in a standing position with folded wings.

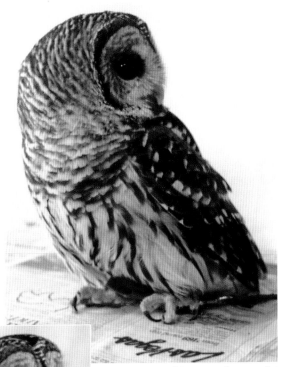

When standing on a flat surface, the talons can be fully extended or curled under. This photograph shows the curled-under position, which means the owl is very relaxed.

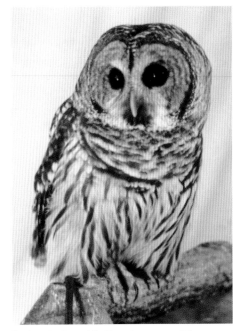

The heart-shaped feather rings around the eyes are easily discernible on this perched owl.

Note the transition from barring to spears on the feathers.

© Copyright 2008

This owl is demonstrating a
very alert pose; it is observing
a live chick out of sight.

Notice the extended
position of the talons and
the radiating rings of color
wrapping the head and neck.

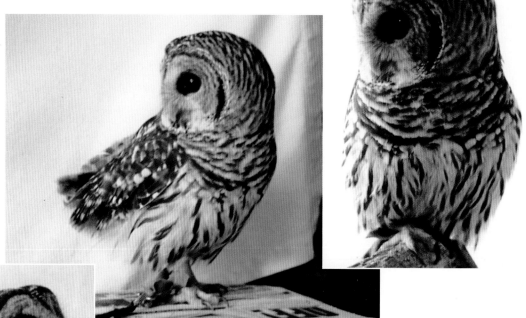

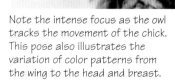

Note the intense focus as the owl
tracks the movement of the chick.
This pose also illustrates the
variation of color patterns from
the wing to the head and breast.

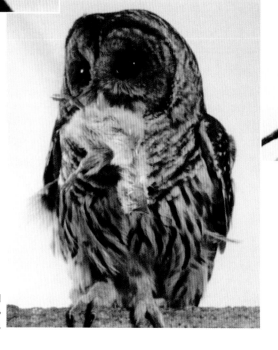

This owl is showing a natural
perched position. Observe the
short breast feathers and the
longer stomach feathers.

The owl has just killed its meal
by biting through the chick's
body with its powerful beak.

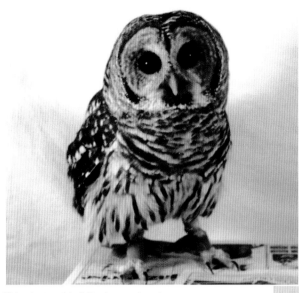

Observe the tawny, light rust coloring among the white and dark brown spears on the breast area.

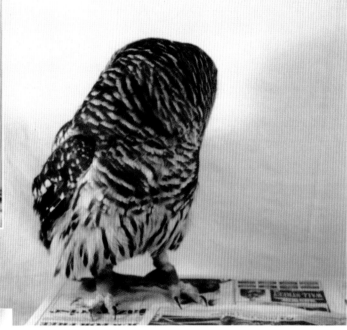

This alert owl is following my hand movement, watching and preparing to react defensively.

Note the fluffiness of the body feathers as the owl continues to track my movement.

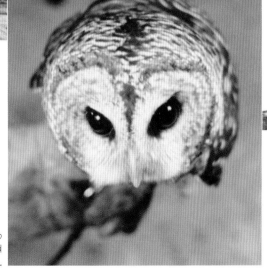

This owl is tilted forward to demonstrate the extended head present in flight poses.

Observe the position of the talons while the owl is in a perched pose.

Denny Rogers

165

© COPYRIGHT 2008

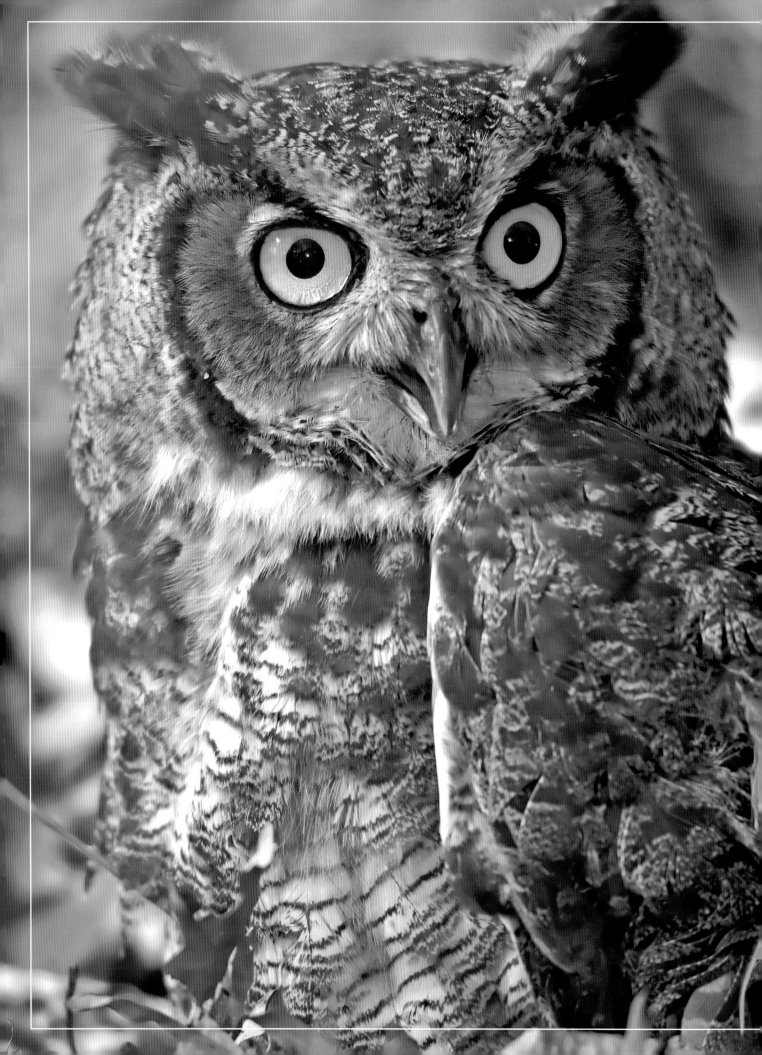

THE GREAT HORNED OWL

© COPYRIGHT 2008

GREAT HORNED OWL FACTS

The great horned owl (*Bubo virginianus*) is one of the largest and most powerful of all North American owls, and is the largest North American owl with ear tufts. It is 18 to 25 inches (46 to 64 centimeters) in length and has a wingspan of 36 to 60 inches (91 to 152 centimeters), weighing between 24 and 88 ounces (680 grams to 2500 grams). Subspecies are found from upper North America down through mid South America. Other names for the great horned owl include the big hoot owl, cat owl, chicken owl, eagle owl, hoot owl, horned owl, king owl, winged tiger, and Virginia barred owl.

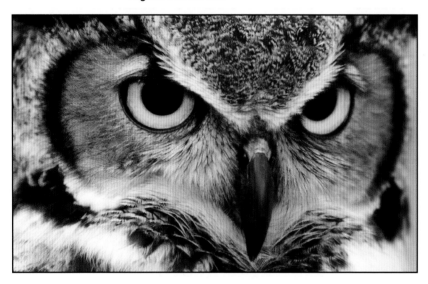

Though the female is the larger of the species, both sexes look alike. The owl's body is brown, spotted with darker brown, and white throat feathers contrast with dark cross-barred underparts. Plumage coloring varies from a pale hue in the southeastern and southwest U.S. to a darker shade in the Pacific Northwest to a very pale buff-colored subspecies in the Arctic.

The call of the great horned owl is variable but usually consists of a deep, soft, resonant, six-noted hoot: Whoo! Whoo-whoo-whoo! Whoo! Whoo! When hooting, adult owls lean forward, vibrate their white throat feathers, and lift their short tails. They will respond to man-made imitations of their calls.

The great horned owl has extremely acute hearing, aided by very large ear openings concealed behind facial discs that act as parabolic reflectors to collect and funnel sound waves down the ear openings. Its visual sensitivity is at least 35 times greater than a human's. This owl has a total frontal view of 60 degrees to 70 degrees and can rotate its head 270 degrees, making the total backward peripheral vision about 340 degrees.

The great horned owl is killed by poaching, automobile traffic, entanglements in fences, electrocution, and starvation. In the wild, great horned owls live around 12-14 years. Records indicate that a captive male lived 29 years and that a captive female laid eggs for 19 years.

Diet and Habitat

While its feeding habits are mostly nocturnal, the great horned owl does hunt both day and night in woods, mountains, marshes, dunes, and open deserts. It swoops and catches prey in flight. A great horned owl can kill prey up to three times as heavy as itself, and eats from a variety of mammalian, bird, reptile, amphibian, fish, and insect prey. This large range of prey includes shrews, rabbits, squirrels, chipmunks, wood rats, mice, muskrats, minks, weasels, skunks, pocket gophers, woodchucks, opossums, and cats; bats, grebes, ducks, geese, swans, bitterns, herons, coots, pheasants, grouse, turkeys, chickens, guinea fowl, doves, woodpeckers, jays, crows, blackbirds, meadowlarks, and all small birds; marsh, Cooper's, red-tailed, and red-shouldered hawks; barn, barred, long-eared, and screech owls; frogs, snakes, turtles, young alligators, lizards; eels, dace, goldfish, bullheads, crayfish; and scorpions, spiders, worms, and other large bugs.

When discovered by crows during the day, the owl is pursued—or mobbed—in flight. This is the prey's revenge on the predator. A group of crows, sometimes containing hundreds, will chase the owl, cawing and dive-bombing the predator until it leaves the area.

The great horned owl is migratory in Northern Canada and moves south during the fall and winter

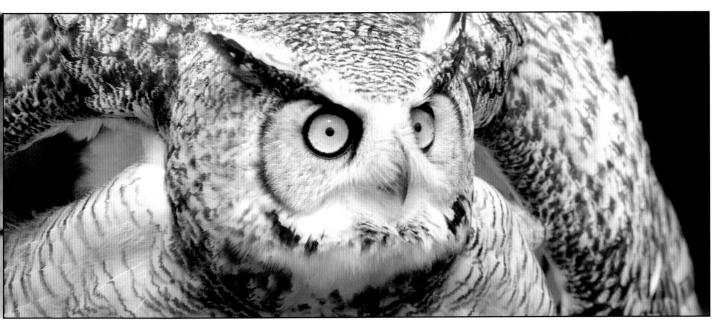

of the far northern regions. It roosts during the day in the thick tops of evergreen trees or in the tops of hardy deciduous trees that keep leaves through the winter.

Nesting

The great horned owl nests 15 to 70 feet (5 to 21 meters) up in the old nest of a red-tailed hawk, bald eagle, heron, crow, or squirrel. These owls will also dwell in caves, cliffs, tree hollows, and even sometimes on the ground.

Breeding and courtship take place in the spring for great horned owls two years of age and older. A normal clutch has two or three eggs, and occasionally as many as six. Nesting takes place in the spring, and the eggs are incubated by both sexes in 26 to 30 days. The young are fed on the ground after leaving the nest but before fledging, which occurs 63 to 70 days after hatching—usually in June.

Flight

With its flight speed reaching 40 miles per hour (64 kilometers per hour), the great horned owl flies silently due to fine fringes and a velvety pile over the surface of the feathers, which deaden the noise as it breaks through the air.

For more information on the mechanics and physics of flight, please see the Flight section on pages 232 through 237.

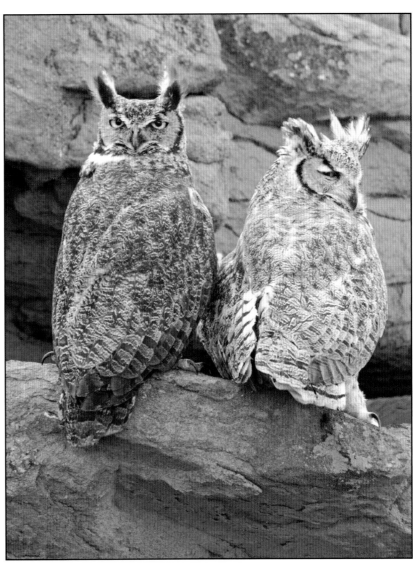

© Copyright 2008

DRAWINGS

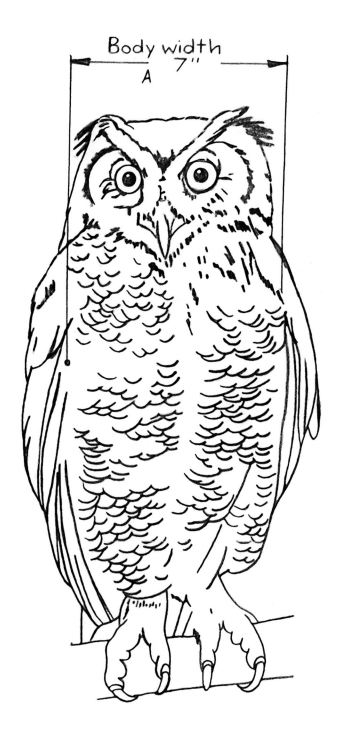

Body width
7"
A

See the chart on pages 194 through 195 for a listing of the measurements. Also included are nine additional scales showing each measurement reduced proportionately so that accurate patterns can be laid out in any size.

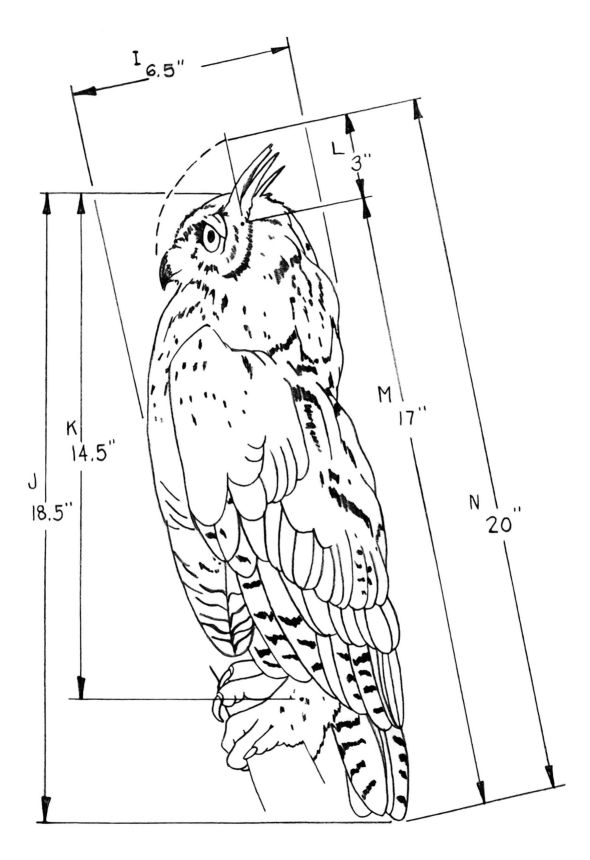

I 6.5"

L 3"

M 17"

K 14.5"

J 18.5"

N 20"

See the chart on pages 194 through 195 for a listing of the measurements. Also included are nine additional scales showing each measurement reduced proportionately so that accurate patterns can be laid out in any size.

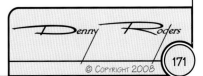

© COPYRIGHT 2008

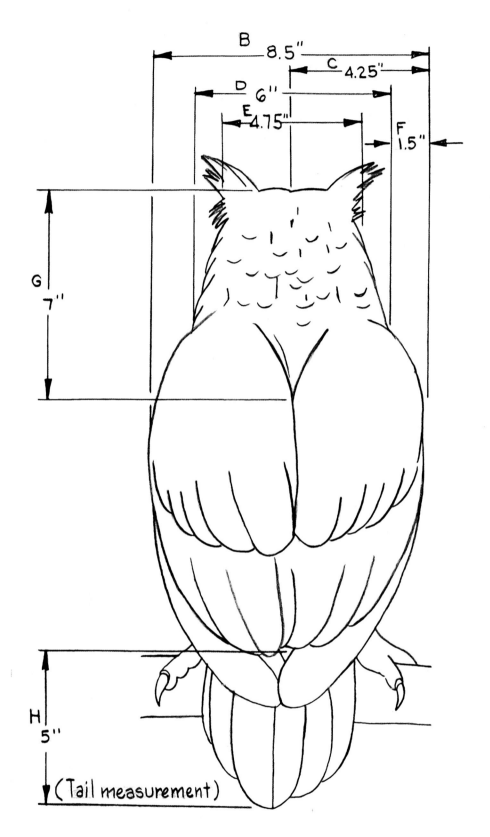

B 8.5"
C 4.25"
D 6"
E 4.75"
F 1.5"
G 7"
H 5"
(Tail measurement)

See the chart on pages 194 through 195 for a listing of the measurements. Also included are nine additional scales showing each measurement reduced proportionately so that accurate patterns can be laid out in any size.

X
1.75"

Y
1.25"

Z
3.25"

AA
1.5"

BB
.375"

CC
1.5"

DD
1"

EE 2"

FF
3"

Pivot

See the chart on pages 194 through 195 for
a listing of the measurements. Also included
are nine additional scales showing each
measurement reduced proportionately so that
accurate patterns can be laid out in any size.

Denny Rogers

© COPYRIGHT 2008

LLL 50"

MMM 24"

NNN 17"

OOO 9.5"

III 15"

HHH 19.5"

JJJ 8"

KKK 4.5"

PPP 2.5"

SSS 19.5"

RRR 6.75"

QQQ 4.62"

30°

See the chart on pages 194 through 195 for a listing of the measurements. Also included are nine additional scales showing each measurement reduced proportionately so that accurate patterns can be laid out in any size.

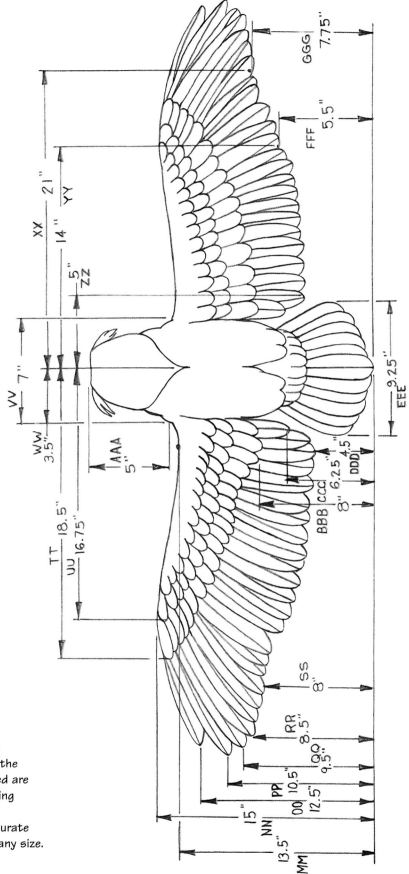

See the chart on pages 194 through 195 for a listing of the measurements. Also included are nine additional scales showing each measurement reduced proportionately so that accurate patterns can be laid out in any size.

GGG 7.75"

FFF 5.5"

XX 21"

YY 14"

ZZ 5"

VV 7"

WW 3.5"

AAA 5"

EEE 9.25"

BBB 8"

CCC 6.25"

DDD 4.5"

TT 18.5"

UU 16.75"

SS 8"

RR 8.5"

QQ 9.5"

PP 10.5"

OO 12.5"

NN 15"

MM 13.5"

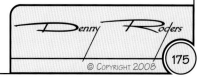

Denny Rogers

© Copyright 2008

UNDERSIDE

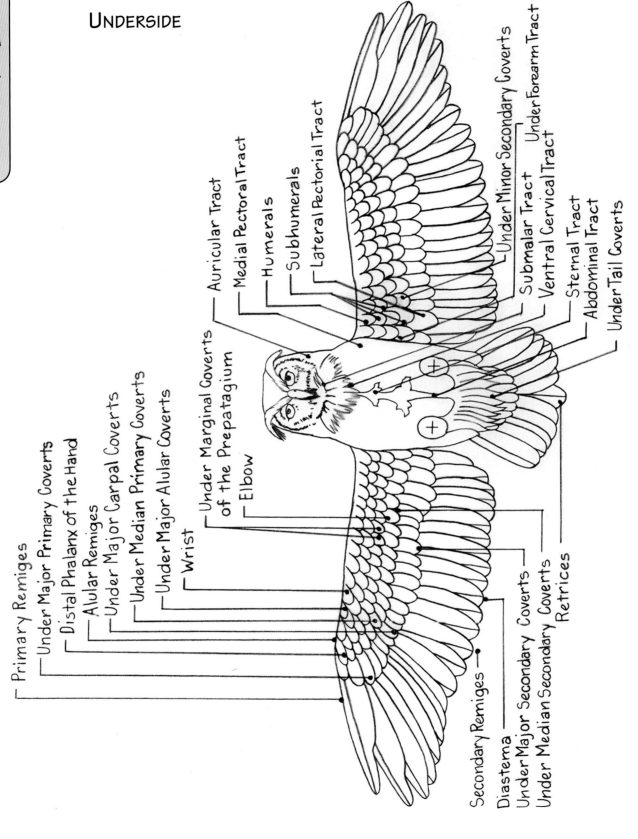

Primary Remiges
Under Major Primary Coverts
Distal Phalanx of the Hand
Alular Remiges
Under Major Carpal Coverts
Under Median Primary Coverts
Under Major Alular Coverts
Wrist
Under Marginal Coverts of the Prepatagium
Elbow

Auricular Tract
Medial Pectoral Tract
Humerals
Subhumerals
Lateral Pectoral Tract

Under Minor Secondary Coverts
Under Forearm Tract
Submalar Tract
Ventral Cervical Tract
Sternal Tract
Abdominal Tract
Under Tail Coverts

Secondary Remiges
Diastema
Under Major Secondary Coverts
Under Median Secondary Coverts
Retrices

TOPSIDE

Upper Median Primary Coverts (Underneath)
Alular Remiges
Upper Major Primary Coverts
Distal Phalanx of the Hand (Underneath)
Upper Marginal Coverts of the Alular
Wrist
Carpal Remex
Upper Major Carpal Covert
Under Median Carpal Covert
Upper Minor Carpal Covert
Elbow
Shoulder

Interscapular Tract
Dorsal Tract
Shoulder Tract
Humeral Tract
Post Humeral Tract
Upper Post Humeral Tract

Dorsal Caudal Tract
Upper Tail Coverts
Retrices

Median Coverts
Upper Median Secondary Coverts
Secondaries
Upper Major Secondary Coverts
Major Coverts

Primary Remiges

Diastataxic Gap

Secondary Remiges

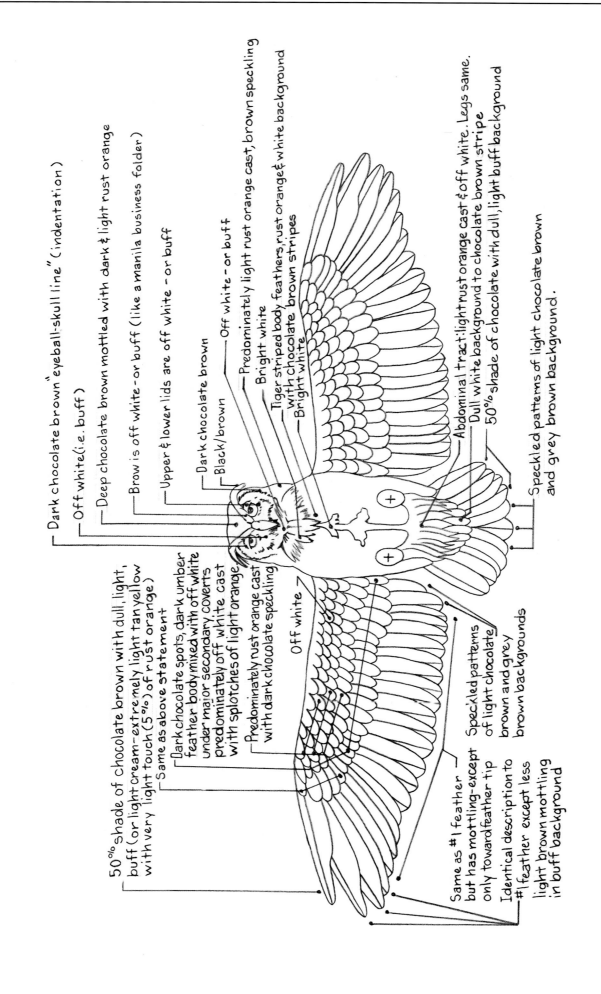

Dark chocolate brown "eyeball-skull line" (indentation)

Off white (i.e. buff)

Deep chocolate brown mottled with dark & light rust orange

Brow is off white - or buff (like a manila business folder)

Upper & lower lids are off white - or buff

Dark chocolate brown

Black/brown

Off white - or buff

Predominately light rust orange cast, brown speckling

Bright white

Tiger striped body feathers, rust orange & white background with chocolate brown stripes

Bright white

Abdominal tract: light rust orange cast & off white. Legs same.

Dull white background to chocolate brown stripe

50% shade of chocolate with dull, light buff background

Speckled patterns of light chocolate brown and grey brown background.

50% shade of chocolate brown with dull, light, buff (or light cream – extremely light tan yellow with very light touch (5%) of rust orange)

Same as above statement

Dark chocolate spots, dark umber feather body mixed with off white under major secondary coverts predominately off white cast with splotches of light orange

Predominately rust orange cast with dark chocolate speckling

Off white

Speckled patterns of light chocolate brown and grey brown backgrounds

Same as #1 feather but has mottling-except only toward feather tip

Identical description to #1 feather except less light brown mottling in buff background

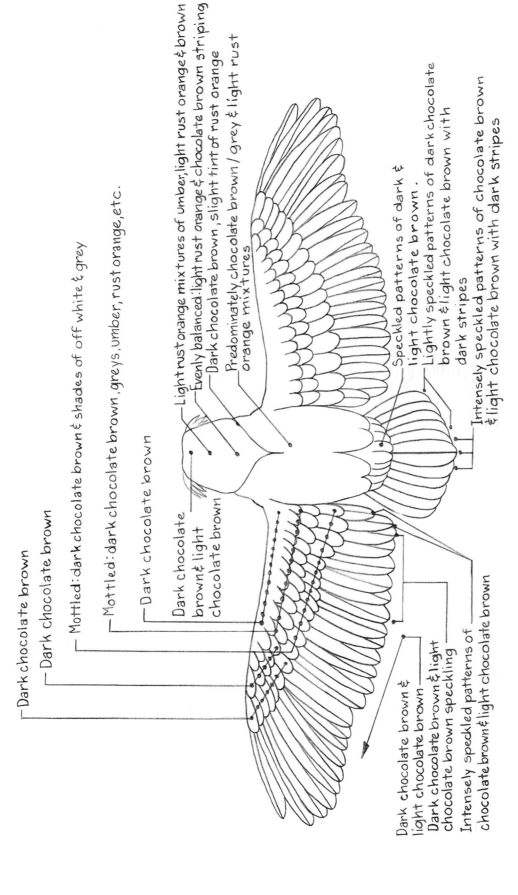

Dark chocolate brown

Dark chocolate brown

Mottled: dark chocolate brown & shades of off white & grey

Mottled: dark chocolate brown, greys, umber, rust orange, etc.

Dark chocolate brown

Dark chocolate brown & light chocolate brown

Light rust orange mixtures of umber, light rust orange & brown

Evenly balanced: light rust orange & chocolate brown striping

Dark chocolate brown, slight tint of rust orange

Predominately chocolate brown / grey & light rust orange mixtures

Speckled patterns of dark & light chocolate brown.

Lightly speckled patterns of dark chocolate brown & light chocolate brown with dark stripes

Intensely speckled patterns of chocolate brown & light chocolate brown with dark stripes

Dark chocolate brown & light chocolate brown

Dark chocolate brown & light chocolate brown speckling

Intensely speckled patterns of chocolate brown & light chocolate brown

© COPYRIGHT 2008

Denny Rogers

TO MATCH THE DIMENSION ON PAGES 174 AND 175, ENLARGE TO 323%. HOWEVER, AS DESCRIBED ON PAGE 168, WINGSPANS CAN VARY FROM 36 TO 60 INCHES. A SIMPLE STEP TO ENLARGE THIS PATTERN FOR EXACT MEASUREMENTS WOULD BE TO TAKE THE BOOK TO A LOCAL COPY SHOP, CREATE A PHOTOCOPY OF PAGES 180 AND 181, CUT APART, TAPE THE BODY TOGETHER, ASSIGN THE ENLARGED PERCENTAGE, AND RUN A LIFE-SIZE COPY TO THE DESIRED WINGSPAN FOR YOUR PROJECT. ALL DIMENSIONS WILL ENLARGE PROPORTIONATELY ON AN ENGINEERING PRINT MACHINE.

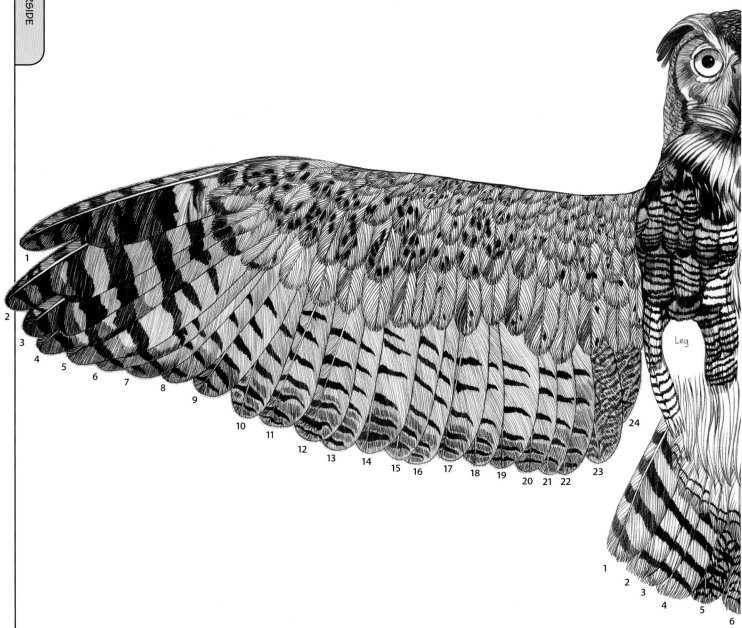

Note: This was the third bird I illustrated, following the eagle and the red tail hawk. It was after this owl that a woodcarver called and suggested illustrating each individual feather. Therefore, there are not feather charts for the great horned owl like there are for the other two owls in this book. The great horned owl has 24 wing flight feathers and 12 tail feathers, and each is easily traced.

Denny Rogers

© COPYRIGHT 2008

To match the dimension on pages 174 and 175, enlarge to 323%. However, as described on page 168, wingspans can vary from 36 to 60 inches. A simple step to enlarge this pattern for exact measurements would be to take the book to a local copy shop, create a photocopy of pages 182 and 183, cut apart, tape the body together, assign the enlarged percentage, and run a life-size copy to the desired wingspan for your project. All dimensions will enlarge proportionately on an engineering print machine.

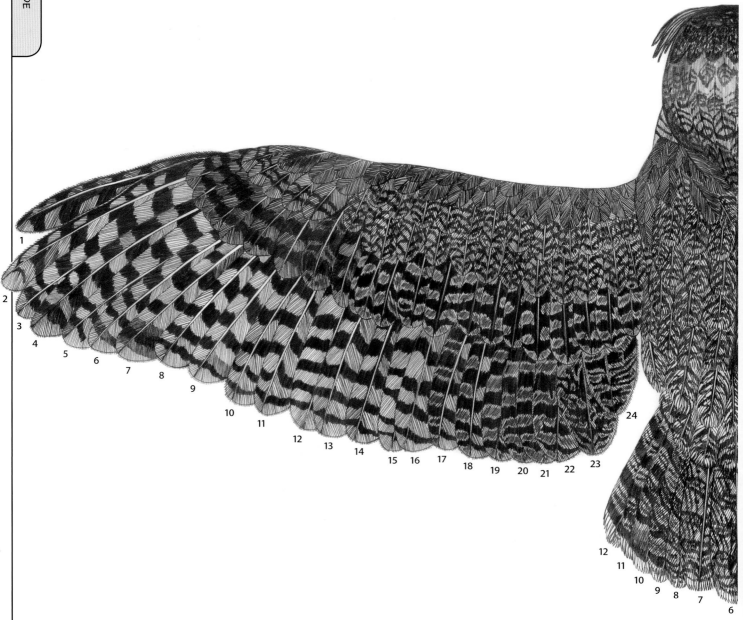

1
2
3
4
5
6
7
8
9
10
11
12
13
14
15
16
17
18
19
20
21
22
23
24

1
2
3
4
5
6

Denny Rogers

© COPYRIGHT 2008

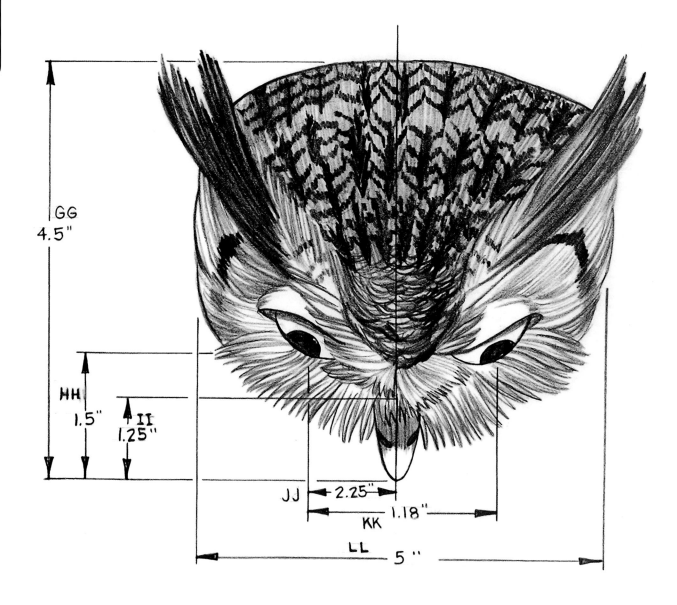

GG
4.5"

HH
1.5"

II
1.25"

JJ ← 2.25" →

KK 1.18"

LL 5"

See the chart on pages 194 through 195 for a listing of the measurements. Also included are nine additional scales showing each measurement reduced proportionately so that accurate patterns can be laid out in any size.

This aggressive expression shows the interior beak appearance, shape of the outer beak, and tongue contraction.

© COPYRIGHT 2008

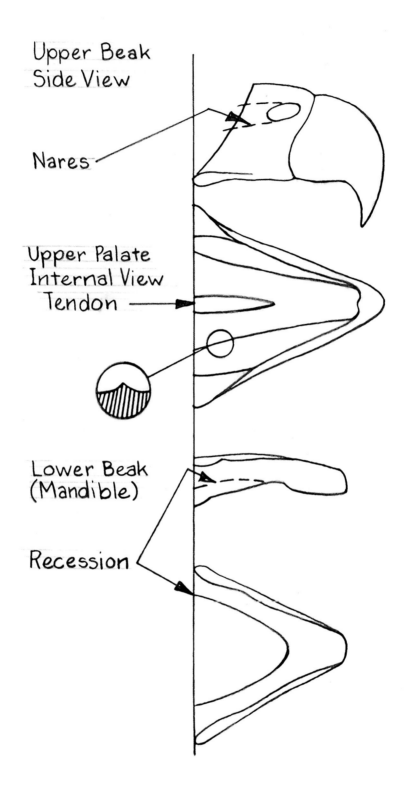

Upper Beak
Side View

Nares

Upper Palate
Internal View
Tendon

Lower Beak
(Mandible)

Recession

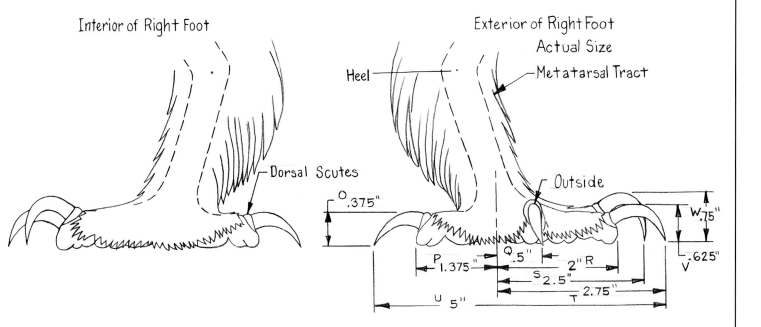

Interior of Right Foot

Exterior of Right Foot
Actual Size

Heel

Metatarsal Tract

Dorsal Scutes

Outside

O .375"

P 1.375"

Q .5"

2" R

S 2.5"

T 2.75"

U 5"

W .75"

V .625"

See the chart on pages 194 through 195 for a listing of the measurements. Also included are nine additional scales showing each measurement reduced proportionately so that accurate patterns can be laid out in any size.

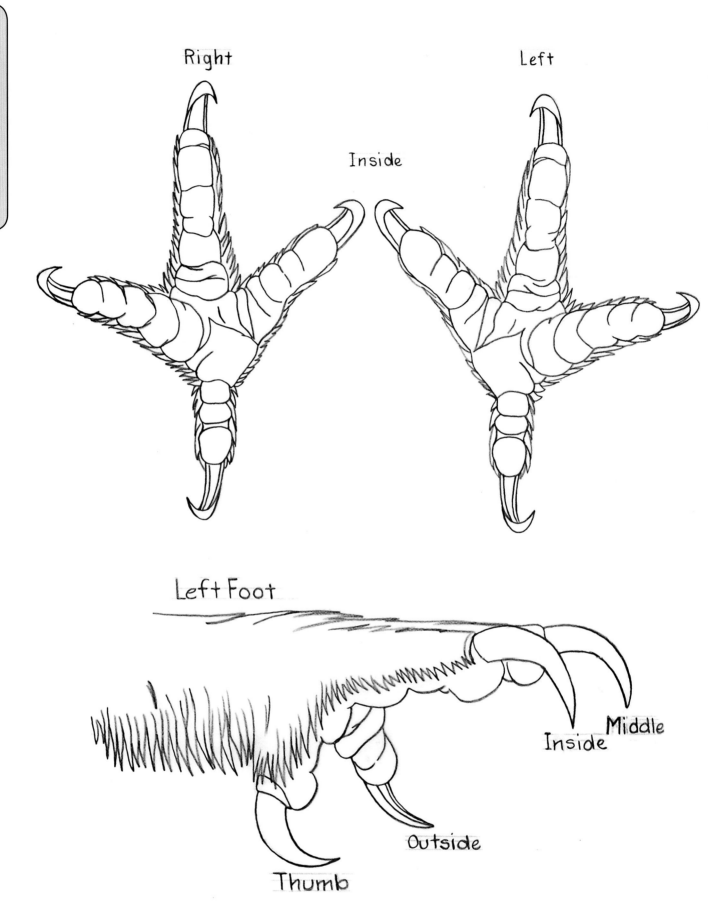

Right

Left

Inside

Left Foot

Middle

Inside

Outside

Thumb

Underside

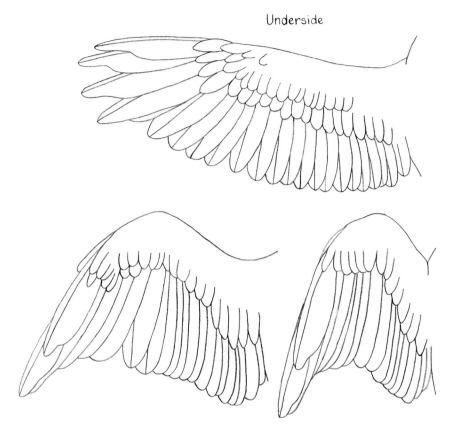

Topside

Denny Roders
© COPYRIGHT 2008

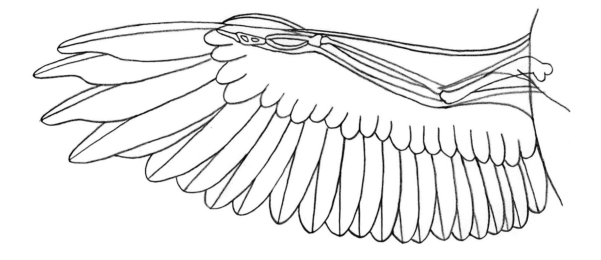

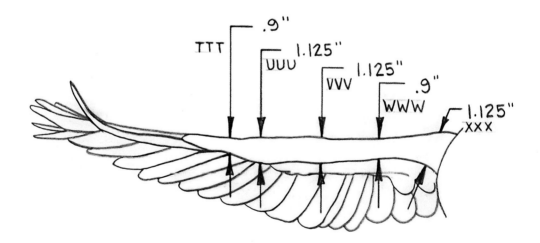

See the chart on pages 194 through 195 for a listing of the measurements. Also included are nine additional scales showing each measurement reduced proportionately so that accurate patterns can be laid out in any size.

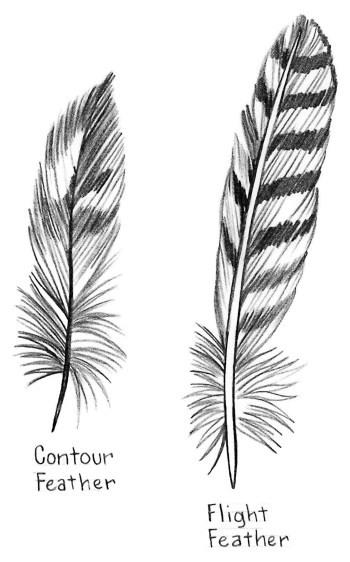

Contour
Feather

Flight
Feather

Denny Rogers

© COPYRIGHT 2008

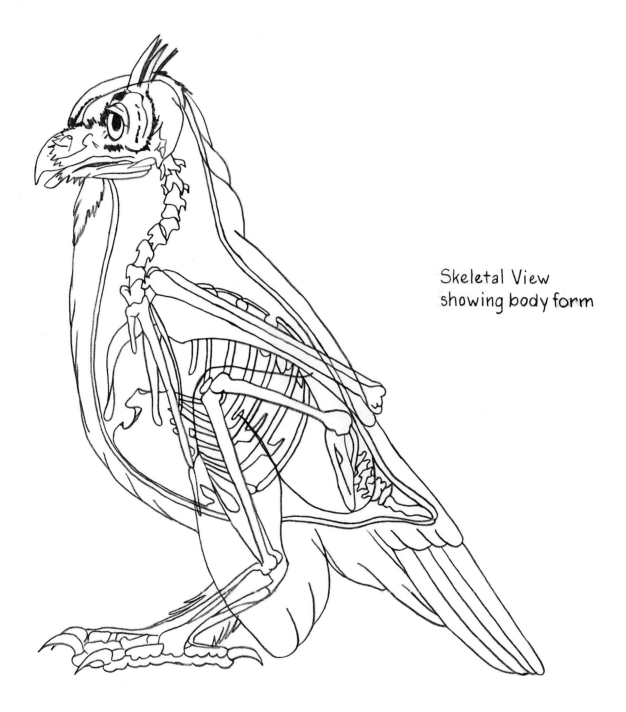

Skeletal View
showing body form

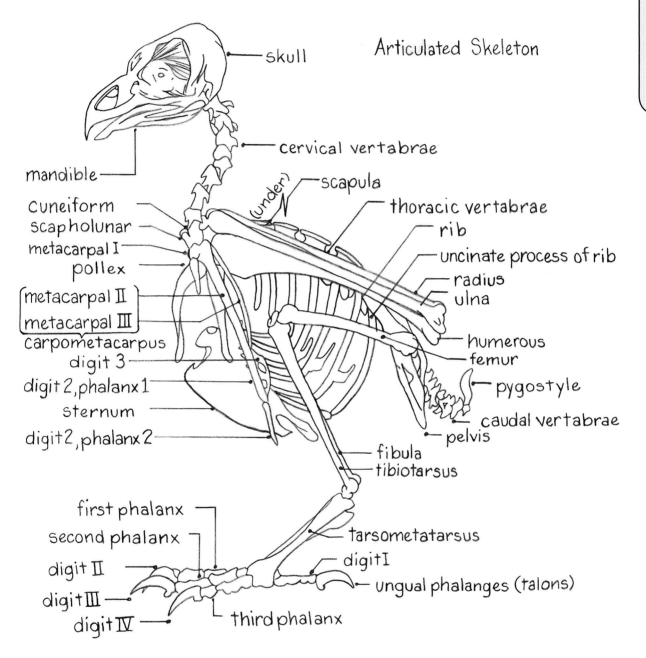

Articulated Skeleton

skull

cervical vertabrae

mandible

scapula

(under)

thoracic vertabrae

rib

cuneiform

scapholunar

metacarpal I

pollex

uncinate process of rib

radius

ulna

metacarpal II

metacarpal III

carpometacarpus

digit 3

humerous

femur

digit 2, phalanx 1

sternum

pygostyle

digit 2, phalanx 2

caudal vertabrae

pelvis

fibula

tibiotarsus

first phalanx

second phalanx

tarsometatarsus

digit II

digit I

digit III

ungual phalanges (talons)

digit IV

third phalanx

© COPYRIGHT 2008

Great Horned Owl Measurement Chart

Each measurement on this chart is coded from A to XXX. These letters correspond with the measurements on pages 170-175, 184, 187, and 190. Also listed are nine additional scales that show each measurement reduced proportionately so that patterns can be laid out in any size. The scales contain decimal equivalents.

	Full Scale	⁹⁄₁₀ Scale	⁴⁄₅ Scale	⁷⁄₁₀ Scale	³⁄₅ Scale	¹⁄₂ Scale	²⁄₅ Scale	³⁄₁₀ Scale	¹⁄₅ Scale	¹⁄₁₀ Scale
A	7.00	6.30	5.60	4.90	4.20	3.50	2.80	2.10	1.40	0.70
B	8.50	7.65	6.80	5.95	5.10	4.25	3.40	2.55	1.70	0.85
C	4.25	3.83	3.40	2.98	2.55	2.13	1.70	1.28	0.85	0.43
D	6.00	5.40	4.80	4.20	3.60	3.00	2.40	1.80	1.20	0.60
E	4.75	4.28	3.80	3.33	2.85	2.38	1.90	1.43	0.95	0.48
F	1.50	1.35	1.20	1.05	0.90	0.75	0.60	0.45	0.30	0.15
G	7.00	6.30	5.60	4.90	4.20	3.50	2.80	2.10	1.40	0.70
H	5.00	4.50	4.00	3.50	3.00	2.50	2.00	1.50	1.00	0.50
I	6.50	5.85	5.20	4.55	3.90	3.25	2.60	1.95	1.30	0.65
J	18.50	16.65	14.80	12.95	11.10	9.25	7.40	5.55	3.70	1.85
K	14.50	13.05	11.60	10.15	8.70	7.25	5.80	4.35	2.90	1.45
L	3.00	2.70	2.40	2.10	1.80	1.50	1.20	0.90	0.60	0.30
M	17.00	15.30	13.60	11.90	10.20	8.50	6.80	5.10	3.40	1.70
N	20.00	18.00	16.00	14.00	12.00	10.00	8.00	6.00	4.00	2.00
O	0.38	0.34	0.30	0.26	0.23	0.19	0.15	0.11	0.08	0.04
P	1.38	1.24	1.10	0.96	0.83	0.69	0.55	0.41	0.28	0.14
Q	0.50	0.45	0.40	0.35	0.30	0.25	0.20	0.15	0.10	0.05
R	2.00	1.80	1.60	1.40	1.20	1.00	0.80	0.60	0.40	0.20
S	2.50	2.25	2.00	1.75	1.50	1.25	1.00	0.75	0.50	0.25
T	2.75	2.48	2.20	1.93	1.65	1.38	1.10	0.83	0.55	0.28
U	5.00	4.50	4.00	3.50	3.00	2.50	2.00	1.50	1.00	0.50
V	0.63	0.56	0.50	0.44	0.38	0.31	0.25	0.19	0.13	0.06
W	0.75	0.68	0.60	0.53	0.45	0.38	0.30	0.23	0.15	0.08
X	1.75	1.58	1.40	1.23	1.05	0.88	0.70	0.53	0.35	0.18
Y	1.25	1.13	1.00	0.88	0.75	0.63	0.50	0.38	0.25	0.13
Z	3.25	2.93	2.60	2.28	1.95	1.63	1.30	0.98	0.65	0.33
AA	1.50	1.35	1.20	1.05	0.90	0.75	0.60	0.45	0.30	0.15
BB	0.38	0.34	0.30	0.26	0.23	0.19	0.15	0.11	0.08	0.04
CC	1.50	1.35	1.20	1.05	0.90	0.75	0.60	0.45	0.30	0.15
DD	1.00	0.90	0.80	0.70	0.60	0.50	0.40	0.30	0.20	0.10
EE	2.00	1.80	1.60	1.40	1.20	1.00	0.80	0.60	0.40	0.20
FF	3.00	2.70	2.40	2.10	1.80	1.50	1.20	0.90	0.60	0.30
GG	4.50	4.05	3.60	3.15	2.70	2.25	1.80	1.35	0.90	0.45
HH	1.50	1.35	1.20	1.05	0.90	0.75	0.60	0.45	0.30	0.15
II	1.25	1.13	1.00	0.88	0.75	0.63	0.50	0.38	0.25	0.13
JJ	2.25	2.03	1.80	1.58	1.35	1.13	0.90	0.68	0.45	0.23
KK	1.18	1.06	0.94	0.83	0.71	0.59	0.47	0.35	0.24	0.12
LL	5.00	4.50	4.00	3.50	3.00	2.50	2.00	1.50	1.00	0.50

	Full Scale	⁹⁄₁₀ Scale	⁴⁄₅ Scale	⁷⁄₁₀ Scale	³⁄₅ Scale	½ Scale	²⁄₅ Scale	³⁄₁₀ Scale	⅕ Scale	¹⁄₁₀ Scale
MM	13.50	12.15	10.80	9.45	8.10	6.75	5.40	4.05	2.70	1.35
NN	15.00	13.50	12.00	10.50	9.00	7.50	6.00	4.50	3.00	1.50
OO	12.50	11.25	10.00	8.75	7.50	6.25	5.00	3.75	2.50	1.25
PP	10.50	9.45	8.40	7.35	6.30	5.25	4.20	3.15	2.10	1.05
QQ	9.50	8.55	7.60	6.65	5.70	4.75	3.80	2.85	1.90	0.95
RR	8.50	7.65	6.80	5.95	5.10	4.25	3.40	2.55	1.70	0.85
SS	8.00	7.20	6.40	5.60	4.80	4.00	3.20	2.40	1.60	0.80
TT	18.50	16.65	14.80	12.95	11.10	9.25	7.40	5.55	3.70	1.85
UU	16.75	15.08	13.40	11.73	10.05	8.38	6.70	5.03	3.35	1.68
VV	7.00	6.30	5.60	4.90	4.20	3.50	2.80	2.10	1.40	0.70
WW	3.50	3.15	2.80	2.45	2.10	1.75	1.40	1.05	0.70	0.35
XX	21.00	18.90	16.80	14.70	12.60	10.50	8.40	6.30	4.20	2.10
YY	14.00	12.60	11.20	9.80	8.40	7.00	5.60	4.20	2.80	1.40
ZZ	5.00	4.50	4.00	3.50	3.00	2.50	2.00	1.50	1.00	0.50
AAA	5.00	4.50	4.00	3.50	3.00	2.50	2.00	1.50	1.00	0.50
BBB	8.00	7.20	6.40	5.60	4.80	4.00	3.20	2.40	1.60	0.80
CCC	6.25	5.63	5.00	4.38	3.75	3.13	2.50	1.88	1.25	0.63
DDD	4.50	4.05	3.60	3.15	2.70	2.25	1.80	1.35	0.90	0.45
EEE	9.25	8.33	7.40	6.48	5.55	4.63	3.70	2.78	1.85	0.93
FFF	5.50	4.95	4.40	3.85	3.30	2.75	2.20	1.65	1.10	0.55
GGG	7.75	6.98	6.20	5.43	4.65	3.88	3.10	2.33	1.55	0.78
HHH	19.50	17.55	15.60	13.65	11.70	9.75	7.80	5.85	3.90	1.95
III	15.00	13.50	12.00	10.50	9.00	7.50	6.00	4.50	3.00	1.50
JJJ	8.00	7.20	6.40	5.60	4.80	4.00	3.20	2.40	1.60	0.80
KKK	4.50	4.05	3.60	3.15	2.70	2.25	1.80	1.35	0.90	0.45
LLL	50.00	45.00	40.00	35.00	30.00	25.00	20.00	15.00	10.00	5.00
MMM	24.00	21.60	19.20	16.80	14.40	12.00	9.60	7.20	4.80	2.40
NNN	17.00	15.30	13.60	11.90	10.20	8.50	6.80	5.10	3.40	1.70
OOO	9.50	8.55	7.60	6.65	5.70	4.75	3.80	2.85	1.90	0.95
PPP	2.50	2.25	2.00	1.75	1.50	1.25	1.00	0.75	0.50	0.25
QQQ	4.62	4.16	3.70	3.23	2.77	2.31	1.85	1.39	0.92	0.46
RRR	6.75	6.08	5.40	4.73	4.05	3.38	2.70	2.03	1.35	0.68
SSS	19.50	17.55	15.60	13.65	11.70	9.75	7.80	5.85	3.90	1.95
TTT	1.00	0.90	0.80	0.70	0.60	0.50	0.40	0.30	0.20	0.10
UUU	1.25	1.13	1.00	0.88	0.75	0.63	0.50	0.38	0.25	0.13
VVV	1.25	1.13	1.00	0.88	0.75	0.63	0.50	0.38	0.25	0.13
WWW	1.00	0.90	0.80	0.70	0.60	0.50	0.40	0.30	0.20	0.10
XXX	1.25	1.13	1.00	0.88	0.75	0.63	0.50	0.38	0.25	0.13

© COPYRIGHT 2008

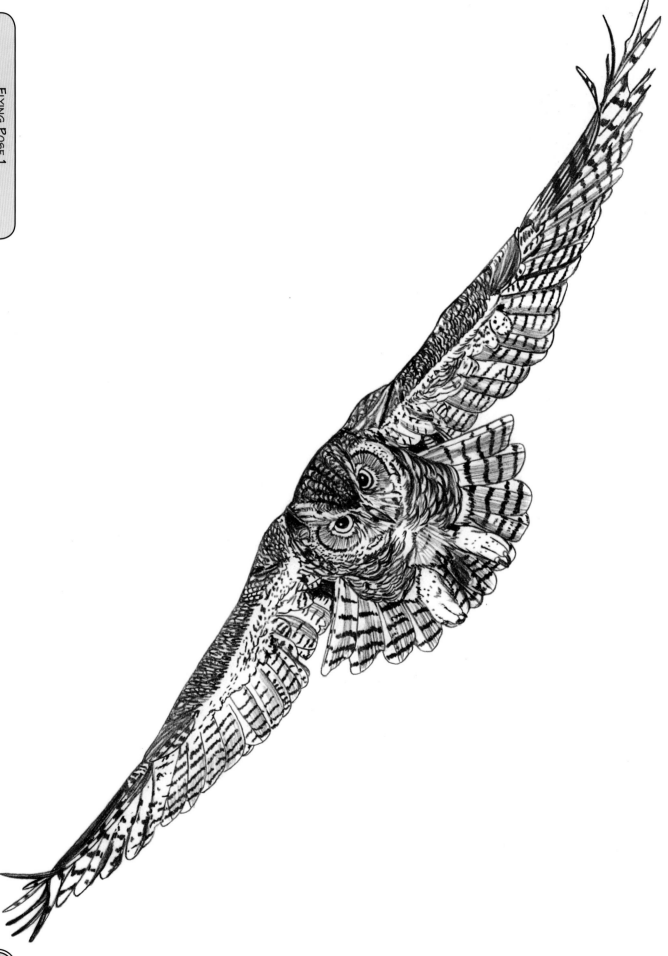

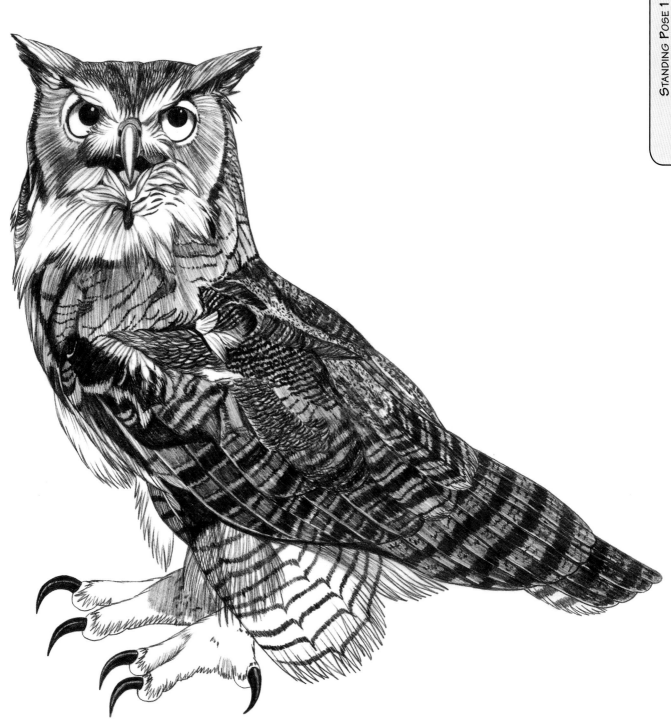

Denny Rogers
© COPYRIGHT 2008

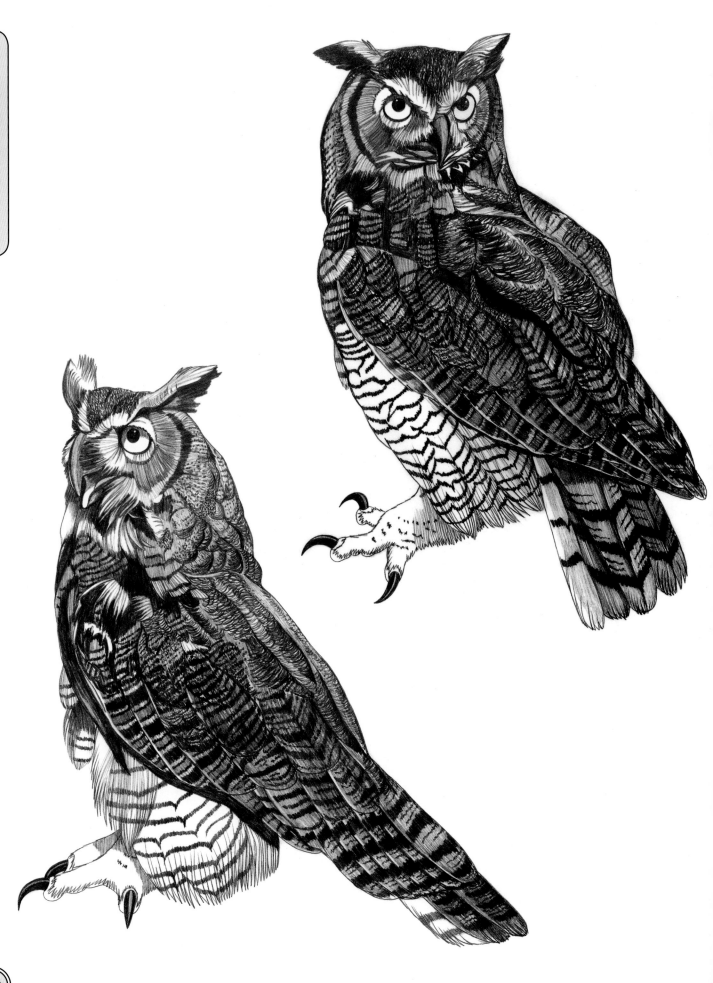

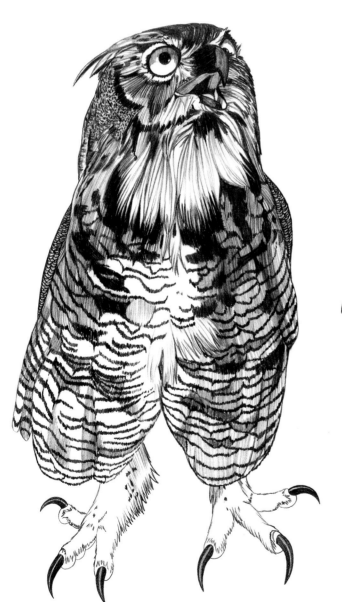
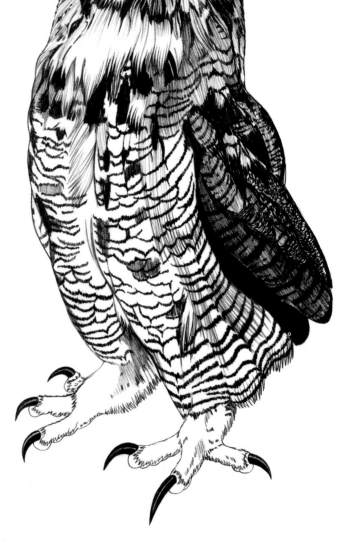

Denny Rogers

© Copyright 2008

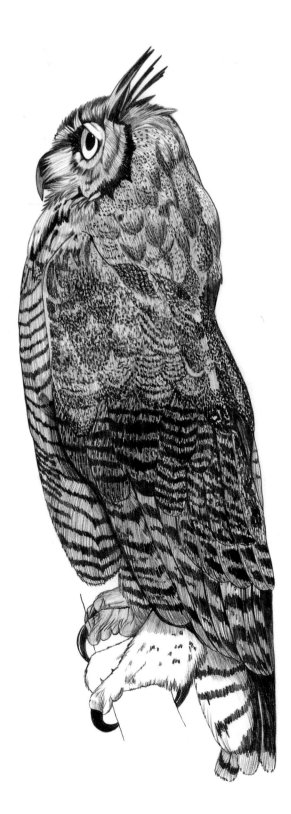
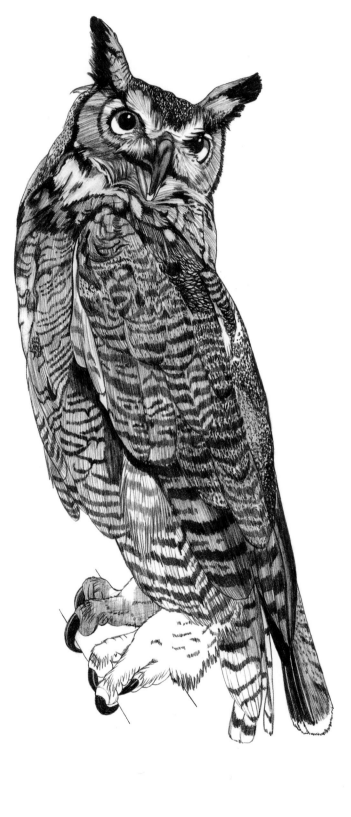

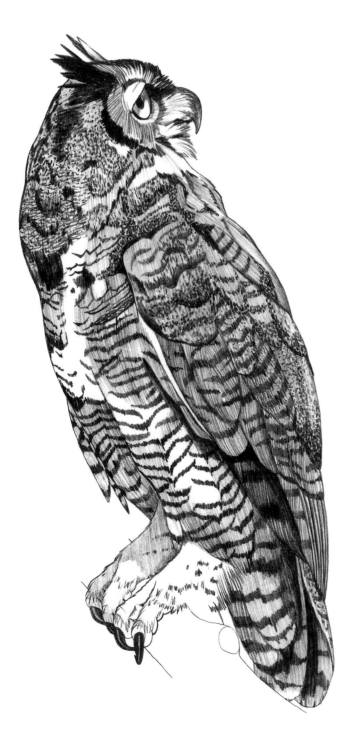

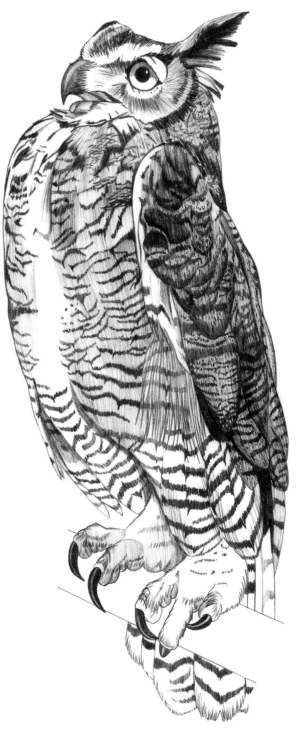

Denny Rogers

© COPYRIGHT 2008

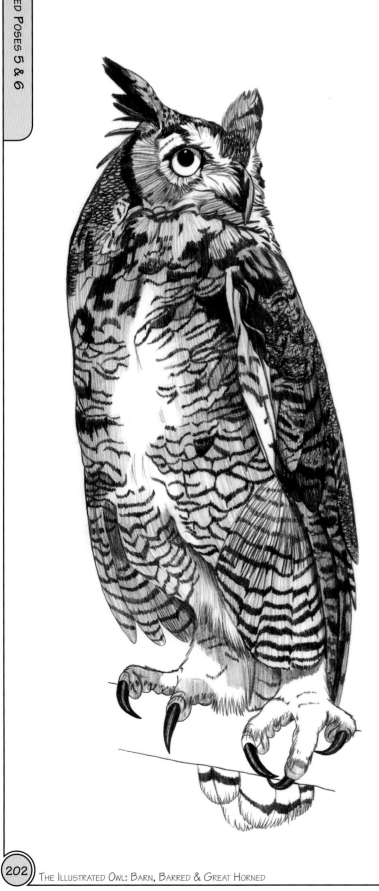
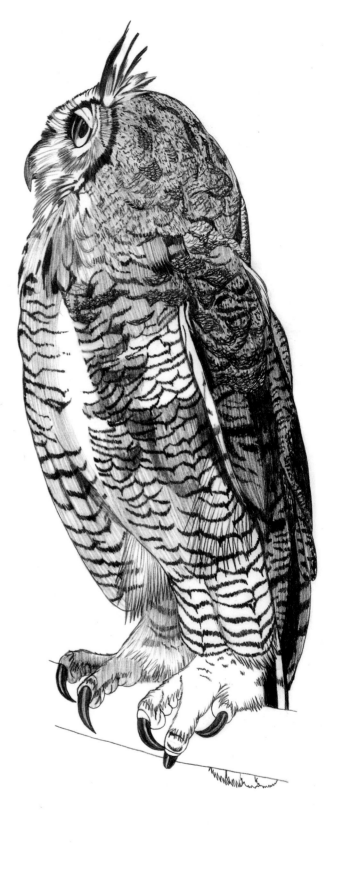

Denny Rodgers

© Copyright 2008

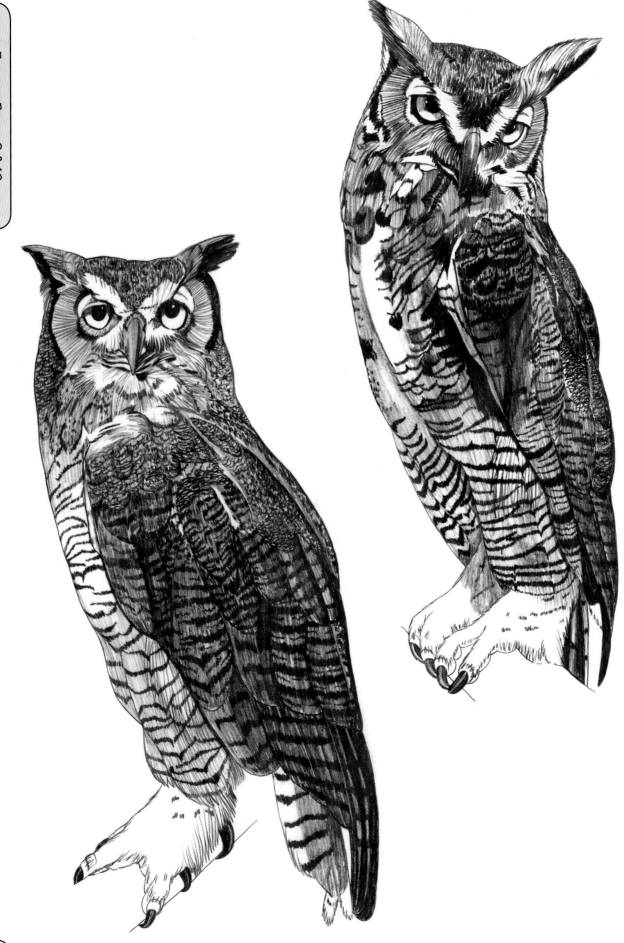

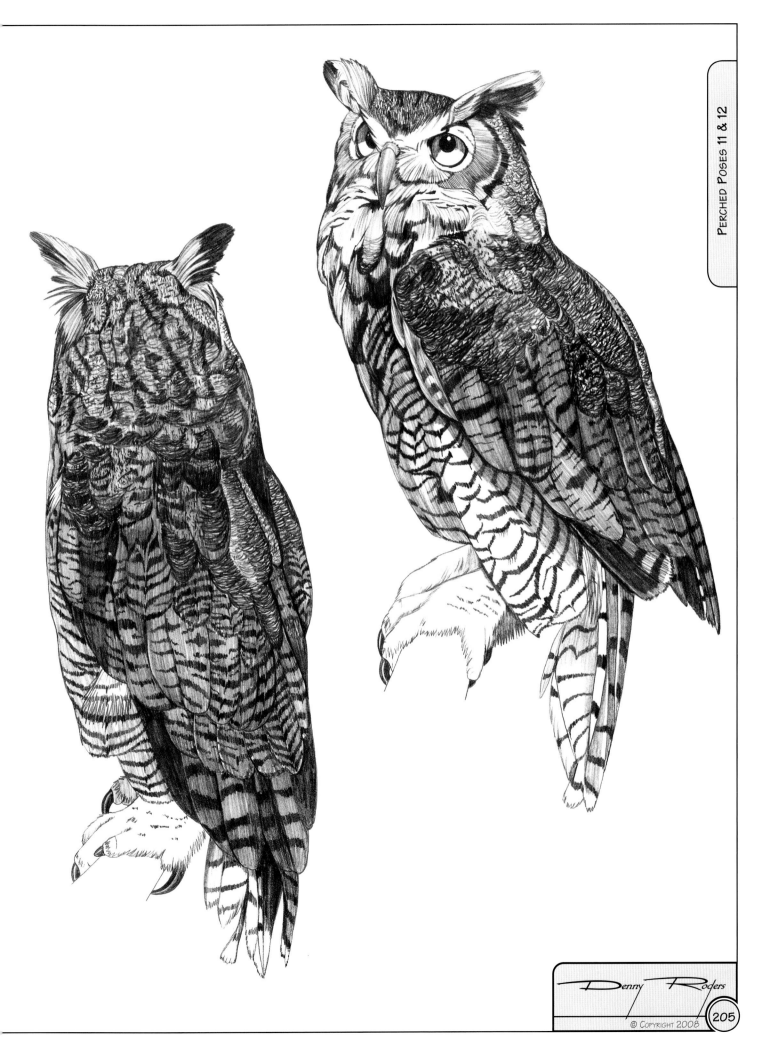

Denny Rogers

© COPYRIGHT 2008

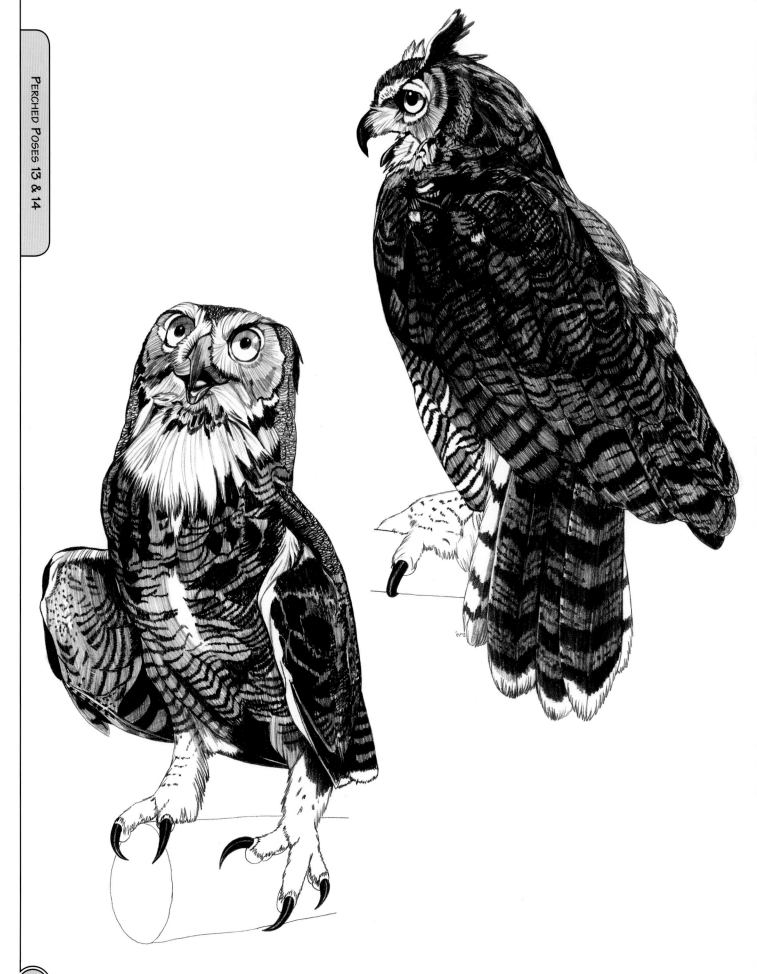

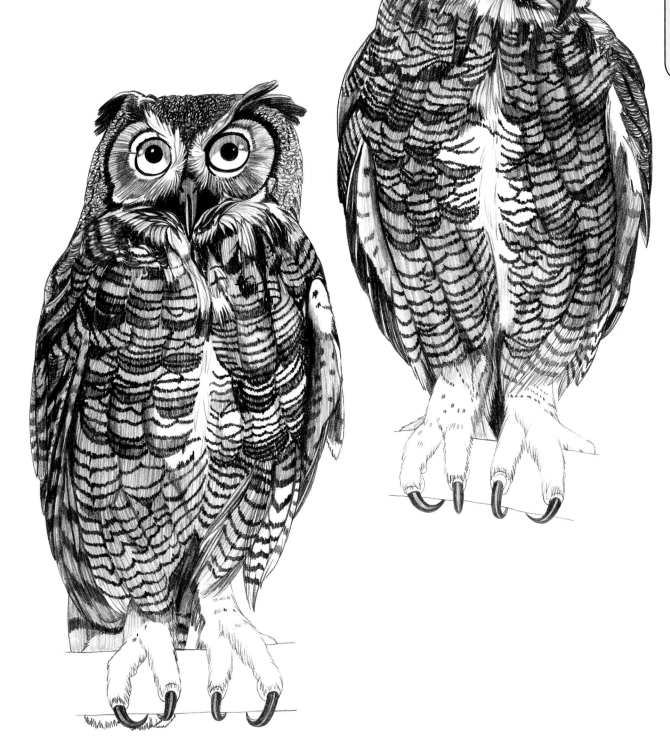

© Copyright 2008

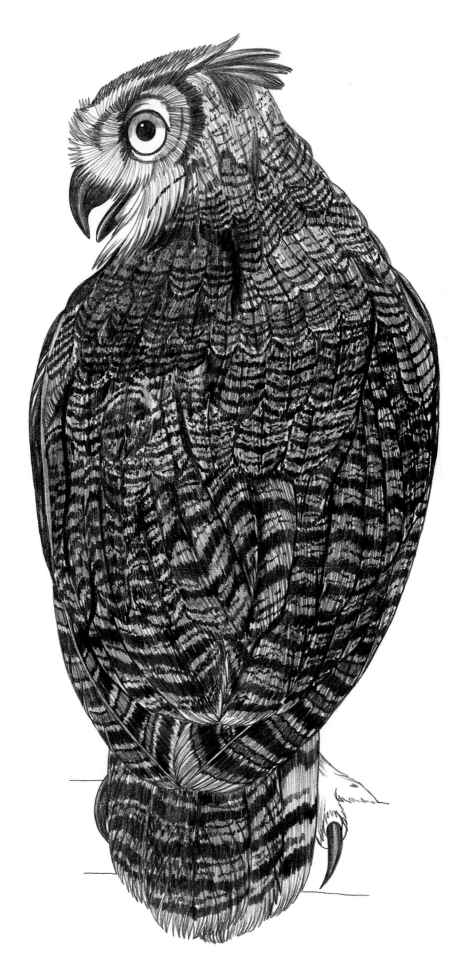

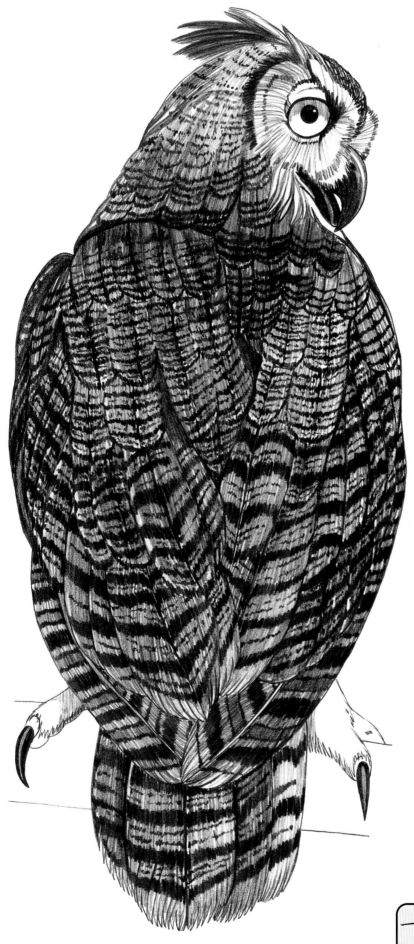

Denny Rogers

© COPYRIGHT 2008

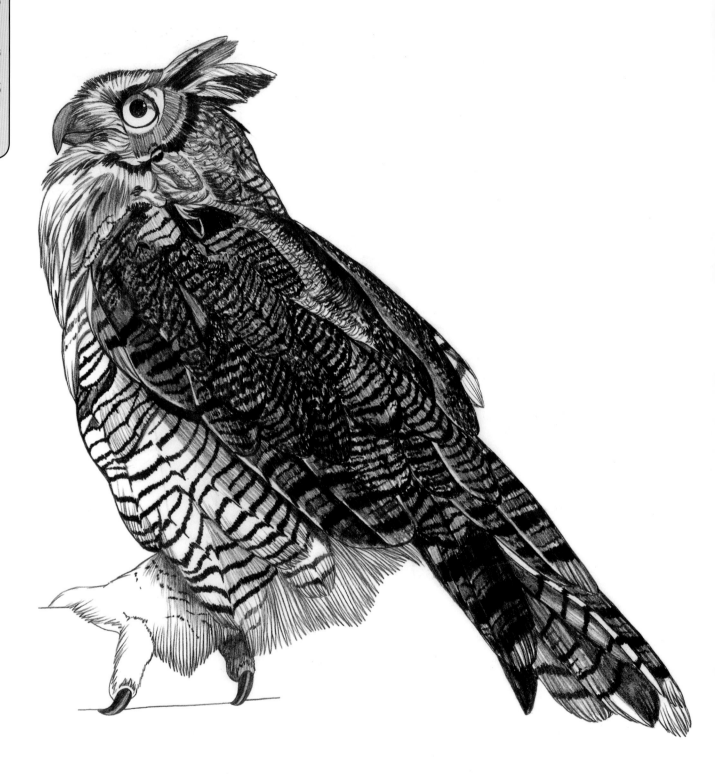

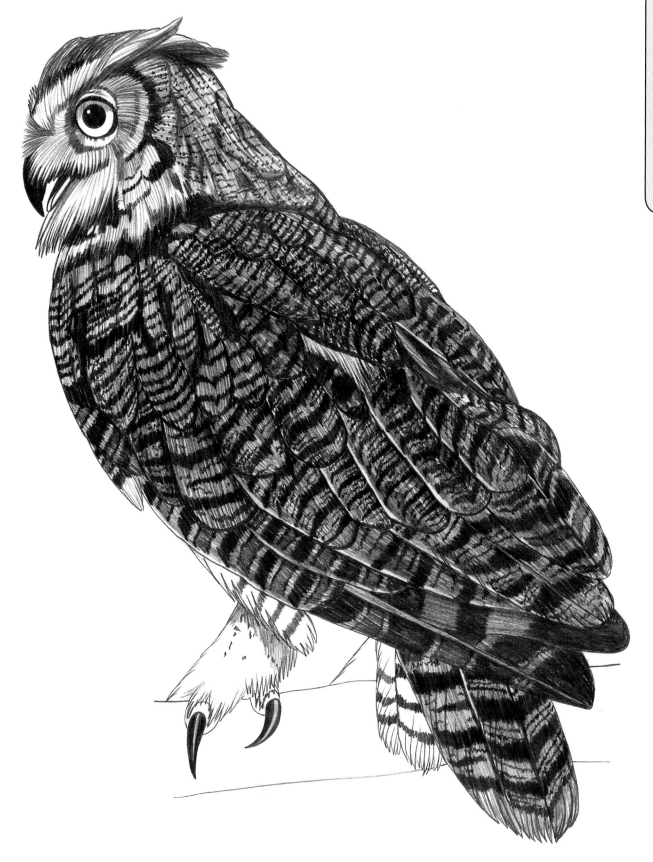

© COPYRIGHT 2008

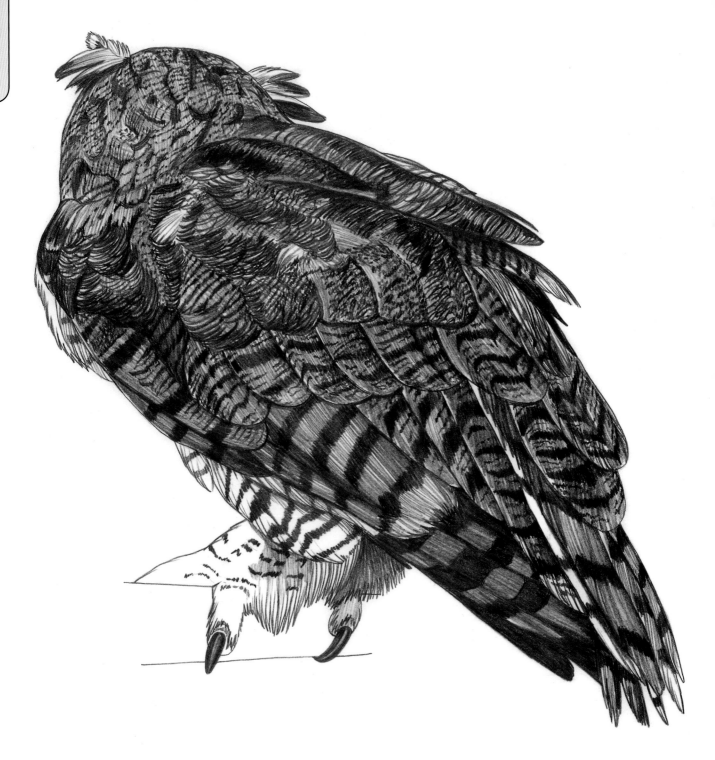

REFERENCE

There is a pair of great horned owls that have been nesting in my back yard for a few years, and I interact with them regularly. I've finally developed a fairly credible imitation of their calls, and many times on my walk to the studio for night work, I'll pause to talk to "my" pair of owls. On one memorable night, they were answering me call for call. All of a sudden, what was calling in front of me, was now answering behind me. As I turned to try to locate this phantom, I felt the breeze from another set of wings to my left. I stood stone still, not sure what their intent was, knowing they had the advantage of dark. Then one started calling, and then the other—each not ten feet away. I tentatively called back, figuring if they meant to attack, it didn't matter if I hooted or screamed. Both answered, and then...silence. I heard nothing of their exit, but gone

they were, leaving me honored to be allowed into their world for those few brief minutes.

Don't be intimidated by the complex patterning of this owl. Careful study of close-up photos, a study skin, or a taxidermy mount (if you have access) will help greatly. Look at the entire bird as a whole for the overall impression; then break it down. Look at each feather group and note the overall color and pattern. Then, study a few individual feathers on their own and note the pattern. Replicate the pattern and coloring on all the feathers in that group and you will achieve the complexity of the plumage. Make sure you select several feathers from each group and replicate those differing colors and patterns for variation.

Couple this with the anatomy reference Denny has given you and incorporate your own style and vision to create a work to rival the real thing.

—Lori Corbett

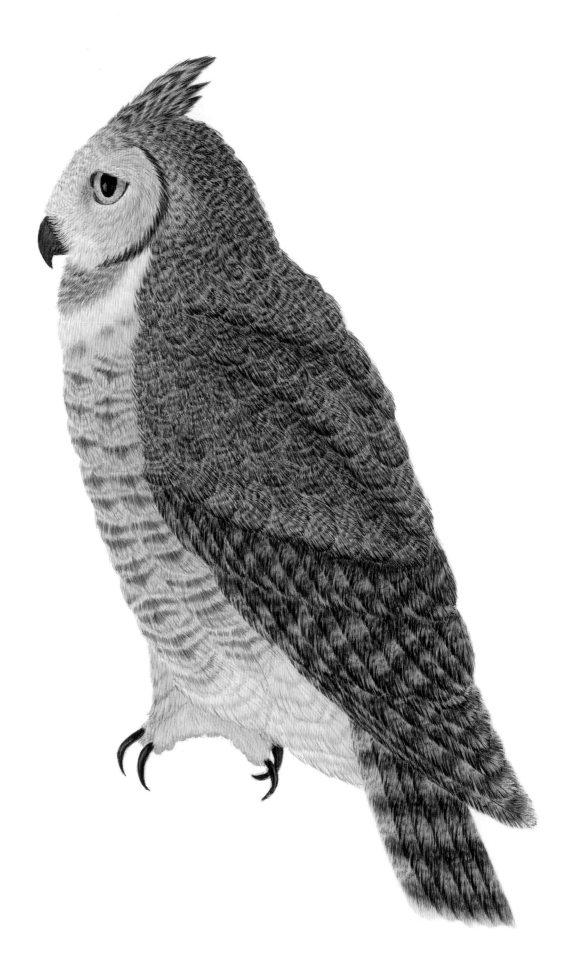

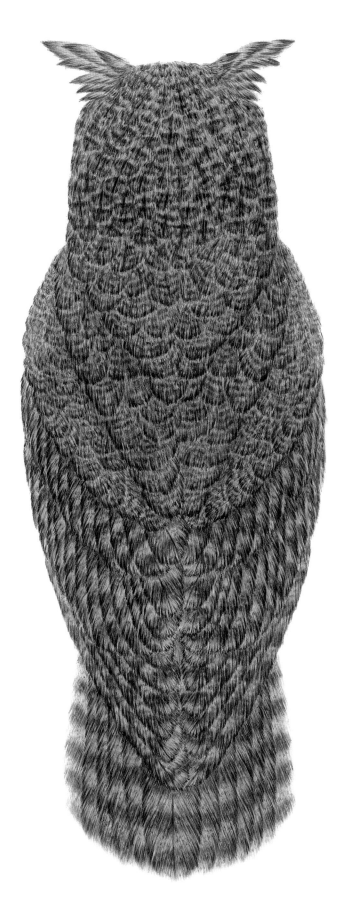

Denny Rogers

Great Horned Owl

PAINT MIXES

COLOR LIST:
RAW UMBER (PBR 7)
ULTRAMARINE BLUE (PB 29)
TITAN BUFF, ALSO CALLED TITANIUM BUFF,
 UNBLEACHED TITANIUM (PW 6)
BURNT UMBER (PBR 7)
YELLOW OCHRE (PBR 43)
TITANIUM WHITE (PW 6)
BURNT SIENNA (PBR 7)

GLAZING COLORS:
ZINC WHITE (PW 4)
TRANSPARENT YELLOW IRON OXIDE (PY 42)
TRANSPARENT RED IRON OXIDE (PR 101)
*QUINACRIDONE GOLD (PO 48/PO 49)

*GOLDEN'S VERSION OF QUINACRIDONE GOLD IS A MIXTURE. OTHER BRANDS MAY BE A SINGLE PIGMENT COLOR. EITHER IS ACCEPTABLE.

THESE GLAZING PIGMENTS, WITH THE EXCEPTION OF ZINC WHITE, ARE POWERFUL COLORS. A LITTLE BIT GOES LONG WAY. USE CAUTION—IT'S BEST TO APPLY A DILUTED LAYER AND ADD ANOTHER IF NECESSARY. ONCE THESE PIGMENTS ARE APPLIED, IT'S VERY DIFFICULT TO DISGUISE THEM IF TOO MUCH IS USED.

DO NOT SUBSTITUTE OTHER WHITES, SUCH AS TITANIUM WHITE, WHEN ZINC WHITE IS CALLED FOR. ZINC WHITE IS A TRANSPARENT WHITE AND IS ABSOLUTELY ESSENTIAL FOR THE TECHNIQUE DESCRIBED. THIS WILL ALLOW UNDERLYING DETAILS TO SHOW THROUGH, WHILE SOFTENING THE OVERALL AREA. AN OPAQUE WHITE (TITANIUM WHITE) WILL OBSCURE THE UNDERLYING DETAIL TOO MUCH AND ALSO GIVE THE AREA A CHALKY EFFECT, RATHER THAN A SOFT COLOR CHANGE. THIS IS TRUE IN ALL INSTANCES OF ZINC WHITE BEING CALLED FOR IN THESE INSTRUCTIONS.

MAKE A LARGE QUANTITY OF MIX 1 AND STORE IN AN AIRTIGHT CONTAINER. THESE ARE THE BASE MIXTURES FOR MANY OF THE OTHER MIXES.

FULL STRENGTH DILUTED

MIX 1
TITAN BUFF = 50%
BURNT UMBER = 30%
YELLOW OCHRE = 20%
ULTRAMARINE BLUE = A TOUCH
 (TO GREY THE MIX)

FULL STRENGTH DILUTED

MIX 2
MIX 1 = 50%
BURNT UMBER = 50%

FULL STRENGTH DILUTED

MIX 3
BURNT UMBER = 60%
ULTRAMARINE BLUE = 40%

NOTE: LOOK FOR VARIOUS BROWNS, GRAYS, OCHRES, AND OCCASIONAL RUSTY COLORS IN THE COMPLEX PLUMAGE OF THE GREAT HORNED OWL. AN IMPORTANT PART OF ACHIEVING SOFTNESS IN THE COMPLEX FEATHER DETAIL IS TO ESTABLISH VARIATIONS IN VALUE DURING THE BASE COATING STAGE. ONCE DETAIL AND TONING GLAZES HAVE BEEN LAID OVER THE BASE, THE VALUES WILL BE TIED TOGETHER BUT STILL DISCERNABLE. REMEMBER—NOT EVERY FEATHER SHOULD BE IDENTICAL IN VALUE OR PATTERN. YOUR EYE SHOULD BLEND THESE TOGETHER TO CREATE THE OVERALL LOOK. HOWEVER, UPON CLOSE SCRUTINY, INDIVIDUAL DIFFERENCES CAN BE SEEN—THIS IMPORTANT FEATURE IS THE KEY TO TRANSFORM FROM STATIC AND BORING TO REALISTIC AND DYNAMIC.

MIX 4
TRANSPARENT RED
 IRON OXIDE = 50%
TRANSPARENT YELLOW
 IRON OXIDE = 50%

MIX 5
TITANIUM WHITE = 40%
TITAN BUFF = 60%

MIX 6
EQUAL PARTS OF:
TRANSPARENT YELLOW IRON OXIDE
TRANSPARENT RED IRON OXIDE
ZINC WHITE

MIX 7
YELLOW OCHRE = 60%
BURNT SIENNA = 30%
TITAN BUFF = 10%

MIX 8
MIX 7 = 50%
TITAN BUFF = 50%

FULL STRENGTH DILUTED

MIX 9
BURNT UMBER = 40%
ULTRAMARINE BLUE = 60%

SET 1 – TAIL, TOP SURFACE

THE OUTERMOST FEATHER ON EACH SIDE (6) HAS A LIGHTER BASE THAN THE REST OF THE TAIL.

1. BASE COAT FEATHERS #1-5 WITH MIX 1. BASE COAT FEATHER #6 WITH TITAN BUFF.
2. BLOCK IN THE DARK BARRING WITH BURNT UMBER.
3. EITHER WET-BLEND OR AIRBRUSH RANDOM AREAS WITH TITAN BUFF.
4. DO THE SAME WITH MIX 2. ALSO, SOFTEN THE EDGES OF THE DARK BARRING WITH THIS MIX.
5. ADD RANDOM *THIN* LINE ACCENTS THROUGHOUT (INCLUDING THROUGH DARK BARRING) WITH MIX 1.
6. DARKEN THE DARK BARRING WITH A GLAZE OF RAW UMBER. THERE IS DARK VERMICULATION IN THE LIGHT AREAS—ADD THIS WITH MIX 3.
7. THERE IS LIGHT VERMICULATION WITHIN THE DARK BARRING. CREATE THIS WITH MIX 1.
8. SOME OF THE LIGHT AREAS HAVE A GOLDISH CAST. RANDOMLY APPLY A GLAZE OF MIX 4 TO ACHIEVE THIS. DO NOT GLAZE ALL THE LIGHT AREAS.
9. PAINT THE SHAFTS WITH MIX 3.

TAIL, BOTTOM SURFACE (NOT SHOWN IN ILLUSTRATION)
THE BOTTOM SURFACE OF THE TAIL IS A LIGHTER VERSION OF THE TOP SURFACE WITH LESS CONTRAST BETWEEN DARK AND LIGHT BARRING.

SET 2 – LOWER TAIL COVERTS

THE LOWER TAIL COVERTS ARE FAR MORE LOOSELY STRUCTURED THAN THE UPPER TAIL COVERTS. THEY ARE HEAVILY SPLIT AND NOT VERY WELL DEFINED. THE OVERALL COLOR IS LIGHTER THAN THE ABDOMINAL AND BREAST FEATHERS, MAINLY DUE TO LESS VERMICULATION.

1. BASE COAT WITH MIX 5.
2. ADD TWO OR THREE NARROW ROWS OF VERMICULATION WITH MIX 2.
3. ADD RANDOM THIN LINE ACCENTS THROUGHOUT WITH MIX 1 AND TITANIUM WHITE.
4. GLAZE RANDOM AREAS WITH MIX 6. DON'T GLAZE EVERY FEATHER, OR AN ENTIRE FEATHER—THERE IS A PATCHINESS TO THIS AREA.

UPPER TAIL COVERTS (NOT SHOWN IN ILLUSTRATION)
1. BASE COAT WITH MIX 1.
2. BLOCK IN THE DARK VERMICULATION WITH MIX 2.
3. EITHER WET-BLEND OR AIRBRUSH RANDOM AREAS WITH TITAN BUFF AND MIX 2 TO CREATE VARIATION IN VALUE.
4. REPAINT RANDOM LIGHT AREAS BETWEEN THE VERMICULATION WITH MIX 1.
5. ADD RANDOM THIN LINE ACCENTS THROUGHOUT WITH MIX 3.
6. DARKEN RANDOM DARK VERMICULATION WITH MIX 3.
7. SOME OF THE LIGHT AREAS HAVE A GOLDISH CAST. RANDOMLY APPLY A GLAZE OF MIX 4 TO ACHIEVE THIS. DO NOT GLAZE ALL THE LIGHT AREAS.

SET 3 – FEET AND LEGS

THE TOES ARE COVERED ON THE TOP SURFACE WITH VERY FINE FEATHERS, ALMOST RESEMBLING FUR. THE FEATHERING ENDS JUST ABOVE THE LAST JOINT ABOVE THE TALON. PAINT THE TALONS WITH MIX 9. APPLY HIGHLIGHTS ON THE TALONS WITH ZINC WHITE.

1. BASE COAT THE ENTIRE TOE WITH MIX 1.
2. ACCENT RANDOM BARBS WITH MIX 1, TITAN BUFF, AND TITANIUM WHITE TO CREATE VARIATION.
3. APPLY A GLAZE OF DILUTED TRANSPARENT YELLOW IRON OXIDE TO CREATE RANDOM SPLOTCHINESS.
4. GLAZE THE UNDERSIDE OF THE TOES WITH TRANSPARENT RED IRON OXIDE DILUTED TO ABOUT 80% GLAZING MEDIUM TO 20% PIGMENT.
5. BASE COAT TALONS WITH MIX 7.
6. APPLY MIX 8 AT THE TIPS OF THE TALONS AND GRADUALLY BLEND TO LIGHT GRAY NEAR THE TOES.

SET 4 – ABDOMEN, BREAST, THROAT, AND FLANKS

THE FEATHERS IN THE THROAT AREA UNDER THE BEAK ARE NORMALLY COMPRESSED, RESEMBLING A PINECONE. THESE AREAS ARE OVERALL LIGHTER IN COLOR, WITH RANDOM AREAS OF YELLOW AND BRIGHT WHITE. HOWEVER, EACH OWL IS AN INDIVIDUAL: SOME HAVE MORE BARRING; SOME ARE MORE YELLOW. THE WHITE UPPER BREAST FEATHERS UNDER THE THROAT ARE SOFT AND FUR-LIKE.

1. BASE COAT WITH MIX 5.
2. ADD TWO OR THREE NARROW ROWS OF VERMICULATION WITH MIX 3.
3. ADD RANDOM THIN LINE ACCENTS THROUGHOUT WITH MIX 1 AND TITANIUM WHITE.
4. GLAZE RANDOM AREAS WITH MIX 6. DON'T GLAZE EVERY FEATHER, OR AN ENTIRE FEATHER—THERE IS A PATCHINESS TO THIS AREA.
5. APPLY 2-3 DILUTED GLAZE COATS TO THE WHITE THROAT PATCH.

Denny Rogers

SET 5 – PRIMARIES, SECONDARIES, AND TERTIALS

1. BASE COAT WITH MIX 1.
2. BLOCK IN THE DARK BARRING WITH BURNT UMBER.
3. EITHER WET-BLEND OR AIRBRUSH RANDOM AREAS WITH TITAN BUFF TO CREATE VARIATION IN VALUE.
4. DO THE SAME WITH MIX 2. ALSO, SOFTEN THE EDGES OF THE DARK BARRING WITH THIS MIX.
5. ADD RANDOM THIN LINE ACCENTS THROUGHOUT (INCLUDING THROUGH DARK BARRING) WITH MIX 1.
6. DARKEN THE DARK BARRING WITH A GLAZE OF RAW UMBER. THERE IS DARK VERMICULATION IN THE LIGHT AREAS— ADD THIS WITH MIX 3.
7. CREATE LIGHT VERMICULATION WITHIN THE DARK BARRING WITH MIX 1.
8. SOME OF THE LIGHT AREAS HAVE A GOLDISH CAST. RANDOMLY APPLY A GLAZE OF MIX 4 TO ACHIEVE THIS. DO NOT GLAZE ALL THE LIGHT AREAS.
9. PAINT THE SHAFTS WITH MIX 3.

SET 6 – COVERTS

THESE FEATHERS ARE HEAVILY VERMICULATED TO THE POINT THAT IT IS DIFFICULT TO DISTINGUISH INDIVIDUAL FEATHERS. THE GREATER, MEDIAN, AND LESSER PRIMARY COVERTS ARE DARKER THAN THE REST OF THE WING. THIS DOESN'T SHOW MUCH ON THE FOLDED WING IN THE ILLUSTRATION, BUT IT IS SOMETHING TO BE AWARE OF IF YOU ARE GOING TO OPEN THE WING SLIGHTLY, OR ARE GOING TO DO A FLYING OWL.

1. BASE COAT WITH MIX 1.
2. BLOCK IN THE DARK VERMICULATION WITH MIX 2.
3. EITHER WET-BLEND OR AIRBRUSH RANDOM AREAS WITH TITAN BUFF AND MIX 2 TO CREATE VARIATION IN VALUE.
4. REPAINT RANDOM LIGHT AREAS BETWEEN THE VERMICULATION WITH MIX 1.
5. ADD RANDOM *THIN* LINE ACCENTS THROUGHOUT WITH MIX 3.
6. DARKEN RANDOM DARK VERMICULATION WITH MIX 3.
7. SOME OF THE LIGHT AREAS HAVE A GOLDISH CAST. RANDOMLY APPLY A GLAZE OF MIX 4 TO ACHIEVE THIS. DO NOT GLAZE ALL THE LIGHT AREAS.

SET 7 – SCAPULARS, CAPE, AND BACK OF HEAD

THE CAPE AND HEAD FEATHERS ARE HEAVILY VERMICULATED TO THE POINT WHERE IT IS DIFFICULT TO DISTINGUISH INDIVIDUAL FEATHERS.

1. BASE COAT WITH MIX 1.
2. BLOCK IN THE DARK VERMICULATION WITH MIX 2.
3. EITHER WET-BLEND OR AIRBRUSH RANDOM AREAS WITH TITAN BUFF TO CREATE VARIATION IN VALUE. DO THE SAME WITH MIX 2.
4. REPAINT RANDOM LIGHT AREAS BETWEEN THE VERMICULATION WITH MIX 1.
5. ADD RANDOM THIN LINE ACCENTS THROUGHOUT WITH MIX 3.
6. DARKEN RANDOM DARK VERMICULATION WITH MIX 3.
7. SOME OF THE LIGHT AREAS HAVE A GOLDISH CAST. RANDOMLY APPLY A GLAZE OF MIX 4 TO ACHIEVE THIS. DO NOT GLAZE ALL THE LIGHT AREAS.

SET 8 – FACIAL DISKS

CLOSE EXAMINATION OF THE FACE REVEALS THAT THE BARBS ON THE FACIAL DISKS CRISSCROSS EACH OTHER.

1. PAINT THE UPPER MANDIBLE OF THE BEAK WITH MIX 9. ADD HIGHLIGHTS WITH ZINC WHITE.
2. BASE COAT THE DARK BAND AT THE EDGE OF THE DISK WITH MIX 9.
3. BASE COAT THE FEATHERS OVER THE BEAK, A SMALL PATCH UNDER THE EYE, ABOVE THE EYE AND THE EYELID WITH MIX 5.
4. BASE COAT THE FACIAL DISK WITH MIX 7.
5. ADD RANDOM SHADOW STROKES WITH MIX 1 IN THE WHITE AREAS AND WITH MIX 2 IN THE DISK.
6. ACCENT/HIGHLIGHT THE WHITE AREAS WITH STRAIGHT TITANIUM WHITE STROKES.
7. ACCENT/HIGHLIGHT THE FACIAL DISK WITH MIX 8.
8. ADD THE RICTAL BRISTLES (WHISKERS) IN FRONT OF THE EYES WITH MIX 3.

SET 9 – EAR TUFTS

1. BASE COAT THE TUFT FEATHERS WITH MIX 7.
2. BASE COAT THE TIPS AND EDGES OF THE TUFT FEATHERS WITH MIX 9.
3. PULL RANDOM HIGHLIGHT STROKES THROUGH THE ORANGE AREAS WITH MIX 8.
4. PULL RANDOM SHADOW STROKES THROUGH THE TUFT FEATHERS WITH MIX 3.

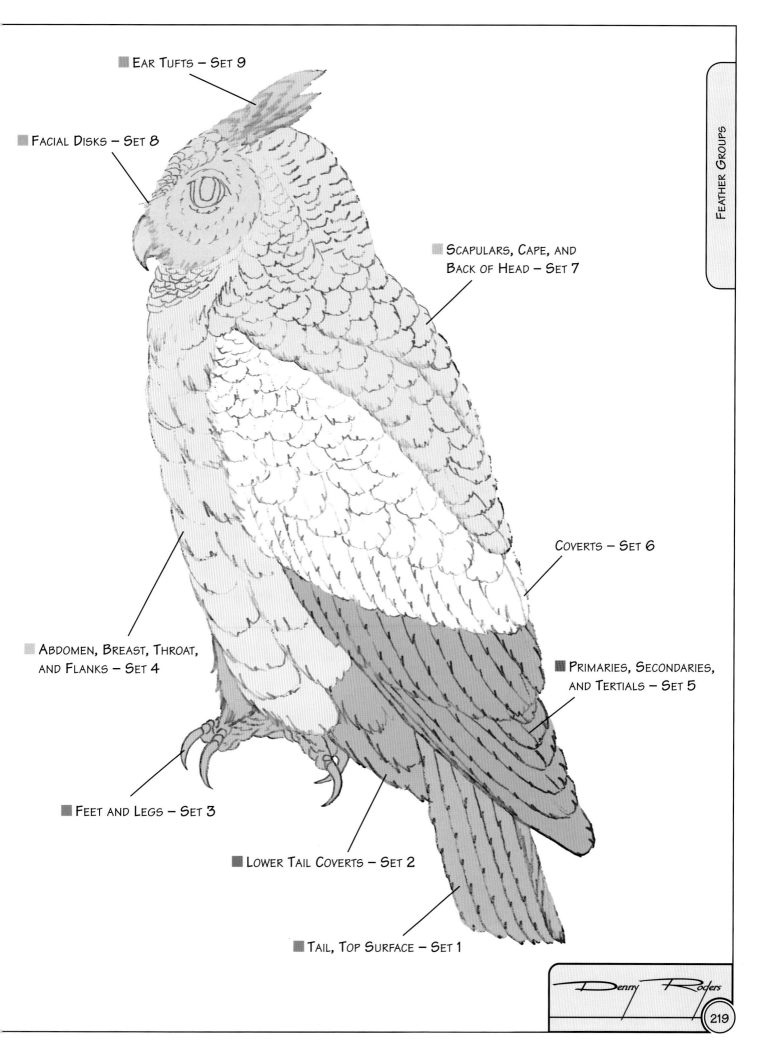

EAR TUFTS – SET 9

FACIAL DISKS – SET 8

SCAPULARS, CAPE, AND
BACK OF HEAD – SET 7

COVERTS – SET 6

ABDOMEN, BREAST, THROAT,
AND FLANKS – SET 4

PRIMARIES, SECONDARIES,
AND TERTIALS – SET 5

FEET AND LEGS – SET 3

LOWER TAIL COVERTS – SET 2

TAIL, TOP SURFACE – SET 1

Denny Rogers

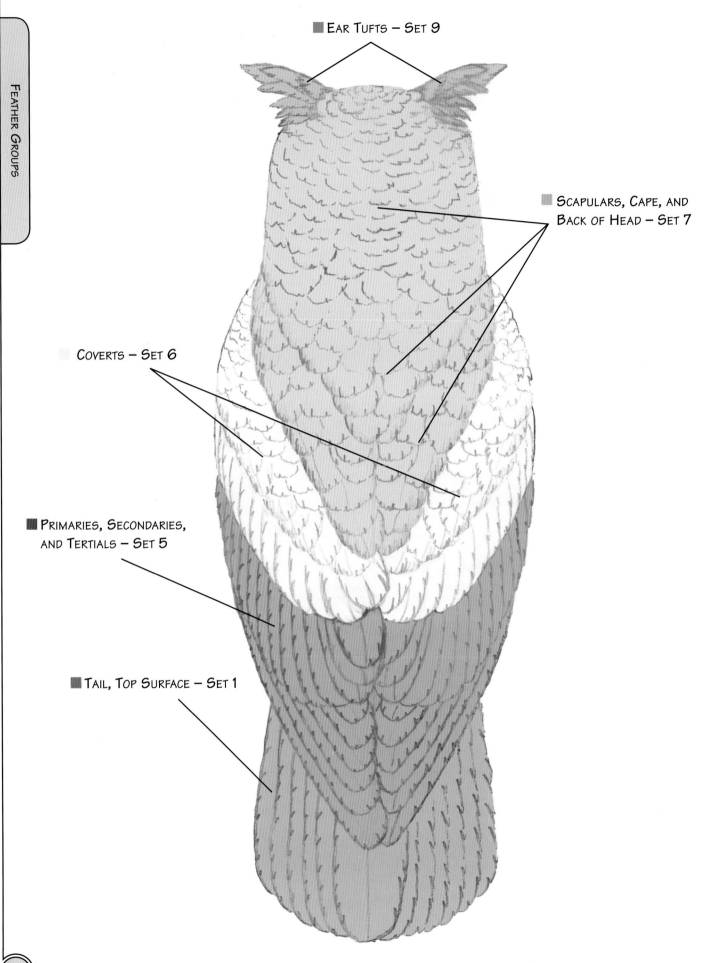

EAR TUFTS – SET 9

SCAPULARS, CAPE, AND
BACK OF HEAD – SET 7

COVERTS – SET 6

PRIMARIES, SECONDARIES,
AND TERTIALS – SET 5

TAIL, TOP SURFACE – SET 1

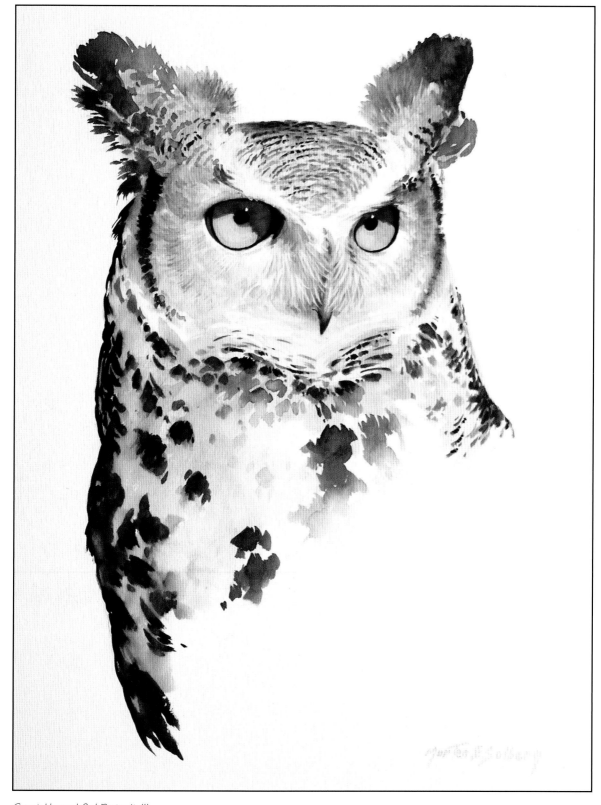

Great Horned Owl Portrait III

Morten E. Solberg

Transparent watercolor, 2007

14" x 10"

This transparent watercolor was approached in the same way that the artist paints acrylics—by placing the darks in first and softening most of the dark edges. Then, the soft shadow was applied to the whites of the feathers and gold was added. Lastly, the artist strengthened the colors until he was satisfied and left the painting as an unfinished portrait.

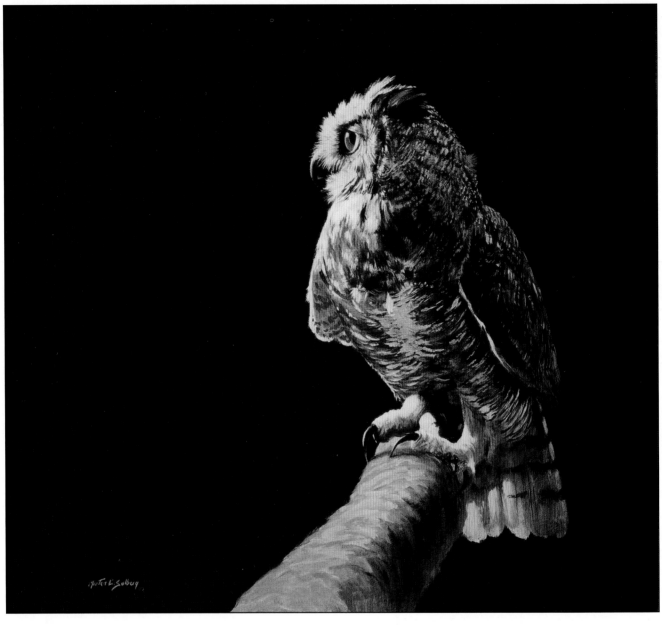

Great Horned Owl Portrait IV

Morten E. Solberg

Oil, 1998

11" x 14"

This original was painted for an exhibition of representational art in Denver, Colorado. The artist wanted to achieve some depth and romance to the piece, so he attempted an "Old Masters" look, utilizing a dark background and strong light on the front of the owl.

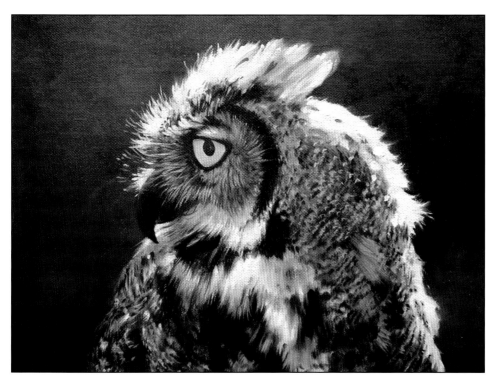

Great Horned Owl Portrait
Morten E. Solberg
Oil on canvas, 2001
9" x 12"

This oil painting is done entirely with a ½" flat brush. The artist concentrated on brush stroke direction, laying in the darks first to form the design, and then adding the gold, the grey, and finally the white. The eye was the most difficult portion of the piece.

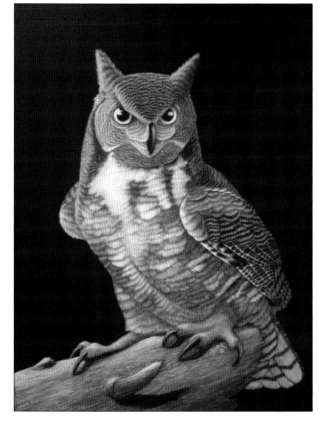

Great Horned Owl
Carol André
Acrylic on scratchboard, 2007

This piece was an exercise in capturing dramatic lighting, the softness of the feathers, and multiple textures. The artist also wanted to capture the chutzpah and fierceness of a great horned owl.

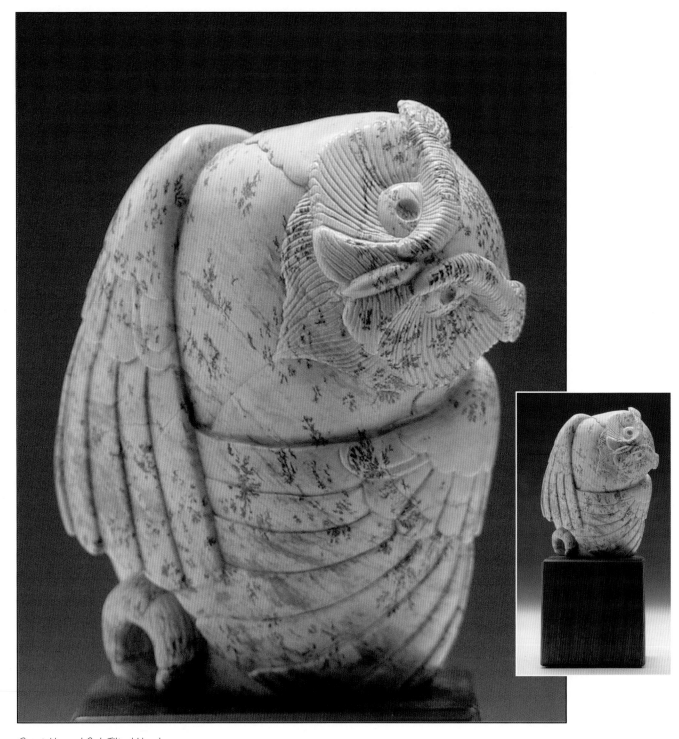

Great Horned Owl, Tilted Head

Clarence P. Cameron

Montana dendritic soapstone and dark-stained cherry base, 2003

8" high

Collection of James Ketchum, Bethesda, Maryland. While at first glance, this owl contains a bit of whimsy, it is still very indicative of the strength of a great horned owl. (And owls actually do tilt their heads like this quite often.)

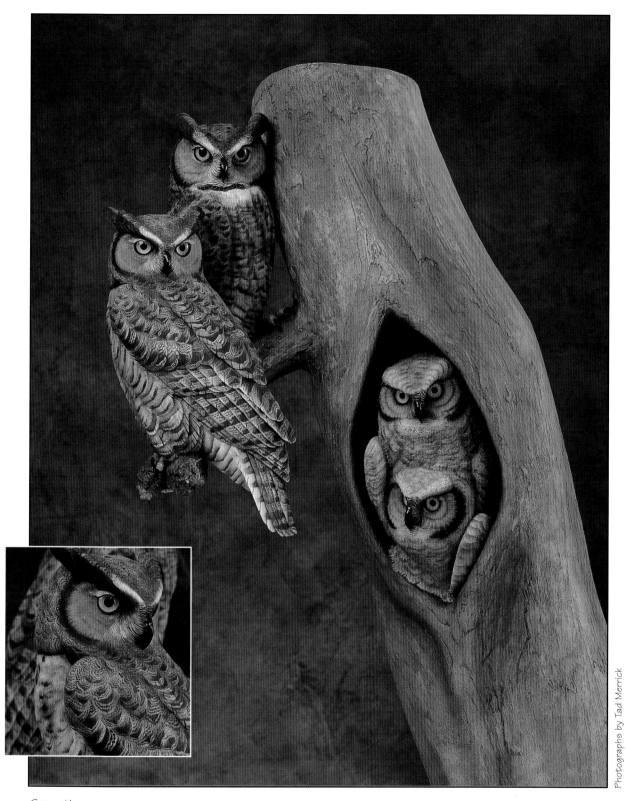

Photographs by Tad Merrick

Generations

Floyd Scholz

Tupelo and maple burl, 2000

This family of great horned owls was a private commission, created to fulfill the owners' desire to bring a little bit of the outside woodlands into their home. The piece was created to fill a curved wall space at the top of a large staircase. The goal was to create a pleasing yet dynamic sculpture of unity and paternal protection. The adults stand guard as the youngsters begin to explore the world around them. The maple burl shelf (not pictured) features leaves carved and stained to resemble a New England forest floor in autumn.

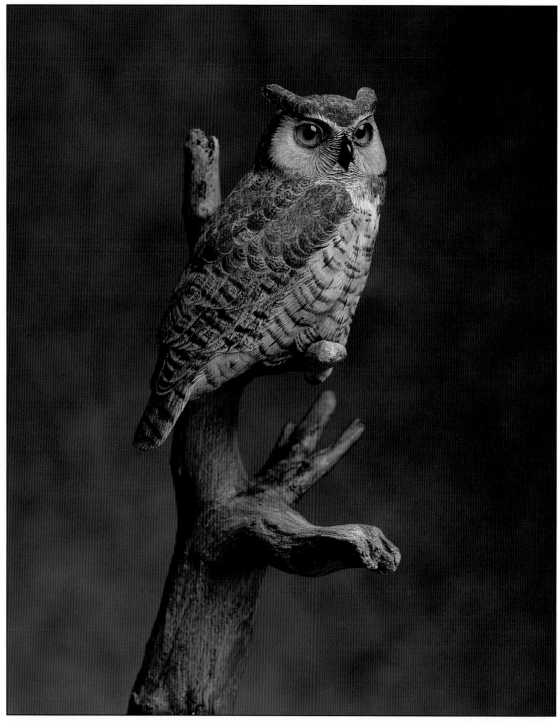

Photograph by Tad Merrick

Nightwatch

Floyd Scholz

Tupelo wood and acrylics, 1998

⅓ scale miniature carving

Private collection. Even in a scaled-down format, the power and grace of this formidable winged hunter comes forth. Its cryptic plumage allows it to blend seamlessly into its forest environment: A classic example of nature's stealthy design.

This perched pose demonstrates alert ear tufts, the natural foot position when perching, and the transition between the mottled wing feathers and the pronounced barring on the legs.

This owl is demonstrating a sitting position. Note the open beak, as well as the angle of the ear tufts. I am also attempting to measure the height of the owl.

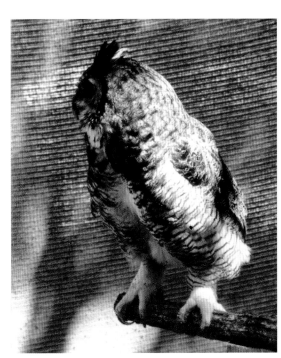

The owl is alert to surrounding distractions (namely, me) and is constantly aware of whether his defense perimeter is breached. Notice the fuzzy feathers on the feet.

Observe the color of the great horned owl's eyes; depending on the light or shade, they can range in color from yellow to orange. Also, note the rotation of the head.

© COPYRIGHT 2008

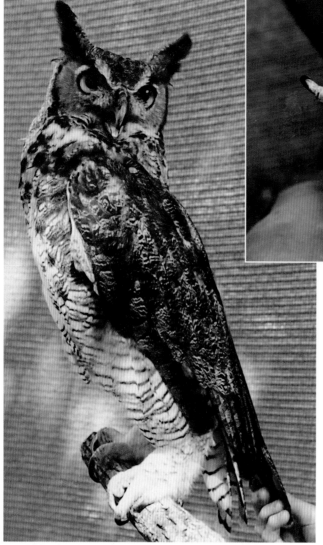

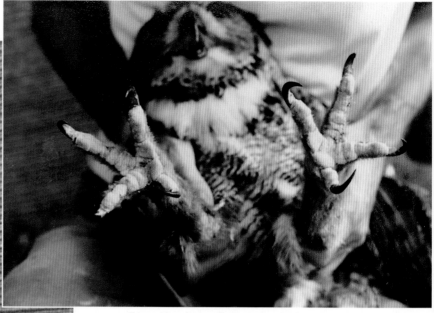

This owl has been rolled onto its back to demonstrate its natural defense position. Observe the open beak and extended talons.

This fully alert, perched owl is ready to react. Notice the open beak; in addition to showing aggression, it is also a technique used to expel heat during the summer. Also note the fully alert position of the ear tufts.

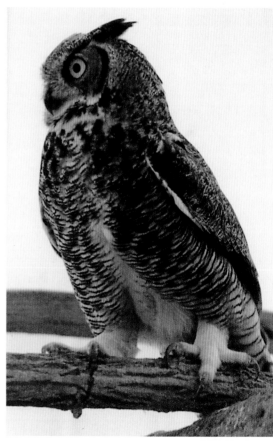

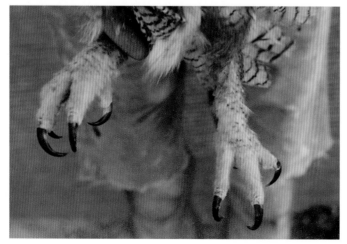

This perched pose captures the relaxed position of the ear tufts, as well as the mottling, pronounced barring, and tawny/white underparts.

Note the relaxed talons in flight position.

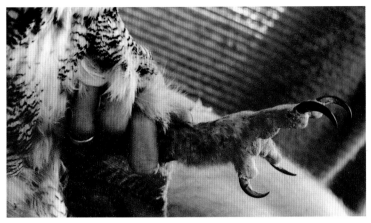

The talons are extended in attack position; this is what they look like when they're about to make a grab.

Observe the transition between the mottled effect and the barring on the top of this fully extended wing. This view is useful for flight poses.

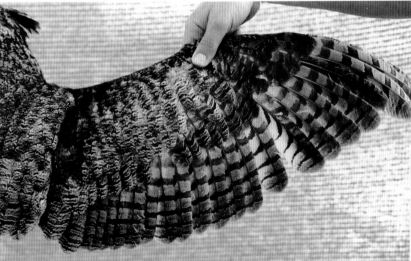

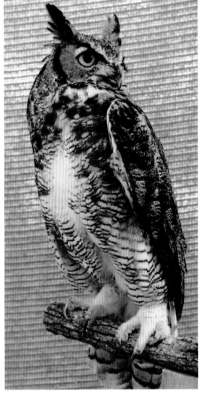

This alert owl is focusing on its prey. The ear tufts are fully extended to aid hearing.

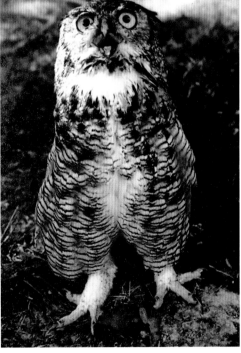

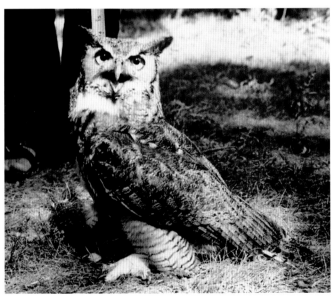

Though this owl is mentally engaged, its body is relaxed. In this sitting pose, the feet are flatter and the pose less erect than a perched pose.

The flattened ear tufts, along with the open beak, show the anger of the owl. When standing fully erect, the owl can gain as much as 8"; this is equivalent to the difference between our squat and stand. Also notice the pure white feathers in the center of the breast.

© COPYRIGHT 2008

Observe the laid-back ear tufts and the richness of the mottling on the wing feathers.

This view highlights the back side of the ear tufts. Also note the whitish underside of the tail feathers in comparison to the darker top sides.

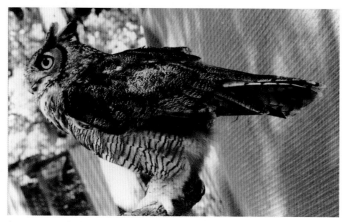

Again, note the laid-back ear tufts; the owl is taking in sight and sound. This view also showcases the barring on the legs.

This alert owl is reacting to my physical challenge. Note the erect ear tufts and open beak.

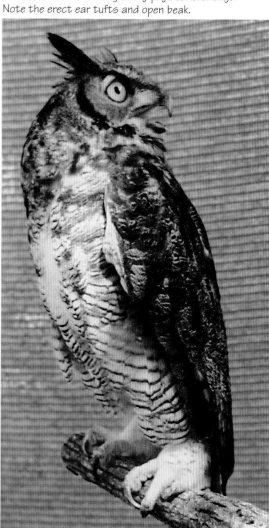

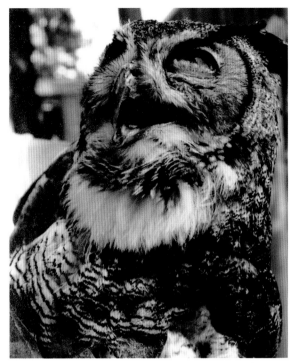

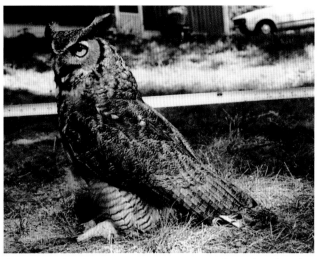

This alert owl is demonstrating a sitting pose. Note the splayed talons and the position of the body in relation to the ground.

Observe the fluffy white feathers around the beak of this aggressive owl. The short bristly eye feather rings, which serve the same function as eyelashes, are especially prominent in this photograph.

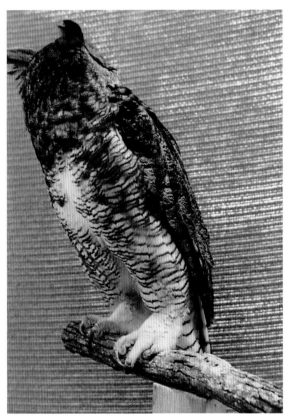

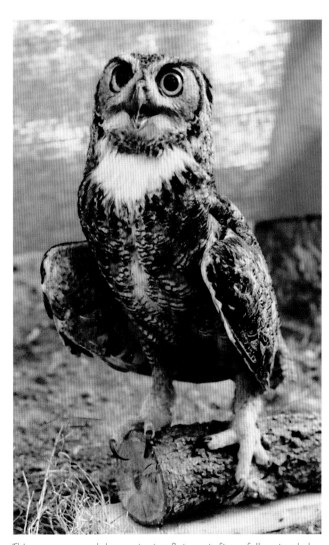

Observe the rotation of the head; the owl is reacting to a noise behind it. Owls have extremely flexible neck rotations; though they cannot turn their heads a complete 360 degrees, they can reach up to 300 degrees.

This very angry owl demonstrates flat ear tufts, a fully extended body, and dropped wings; it is ready to attack with both feet.

THE SCIENCE OF FLIGHT

This section, which includes both anatomy and physics, gets into the nitty-gritty of flight. It is my hope that after reading these pages, you will be able to understand how a bird flies and be able to create more realistic owl art. My studies of bird anatomy qualified me to pen the section on the anatomy of flight; however, I'm not a scientist—just a creative who tries to pull together technical people to move our collective interests forward. In that spirit, I took a trip to Florida to visit my long-time friend, retired professor Jim Thean, PhD in mathematics, physics, and science, and tasked him with explaining the complexities of bird flight from a scientific perspective.

Professor Thean and I have been buddies since early grade school. We grew up together playing sports, hunting, fishing, and pursuing the mysteries of the world. Jim was always voted "Most Likely to Succeed," while I was voted "Most Likely to Do Life Without Parole." We both won—he fulfilled his title, while I escaped mine. We went on to different degrees at different universities, but time and distance haven't eroded our friendship.

Jim's professorships and research took him to Purdue, U. of Georgia, Florida A&M, FSU, and Notre Dame. He has done original research in human toxicology, analytical environmental research, analytical development, and mass spectrometry, as well as developing co-polymers and serving as lab director for world food and manufacturing corporations. He has served on numerous Florida stewardship committees, working on nature preservation and conservation lands. His efforts can be found in your refrigerators, grocery stores, vehicles, tools and materials, wildlife and nature conservation, and the very air you breathe. Today, Floridians know him as Pompano Jim—Fishing Guide. He operates a beach taco stand 200 feet from the famous Red Bar. Jim always enjoys meeting kindred spirits; write him at Dr. Jim Thean, 126 Holtz Ave, #2, Grayton Beach, Florida 32459. If you're lucky, he might take you fishing. If the fish aren't biting, you may gain insight into quantum mechanics, black holes, or what happens when you turn on the headlights of a spaceship traveling at the speed of light.

Dr. Thean wrote the following while watching over the return of some green sea turtle hatchlings to the sea and releasing oversized redfish into the Gulf of Mexico.

The following equations are based on a large female great horned owl with a 25" body length, a 60" wingspan, and 5.5 pound body mass.

The Physics of Flight

By Dr. Jim Thean, PhD

From an artist's perspective, have you wondered what physical principals and corresponding mathematics govern the flight of birds? It's easily explained. Let's look at the basic principles in pictorial comparison between birds' wings and airplane wings.

Figure B represents an airplane wing and an owl wing moving with velocity (V) through a medium. In this case, the medium is air. The airplane wing and bird wing give rise to the potential force needed to overcome gravity to create lift to sustain flight. So, Area = B x C for each body in flight (see **Figure A**).

Figure C dissects an owl and a plane wing, and shows the vector from lift (\vec{L}) for each profile. It is important to compare the two so that you understand how each flyer can maneuver, stall, and change velocity and direction. All of the drawings show the position that the wing must be in to represent realistic situations. Owls fly, stall out, dive, and perform seemingly impossible maneuvers, but all of the flight conditions (α, \vec{L}, \vec{D}, coefficients of lift) must be satisfied at all times.

Figure D represents the attack angle of the flyer. In order to climb, both flyers must adopt a α (angle of attack) through the medium air. The angle of attack can be increased by each flyer until the flyer stalls. This is represented in **Figure E**.

The flyer can climb with any rate of α. It must put more energy into its system as α increases. The bird can use the α stall to "stop" in midair, change directions, or dive. The artist must consider all of these αs when creating an artistic composition of any bird of prey to maintain realism.

Figure A. This diagram shows where to find the dimensions needed to calculate the area of an airfoil or wingspan.

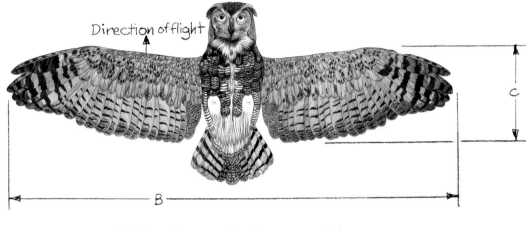

Direction of flight

C

B

$S = BC =$ Area of Wingspan (S)

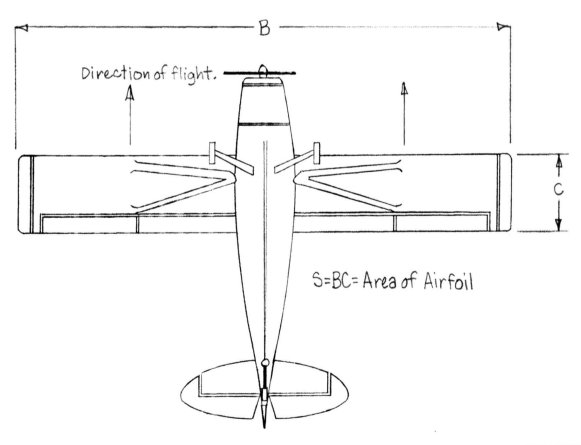

B

Direction of flight.

C

$S = BC =$ Area of Airfoil

© COPYRIGHT 2008

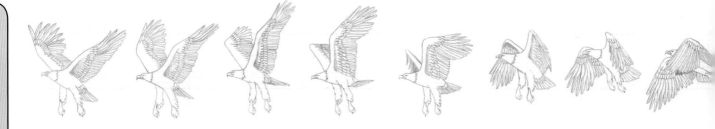

The mathematical formula governing lift is $L = \frac{P}{2} V^2 SC_L$ where P = density of medium; V = velocity through medium; C = coefficient of lift; L = vector quantity; and S = area of airfoil. L has direction as well as magnitude.

The next logical question must be, "Why does movement through air generate lift in the first place?" The answer is the Bernoulli equation. This equation was the result of Bernoulli's work with fluid dynamics. $F\perp$ is a force created when air moves under a wing and rejoins the air moving above a wing at point B. The Bernoulli solution to this dynamic problem demands that F_B be positive and directed upwards. The airplane wing and bird wing both use this principle (**Figure F**). Remember to have consideration for the principles outlined here so that the owls in your artwork present realistic forms, whether in two or three dimensions.

Lift is produced by an airfoil wing's curved shape. Air passes over the rounded upper surfaces, rushing faster than the air moving under the flat bottom surface. This creates low pressure above the wing, causing high pressure under the wing to push the plane upward.

Anatomy of Flight

By Denny Rogers

Flight involves creating one force to overcome another force. Lift is created primarily by the actions of the secondaries and related feather tracts on the inner areas of both wings. The primaries of the wing and their coverts combine to overcome drag, the air pressure against a body. The ratio of lift must be greater than body weight to sustain flight; drag must be reduced to zero to allow forward motion by the primaries. Speed and air density passing the wings and body determine lift and drag and are subject to the shape of the wing and the angle to which the inner and outer wing parts are moving through the air.

A wing is shaped so that air passes across the upper convex surface and the under concave surface to the trailing edge of the flight feathers. The upper air current must travel farther and faster to join the underwing airstream as it meets behind the wing. The higher the speed of an airstream, the less pressure is exerted on the wing surface. That means that the pressure on the topside is less than on the underside, which, in turn, produces upward lift. This produces drag. When drag becomes so great that the airstream no longer flows smoothly across the upper wing surface, turbulence destroys the pressure difference that creates lift, thereby creating the stalling angle. Stalling occurs when drag and backward pressure on the wing stop the forward motion. Stall is used effectively in precision landing.

Wing tip vortex is created when the air from under the wing continues up into the low-pressure area above the wing, creating a secondary drag effect. The spaces between the outside primaries diminish vortex. Each primary feather is itself an airfoil that independently creates lift and diminishes the amount of drag and turbulence.

To change directions, the owl alters the camber, or the length of stroke of one wing. This increases lift on one side and pushes the bird in the opposite direction.

The tail has three functions. It is used as a brake, as a rudder, and to create a trailing slot to enhance the function of the wing. The air over the tail increases the airspeed over the surface of the wing and extends the point of stall when the bird lands.

Lift increases with airspeed but multiplies disproportionately to the airspeed. For example, twice as much airspeed produces four times the amount of lift. The amount of drag increase is more than lift increase. The more speed that is developed, the more lift occurs, which expends less energy and shortens the stroke to sustain flight.

The primaries of the wing tips propel the screech owl forward on the downstroke and upstroke. The remainder of the wing primaries serve as a lifting surface while the wings move to reach the bottom

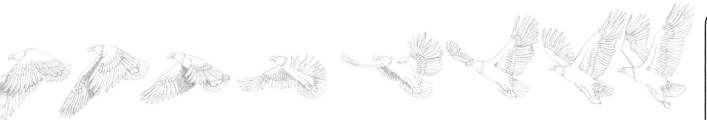

Though an eagle was used to illustrate this flight sequence, the mechanics of flight are the same for owls.

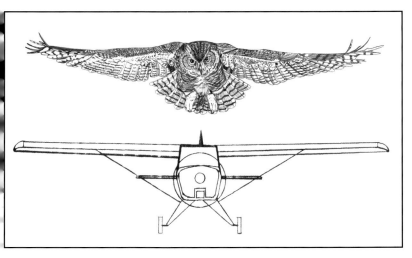

Figure B. Note the prominent leading edge of the wings of the bird and plane, and how the trailing edge tapers to zero to provide lift to both body masses.

This airfoil concept is essential to every category of artisan when creating a bird in flight.

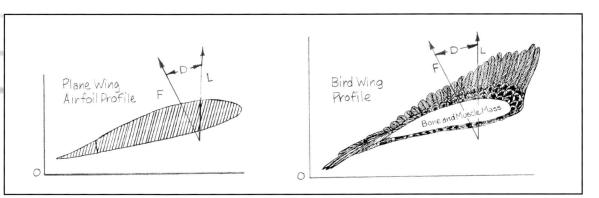

Plane Wing Airfoil Profile

Bird Wing Profile

Bone and Muscle Mass

Figure C. Cross sections of a plane and bird wing showing the vector from lift.

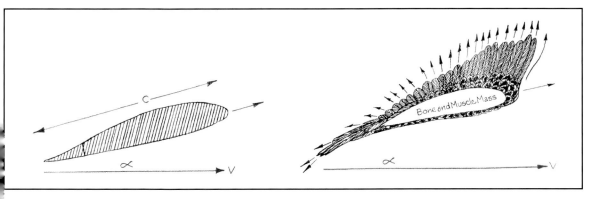

Bone and Muscle Mass

Figure D. Cross sections of a plane and bird wing showing the attack angle of the flyer.

© COPYRIGHT 2008

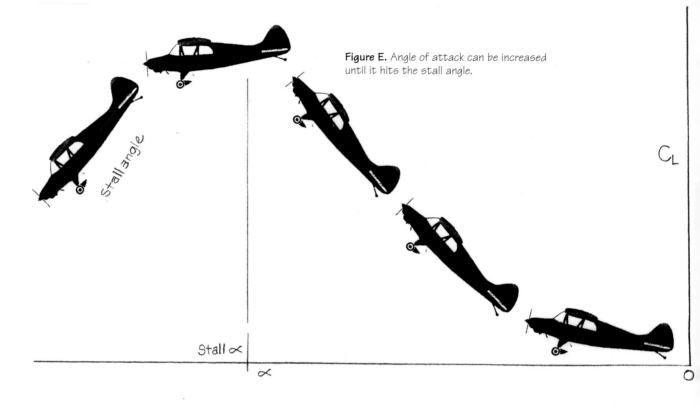

Figure E. Angle of attack can be increased until it hits the stall angle.

Stall angle

C_L

Stall \propto

\propto

O

of the downstroke. The upstroke causes the wings to move at a backward angle, which twists the primaries to allow air to pass through. This causes minimal drag, which pushes the bird forward. At the top of the stroke, the primaries realign with the wing for the downstroke.

The alula functions similar to a thumb. Located at the beginning of the primaries, the alula is flexible and independent and can be used to create faster air currents over the inside of the primaries. This small wing, which can be drawn forward, is used on the downstroke. It increases lift, reduces turbulence, and is used to control stall and braking when landing.

The upper wing and underwing secondaries and the coverts between the shoulder and wrist are the principal parts of a wing. The feathers attached to the elastic forearm skin and forearm bone create the airfoil shape necessary to the wing. This airfoil section provides the principal amount of lift necessary for flight with other body feather tracts contributing less. The humerals, post humerals, and subhumerals between the shoulders and elbows fill the area between the body and secondaries, thereby providing the bird with a greater ability to sustain lift.

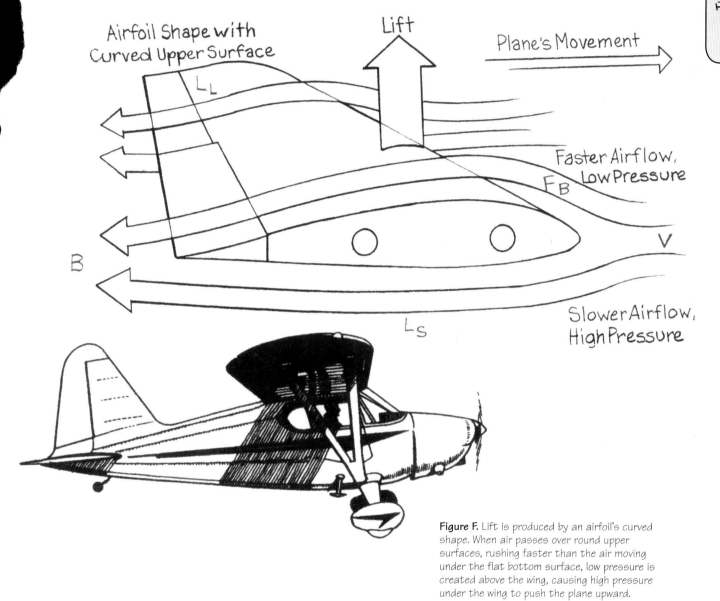

Airfoil Shape with
Curved Upper Surface

L_L

B

Lift

Plane's Movement

Faster Airflow,
Low Pressure

F_B

V

L_S

Slower Airflow,
High Pressure

Figure F. Lift is produced by an airfoil's curved
shape. When air passes over round upper
surfaces, rushing faster than the air moving
under the flat bottom surface, low pressure is
created above the wing, causing high pressure
under the wing to push the plane upward.

Denny Rogers

© COPYRIGHT 2008

Listing of Featured Artists and Contributors

Carol André , Member of Artists for
Conservation (AFC)
c/o Fox Chapel Publishing
1970 Broad St.
East Petersburg, PA 17520
www.natureartists.com

Clarence P. Cameron
Cameron Owls
633 Cedar St.
Madison, WI 53715
www.owlman.com

Lori Corbett
Whispering Eagle Studio
530 E. Fifth St. North
St. Anthony, ID 83445
(208) 624-7717
www.whisperingeagle.com
lcorbett@cableone.net

Tim McEachern
c/o Fox Chapel Publishing
1970 Broad St.
East Petersburg, PA 17520
(603) 358-3075

Tad Merrick
Tad Merrick Photography
P.O. Box 950
Middlebury, VT 05753
(802) 388-9598
www.tadmerrick.com

Denny Rogers
13723 Burr Oak Rd.
Bloomingon, IL 61704
(309) 622-0182

Floyd Scholz
P.O. Box 150
Hancock, VT 05748
(802) 767-3552
www.VermontRaptorAcademy.com
Floyd@VermontRaptorAcademy.com

Jerry Simchuk
415 Orchard Ridge Rd.
Kalispell, MT 59901
(406) 257-1784
www.simchuk.com
Jerry@Simchuk.com

Morten E. Solberg
c/o Fox Chapel Publishing
1970 Broad Street
East Petersburg, PA 17520
(352) 683-4502
www.mortenesolberg.com
solbergsr@aol.com

Dr. Jim Thean
126 Holtz Ave. #2
Grayton Beach, FL 32459
(850) 231-1145

More Great Books from Fox Chapel Publishing

**The Illustrated Owl:
Screech & Snowy**
By Denny Rogers
200 detailed drawings
with color and scale
charts. A visual study
that over-delivers and
Is a must for any artist!
$29.95
ISBN 978-1-56523-285-3

**The Illustrated
Bald Eagle**
By Denny Rogers
Meticulous drawings,
exclusive color and
proportion charts, and
realistic detail to down
to the last feather.
$24.95
ISBN 978-1-56523-284-6

**The Illustrated
Birds of Prey**
By Denny Rogers
A must-have for bird
carvers! Over 200
detailed sketches of
the red-tailed hawk,
American kestral &
peregrine falcon.
$34.95
ISBN 978-1-56523-310-2

Wildlife Designs
By Sue Walters
30 designs and 10
border designs to
create images of North
American wildlife.
$14.95
ISBN 978-1-56523-295-2

**Drawing Mammals
3rd Edition**
By Doug Lindstrand
Color photographs,
sketches, and notes on
20 of North America's
favorite large animals.
$25.00
ISBN 978-1-56523-206-8

**Great Book of
Woodburning**
By Lora S. Irish
Create your own
stunning pyrography
with techniques,
patterns, and easy-to-
follow projects.
$19.95
ISBN 978-1-56523-287-7

LOOK FOR THESE BOOKS AT YOUR LOCAL BOOKSTORE OR WOODWORKING RETAIL

To order direct, call 800-457-9112 or visit www.FoxChapelPublishing.com

By mail, please send check or money order + $4.00 per book for S&H to:
Fox Chapel Publishing, 1970 Broad Street, East Petersburg, PA 17520